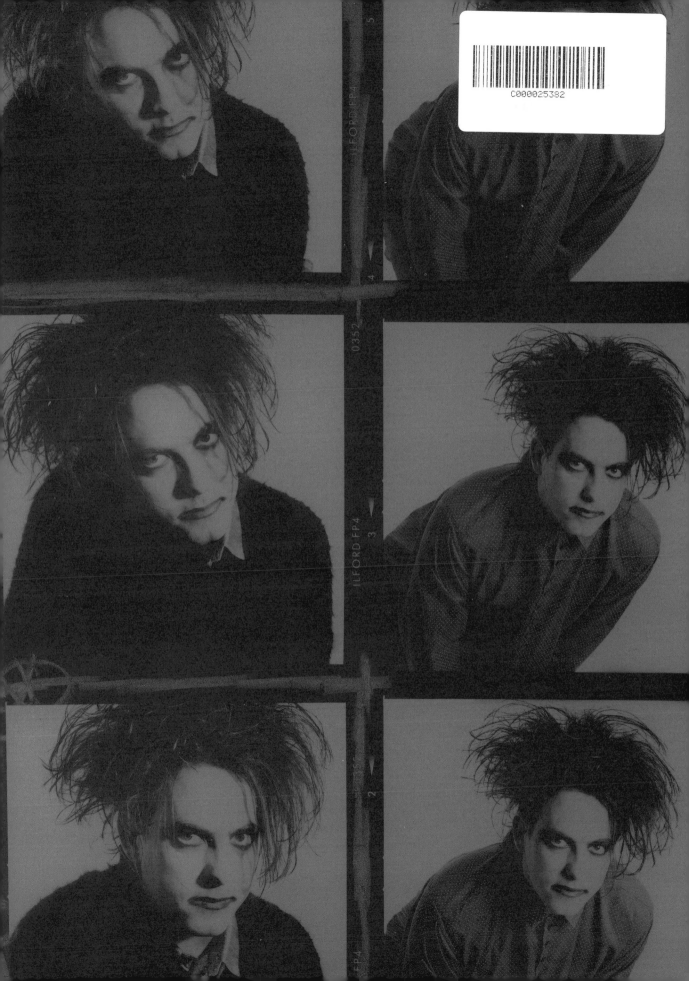

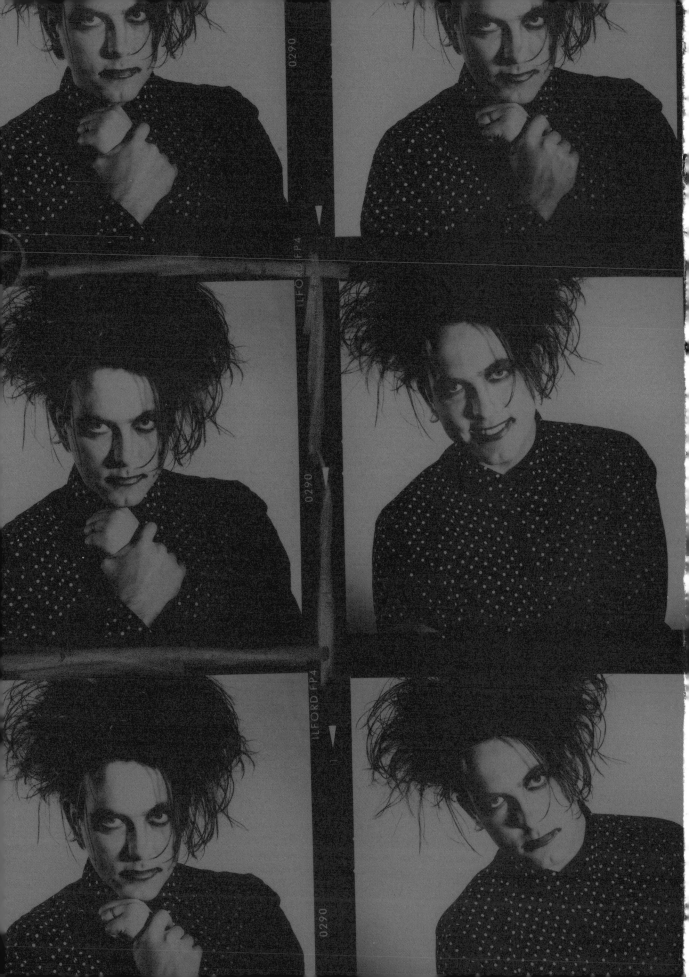

the cure
pictures of you

WELBECK

PHOTOGRAPHS
TOM SHEEHAN

PICTURES OF WHO/HIM/THEM/US
SIMON GODDARD

CONTENTS

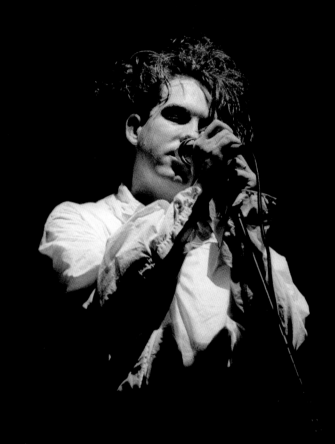

"WHY DON'T YOU AND THE OTHER HERBERT GET STUCK IN THAT SPINNING HENRY WHILST I FIRE OFF A COUPLE OF FRAMES AND WE SHOULD ALL BE DONE BEFORE THE TAPSTER'S HAD TIME TO POUR YOUR NEXT GARGLE…"

MEETING TOM SHEEHAN AS EARLY AS WE DID MEANT MOST SUBSEQUENT PHOTOGRAPHERS – FAFFING, FUSSING, FRETTING, EASILY UNDERSTOOD – SUFFERED BADLY BY COMPARISON

TOM WAS ALWAYS SHORT, SHARP, SURE AND SLIGHTLY FUGITIVE – TRICKING US 'HERBERTS' INTO CASUAL POSE WITH THE ARTFUL BUT SNEAKY TECHNIQUE OF RABBITING-NOT-LOOKING-THROUGH-THE-CAMERA AS HE SNAPPED HAPPILY AWAY – CHIDING US ALL INTO MORE CONSIDERED MOOD WITH A "CHIN UP MINCERS WIDE LESS HAMPSTEADS REMEMBER YOU'RE A GOTH BAND CHAPS" ADMONISHMENT OR TWO – CONFOUNDING US WITH A NINJA-LIKE ABILITY TO HIDE IN PLAIN SIGHT, A ROLL OF FILM CHANGED BEFORE THE SCRUFFS HAD EVEN NOTICED HE WAS TAKING PICTURES…

AND OF COURSE 'SESSIONS WITH SHEEHAN' WERE ALWAYS SO MUCH MORE THAN JUST PICTURE-TAKING – LOSING MEMBERS OF THE ENTOURAGE ONE BY ONE UNTIL THE INVARIABLE SMALL BRUISED BAND OF FOOLS WOULD ARRIVE SOMEWHERE SHADOWED, SMOKY, STRANGE AND OFTEN VERY STOKE-ON…

BUT THE MOST MEMORABLE THING
THE MOST IMPORTANT THING
WAS THE WONDERFUL FEELING WE HAD
THAT HERE WAS SOMEONE WHO WAS NOT ONLY
A REALLY GOOD PHOTOGRAPHER
BUT A REALLY GOOD MAN…

…A REALLY GOOD BAIZE LEGEND RUBY STAR TOP GEEZER SMUDGE MAN!

ROBERT SMITH

I worked with The Cure for more than 20 years, on all sorts of sessions – on tour, in the studio, at festivals, out on location – and I have great memories of the time we've spent together.

I seldom shoot a band I don't know anything about, so I'd heard the music before I first met them in a hotel in Kensington in 1982. That first meeting wasn't a proper photo session, just a little snap for a news story. But one thing I've enjoyed about working with the band is that the feeling of the shoots didn't really change between that first snatched moment and the many sessions we worked on afterwards, once they'd gone on to become one of the greatest UK bands in recent history. You put more thought into a shoot once you know the band's going be on a cover or you have a whole feature to fill, but nothing was changed by the success and momentum the band had as their career went on.

It's always been a very relaxed experience to work with Robert and the band. My way of working is not to be too serious, to have a good sense of humour, not to go in with cast-iron plans but to know what you want to get out of your time with an artist. It can be an intense process, a bit like getting married to someone for half an hour, so I keep it short and sharp and do what needs to be done. Get in, plant the bomb and leave with something in your bag.

I think my way of working chimes well with Robert's, which is why we've worked well together over the years. He has a strong visual sense of exactly what he wants, he understands the process and takes the time to think it out. So when I shot him in Waterloo, I was so pleased to see that he'd brought a few changes of clothes with him, something to give us some options to work with. It showed how he understands the job we're doing.

I have a love of people who are creative in the way that Robert is. How they work so hard on their tunes, commit so much and soar so high, musically. But when they're not working, they're pretty normal people. Of course, I can't help but admire them as artists – the music they write can change your life – but they don't want to hear all that. We have a relationship based on professionalism and mutual respect. They just happen to be incredibly talented.

When I was working with the band, or any of the artists I've shot over the years, I was never thinking about the future. The photographs are for now, not for when hell freezes over. At the time I don't think anyone went out to create anything that would last forever – the photographs, the music, whatever. But now I can look back and see the lasting legacy of some of these photographs, and enjoy the happy memories they bring.

I've probably shot The Cure more often in their various line-ups than any other group I've worked with. It's been a real pleasure to be a small part of their journey.

Tom Sheehan

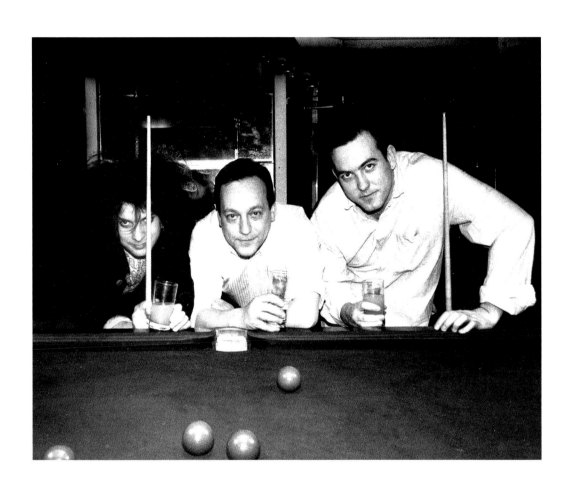

PICTURES OF WHO?
(Never: 1977–1982)

The calendar says 21 April. His eighteenth birthday. Eighteen years the Fates have been watching him. As a little boy eating sand on the beach at Blackpool. As a slightly older little boy reading Penelope Farmer's eerie timeswap kids' book *Charlotte Sometimes* in his bedroom in Crawley – a town possibly twinned with somewhere in Belgium called Creepy – the last flat blob of England people with a window seat flying out of Gatwick see before they slip into the clouds towards somewhere more interesting. As a teenager watching Bowie beam down as Ziggy onstage in Earls Court. And that day at school when the teacher asked the class what they all wanted to be when they grow up. 'A pop star in a band,' he'd said: and half of Sussex laughed itself into the sea.

But the Fates haven't forgotten. Today's the day the boy becomes a man, and they have their own little coming-of-age birthday surprise in store. Because today is Thursday, when the music weeklies hit the shelves, and today, they know, he'll be shuffling to the newsagent for his inky fix of posture, gossip and tour dates. And they will guide his fingers past the *NME* with Bob Marley on the front – *no, not that one* – and *Sounds* with Richard Hell – *yes, tempting, but keep going* – to *Melody Maker* with The Clash on the cover, knowing he'll be unable to resist picking it up and flicking all the way through to the full-page advert on the back.

'Wanna be a recording star?'

Happy birthday to you!

'Get your ass up – take your chances!'

Happy birthday to you!

'Germany's leading pop label that brought you Boney M and Donna Summer is auditioning in Britain.'

Happy birthday dear Robeeeeeeeeert!

'Send tape and photo to Hansa Records,

PO Box 1DT, London.'

Happy birthday toooo yooooou!

Fifteen fumbled pence from his pocket and it's his.

Does he wanna be a recording star? Yes, he does. It's all he wants to be. Someone who makes records like The Sensational Alex Harvey Band, or Nick Drake, or Jimi Hendrix, or David Bowie. Getting all those weird sounds swirling in his head like a candyfloss machine out on to black plastic discs so kids like him can lie on carpets like his mum and dad's and listen to *his* music the way he listens to *Ummagumma* by Pink Floyd. He's not even put off by the advert's main image, which isn't of anyone behind the console of a recording studio, or onstage stood at a microphone, or wiggling two thumbs up sitting in front of a wall of gold discs. No, it's of two women on a motorcycle with a guitar strapped on the back. The one whose face he can't see is thin and blonde. The one whose face he can is a sexy black chick in boots and hot pants, cocking a leg as she gets her proverbial 'ass up'. This, in April 1977, is the image Hansa Records of Germany wish to wave as a dangling carrot of pop nirvana. One that implies life as 'a recording star' is one sweet cycle burn with sexy chicks in hot pants riding pillion. For a lot of 18-year-old men living in Silver Jubilee England, this is as good a reason as any to apply, and of the 1,400 groups who send demo tapes and photos to PO Box 1DT, at least half are comprised of pimply hogs investing all hope, spunk and postage costs on the fickle dream that such a livelihood actually exists.

Robert James Smith isn't one of them.

Bang on eighteen, his head may be forever in the clouds, but his feet are firmly planted on Sussex Council pavement. He has a loving, supportive family happy to let Robert and his friends practise playing their mad, spiky music in the old conservatory extension on the side of their house every Wednesday evening. He is already in love, very permanently, with his girlfriend, Mary. He is not

burning up with vengeance to prove himself to anyone who may have wronged him. He's not thinking about 'a career', even less being 'a star'. He just wants to make records. Which makes him very noble. And very naïve.

If Robert needed reminding exactly what being 'a recording star' entails he could spend the night of his 18th birthday watching *Top Of The Pops*: miming to clapping crowds and Radio 1 disc jockeys, glistening with lipstick in the spotlight like Elkie Brooks, or batting blue-eyeshadowed lids at the lens, surrounded by the snowy Swedish archipelago like Abba, number 1 this week with 'Knowing Me, Knowing You'.

Hair. Make-up. *Image*.

But he's not thinking about any of that, only what this advert might mean for his own band: Easy Cure. Robert plays guitar – the one that cost him 20 quid from Woolworths – and sings backing vocals. There are four others in the group, including his oldest schoolfriend, Lol, and a singer who shares a name with the actor who played Lawrence of Arabia. With nothing to lose apart from prayers, time, ferric, Kodak film and a first-class stamp, they record some songs on a basic cassette recorder, pose for a happy snap and send both on their way to PO Box 1DT. And just like in the movies, the miracle actually happens. Two weeks after their package vanishes into a pillar box, Robert's band are invited to audition at a London studio. It's only when they get there they discover Hansa never actually played Easy Cure's tape: they just liked the photograph. The audition is a shambles, but nobody at Germany's leading pop label that brought you Boney M seems to mind and, before common sense can poop the party, Robert picks up a pen and signs his first recording contract not because of how he sounds, but how he looks.

The ink hasn't dried when the singer surnamed O'Toole bails out and Robert is thrust centre stage as the new front man, just as Hansa suggest they try and record cover versions of old hits from the 1960s. Robert quickly realises this has all been a dreadful mistake. So do Hansa when he

tries to record his own songs about senility, abattoirs and paedophiles. The last straw is when he presents them with a new song, inspired by an Albert Camus novel, called 'Killing An Arab'. He's told they can't release it because Hansa 'need to keep in with the Arabs'. They also think it's rubbish.

Easy Cure's five-year contract is swiftly terminated.

Come the Englandless Argentine World Cup summer of '78, Robert Smith is one year older but an epoch wiser than the green 18-year-old who answered that *Melody Maker* ad. Because this was the Fates' real gift all along. Not to hand the lad his dream on a plate, but to teach him an invaluable lesson about the overstaffed ship of fools that is the SS *Music Biz*: to never ever again place his trust in anyone who wants to sign him for reasons other than the sounds vibrating from his mouth and the pick-ups of his Woolies guitar.

Image? Fuck image!

Thus Easy Cure become more easily The Cure and The Cure become more purely about music. For starters, 'Killing An Arab' isn't rubbish and Robert knows it. So does a man named Chris Parry who signed The Jam and Siouxsie And The Banshees, now looking for groups for his brand-new label. Chris agrees to manage and produce them, and after a sell-out first run on another independent label, 'Killing An Arab' by The Cure becomes the first single on Fiction Records. And so, at the age of 19, Robert Smith properly becomes, if not yet 'a star', 'a recording artiste'.

An artiste in a group without an image. The sleeve of 'Killing An Arab' is a pair of eyes in chiaroscuro. There is no band photograph on the back either. But being inaugural Fiction recording artistes, Robert and The Cure don't escape that easily. Their single is liked – in some quarters *loved* – by the same inky music papers full of postures, gossip, tour dates and adverts with sexy girls in hot pants clambering on to motorbikes, that now want to write about The Cure: who they are, what they're about, what they

look like. Which means blethering into journalists' tape recorders and gawping into photographers' lenses.

Among the first things they say into any such tape recorder concerns the importance of 'integrity' over 'image' and their desire to present themselves on stage as they are off. Which may explain why, in the first photographs of The Cure that appear in the music press, Robert, forever in an oversized raincoat, looks everywhere but towards the lens. Usually somewhere in the vicinity of his shoelaces. It isn't shyness, more a conscientious objection to the cultivation of anything that could plausibly be conceived as an image.

Image? Fuck image!

Two weeks after his 20th birthday, in May 1979, the first album featuring Robert Smith is released as Maggie is still picking out her new curtains for Number 10. There are no photographs of any of the three members of The Cure anywhere on the sleeve of *Three Imaginary Boys*, front, back or inside. Instead, they've chosen to be represented by three household objects.

Robert is a lampstand.

It's not until later that year, when faced with another journalist's cassette recorder, that the lampstand admits the reason, as he sees it, no one likes The Cure is because they have no image.

'There's nothing for them to identify with and imitate, like there is with The Clash, or The Ramones, or The Banshees.'

When the time comes to take an accompanying photograph for the article, headed 'No Image, No Style, No Bullshit', Robert recedes as far as possible into the distance from the other members of the group and stubbornly twists his gaze away from the camera: such is his determination to have the least recognisable mug in the *I-Spy Book Of Post-Punk*. And he intends to stay that way. Because all he has to do is play

it cool and just make sure his group doesn't cock up this blissful state of anonymity by writing anything really popu—

'Right, here comes a good band called The Cure!'

Whoops.

Two days after his 21st birthday, Robert Smith is in BBC Television Centre being introduced by Steve Wright and trying his hardest not to look directly into the bulky Dalek-like cameras of *Top Of The Pops*. The Cure's new single 'A Forest' is just outside the Top 40. High enough to land him slap bang in the same studio as Legs & Co, who, in this week's routine, boogie to a disco tune wearing several different shades of sexy hot pants. All that's missing is a motorcycle to straddle with a guitar on the back. See, Robert – *now* you're a recording star all right!

The pre-recorded show goes out the following evening, between *Tomorrow's World* with Michael Rodd and *Taxi* with Andy Kaufman, when the image of Robert Smith – skulking head to toe in black, a bogbrush haircut and pasty, glum face that could easily confuse viewers he's on season transfer from The Specials – will be broadcast to something in the region of 15 million slack jaws, possibly more. Some of whom will be convinced to spend that week's wage packet on The Cure's second album, out this week, *Seventeen Seconds*. This one at least features photos of the newly rejigged four-man line-up on the back sleeve. And all, including Robert, deliberately foggy and out of focus.

And so The Cure spend the next two years making more albums with hazy, indistinct sleeves, some featuring yet more fittingly indistinct photographs of Robert and his group, as if trying to reassure their listeners that the woozy wobbles of 'The Funeral Party' and 'The Hanging Garden' could only ever be played by an ensemble of amorphous ectoplasmic wraiths. Which isn't so difficult to imagine.

As the pictures get blurrier the music gets bleaker. So does Robert's mood. Two weeks after his 23rd birthday, The Cure's unfunny-as-hell fourth album, *Pornography*, amounts to a cry for help from a young man who's finally decided he doesn't wanna be a recording star anymore. Because after three years he despairs of it all. The endless reminders that his only purpose in life is being part of a group. The endless touring of the same dressing rooms in the same venues with the same graffiti he scribbled on the walls last time he was there. The endless backstage drinks. The endless backstage fights. The endless journalists asking him endlessly stupid questions. The endless photographers trying to coax direct eye contact down the barrel of the lens. The endless fucking of the endless image.

Until the endlessness ends. After an encore somewhere in Belgium, possibly a town called Creepy, when The Cure play a rambling improvised song, of sorts, called 'The Cure Are Dead', and thereafter evaporate in a drunken puff of bad karma. All except Robert and his old schoolfriend, Lol. Two men, barely a band and no image.

If there's any future left in The Cure, maybe it's time they found one?

My first ever encounter with The Cure, in
the Hilton hotel near Shepherd's Bush in
London. We'd met in the bar so they could do
a quick interview for a small news feature in
Melody Maker about their new single 'Let's
Go To Bed'. Robert was also on tour playing
with Siouxsie And The Banshees, who had
a gig at Hammersmith Palais that night.

Robert got a call saying 'showtime!', so he
had to leave straight away for soundcheck.
We moved quickly, found this spot by the exit
and I snapped these shots on the way out.

SHEPHERD'

S BUSH 1982

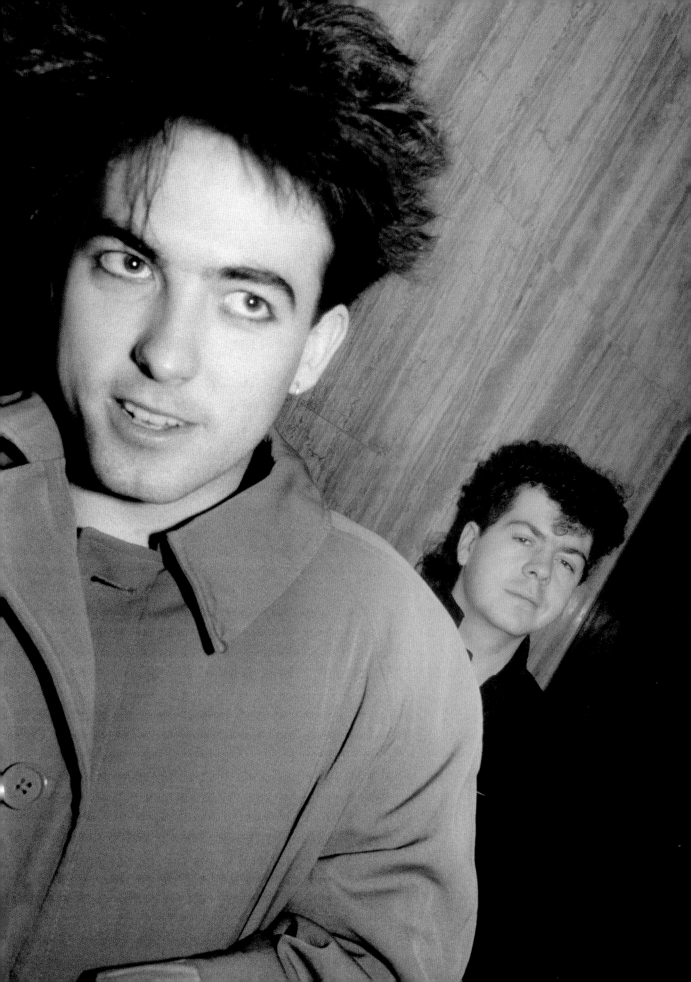

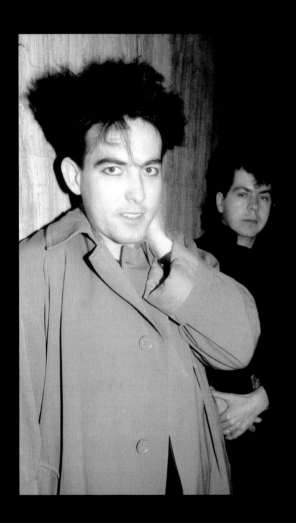

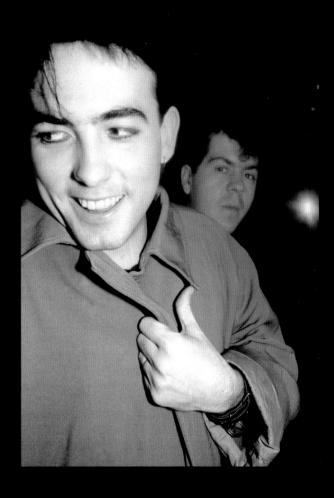

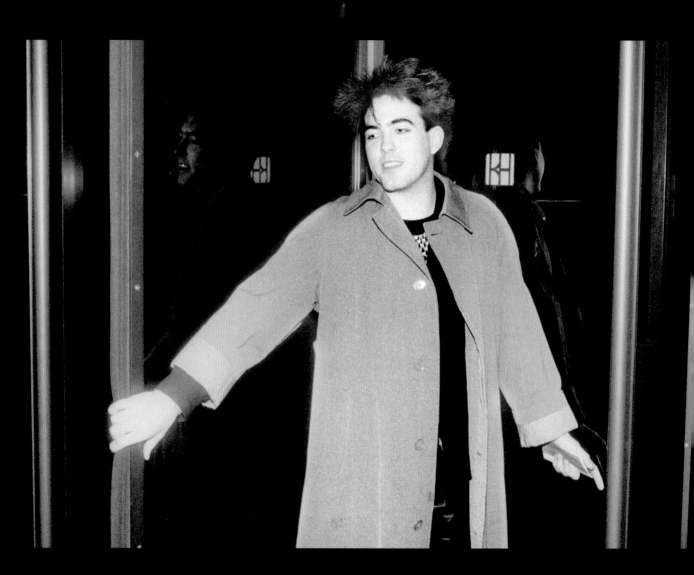

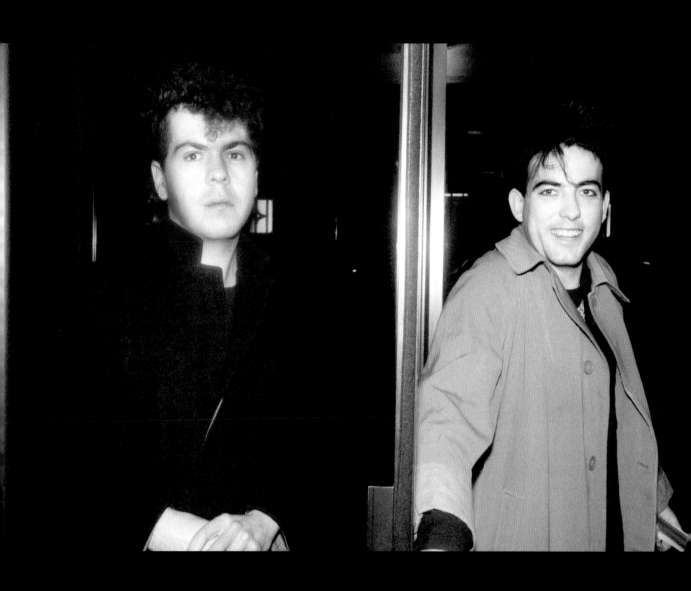

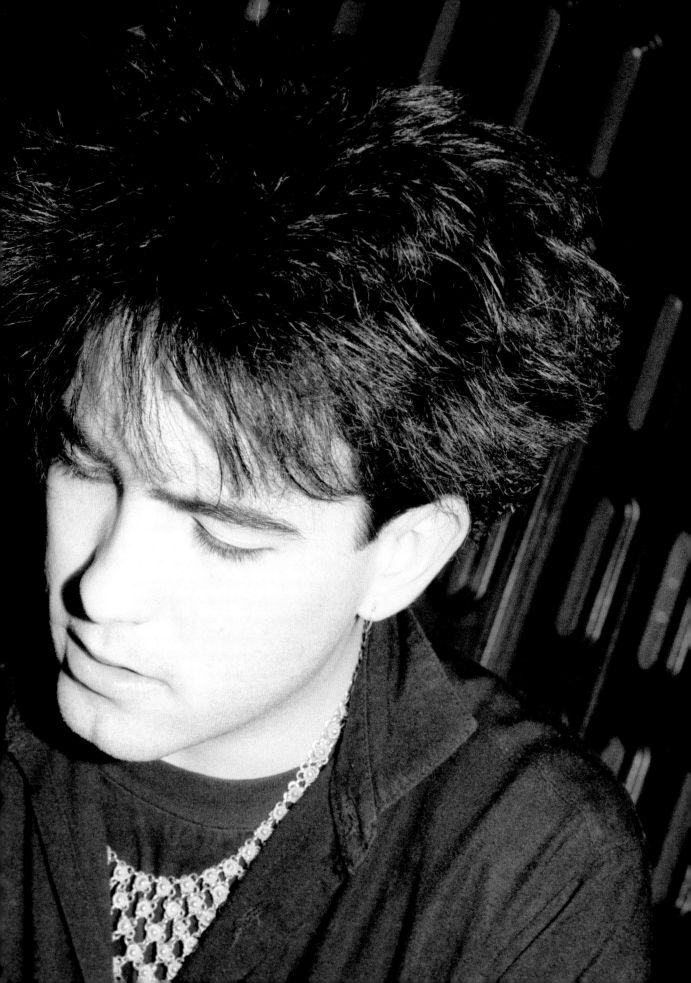

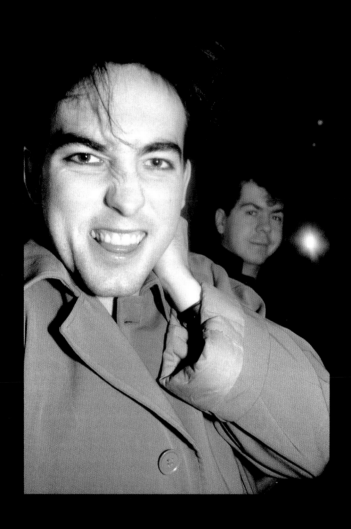

In July 1983 I had my first real, in-depth
session with the band. It was at the
Elephant Fayre, a festival in Cornwall with
an old-school fair kind of vibe: jugglers,
face-painting, that kind of thing.

I took some nice shots at soundcheck
and with some early fans on the Saturday
afternoon. Then, job done, we headed to a
pub in a nearby town. On the way, I spotted a
field that would make an interesting backdrop,
so I shouted to stop the car and we hopped
out, nailed some shots and moved on.

ELEPHANT

FAYRE 1983

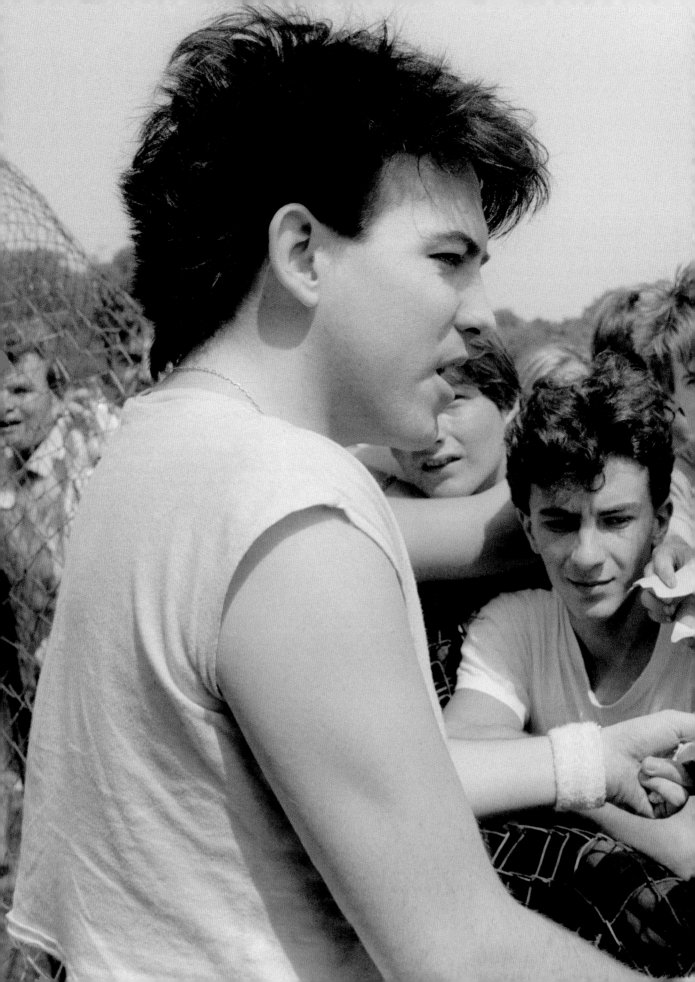

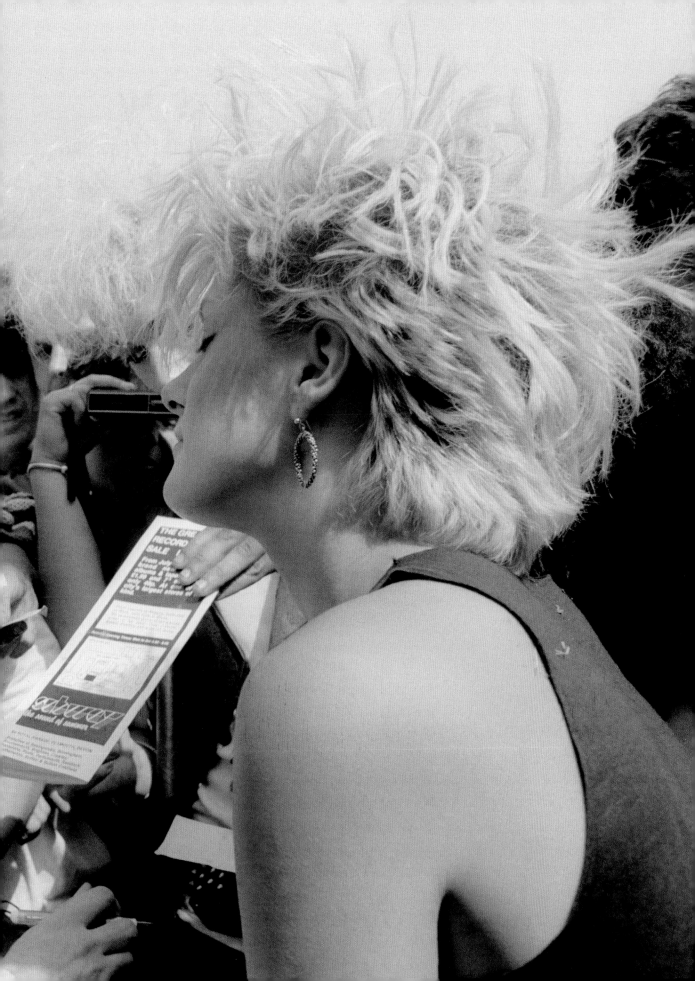

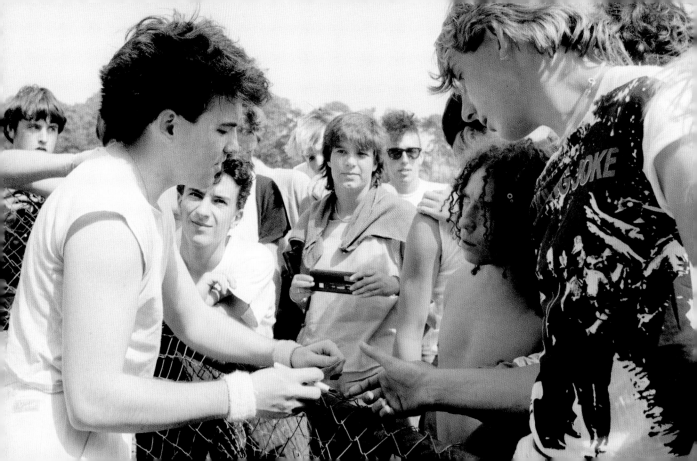

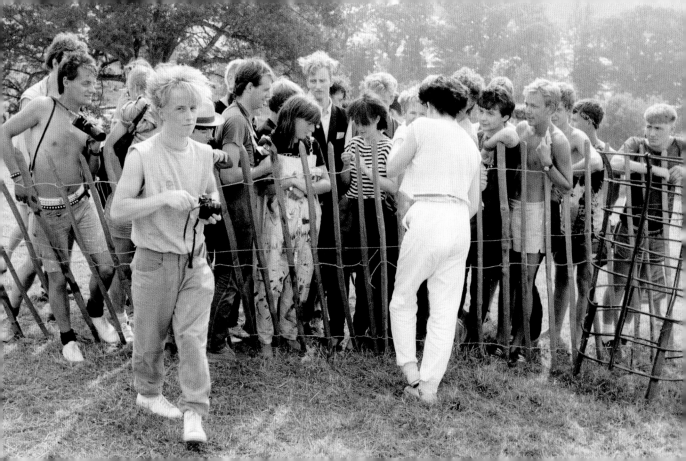

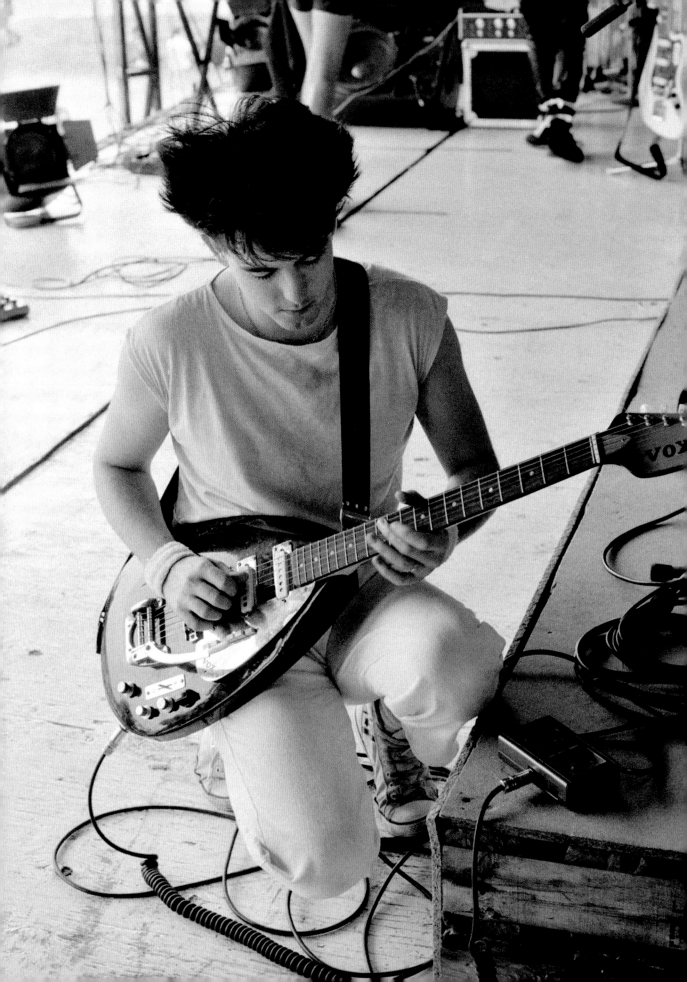

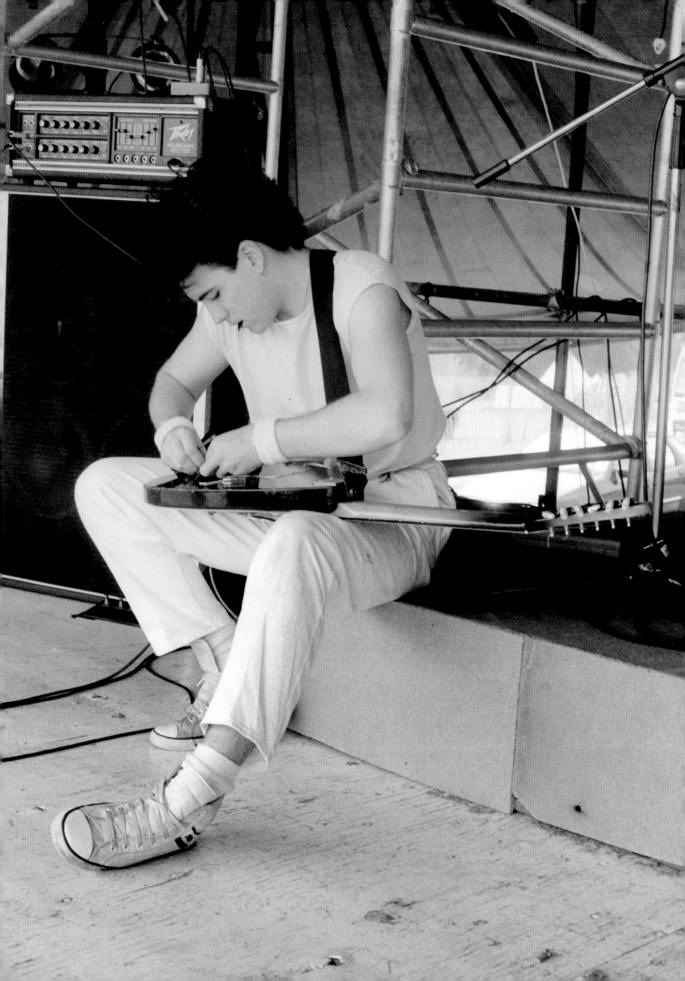

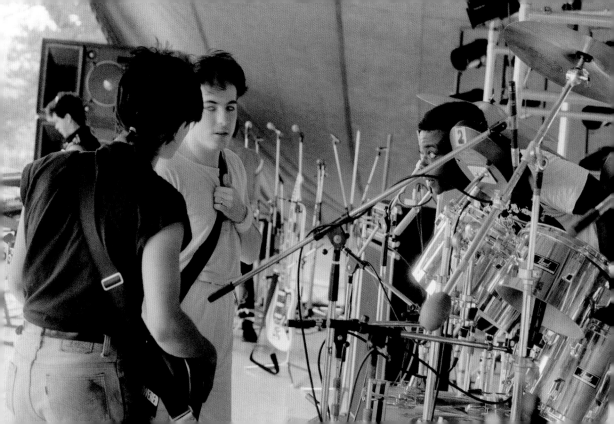

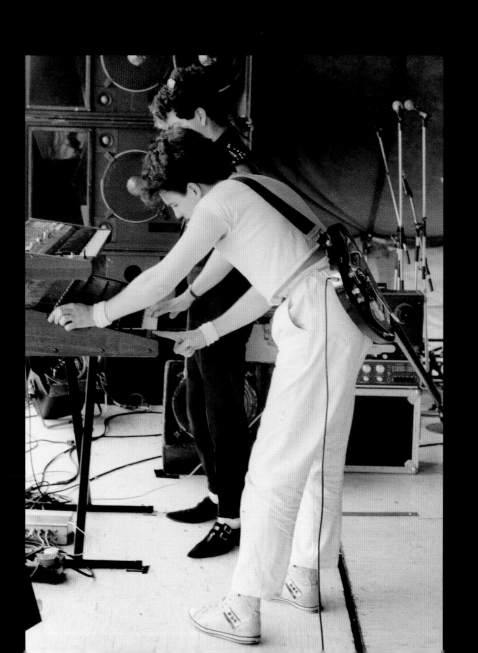

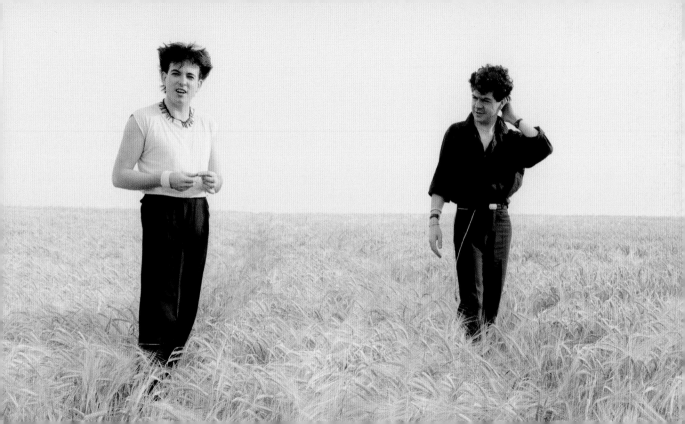

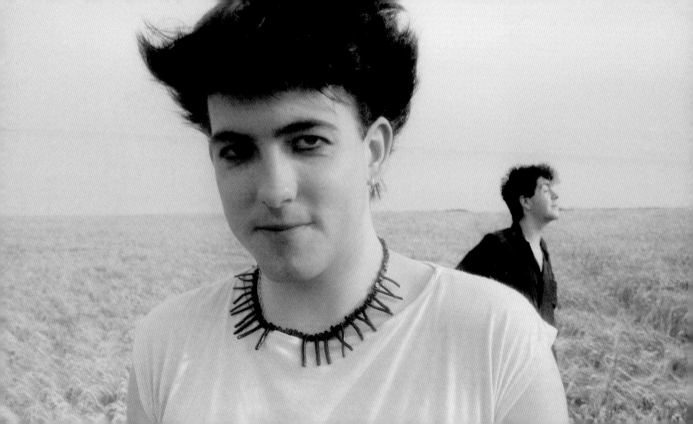

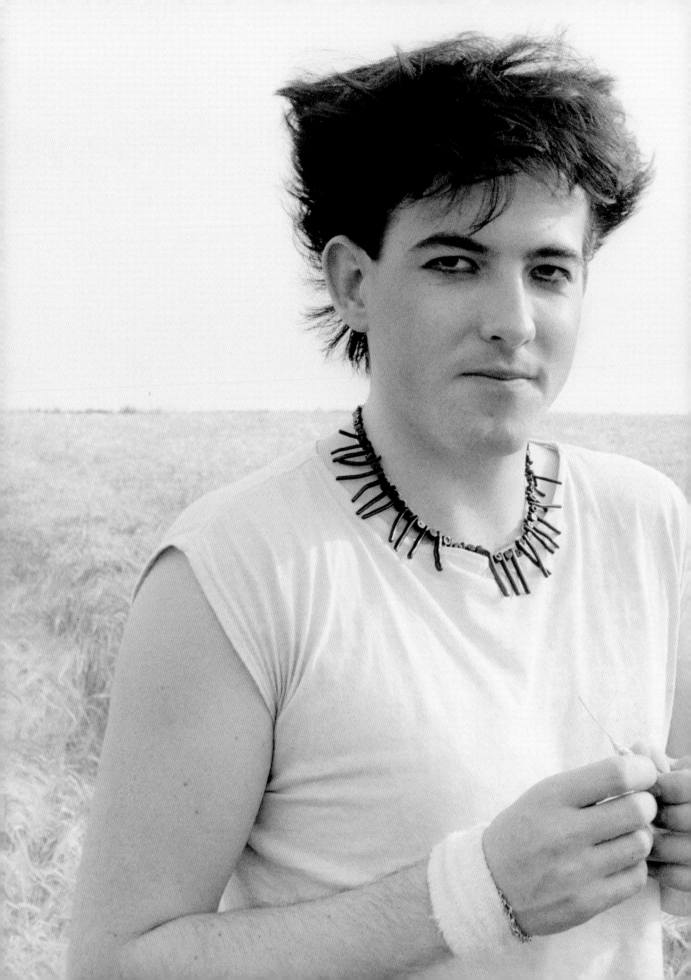

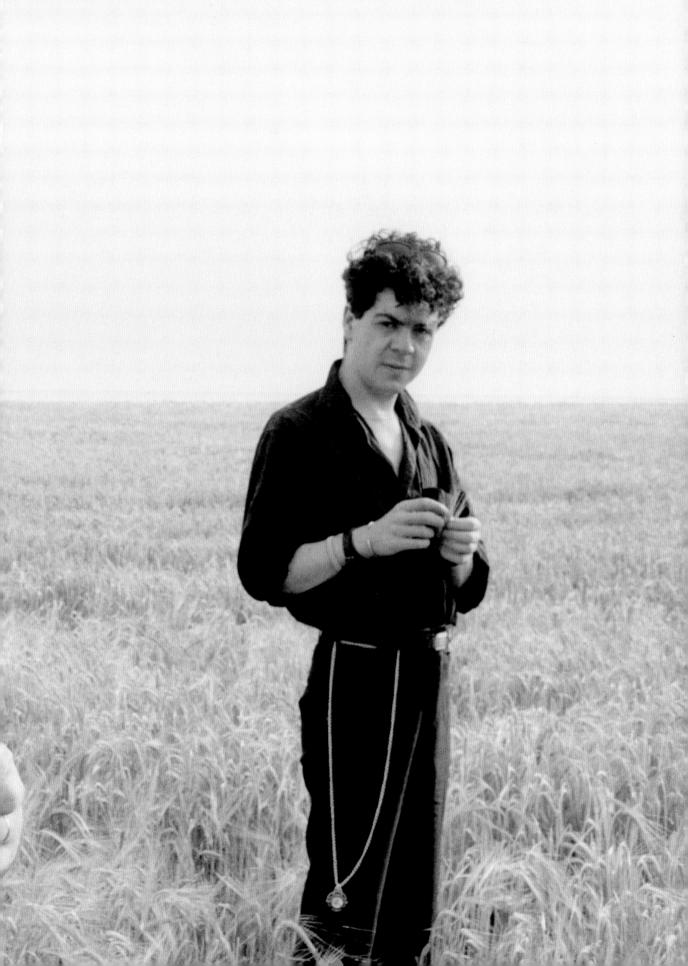

These were taken in September 1983 at Floral Hall in Covent Garden, now part of the Royal Opera House. Robert was still playing with the Banshees, but The Cure's star was rising and so to have the two of them together was a real pull.

SIOUXSIE AND TH

BANSHEES 1983

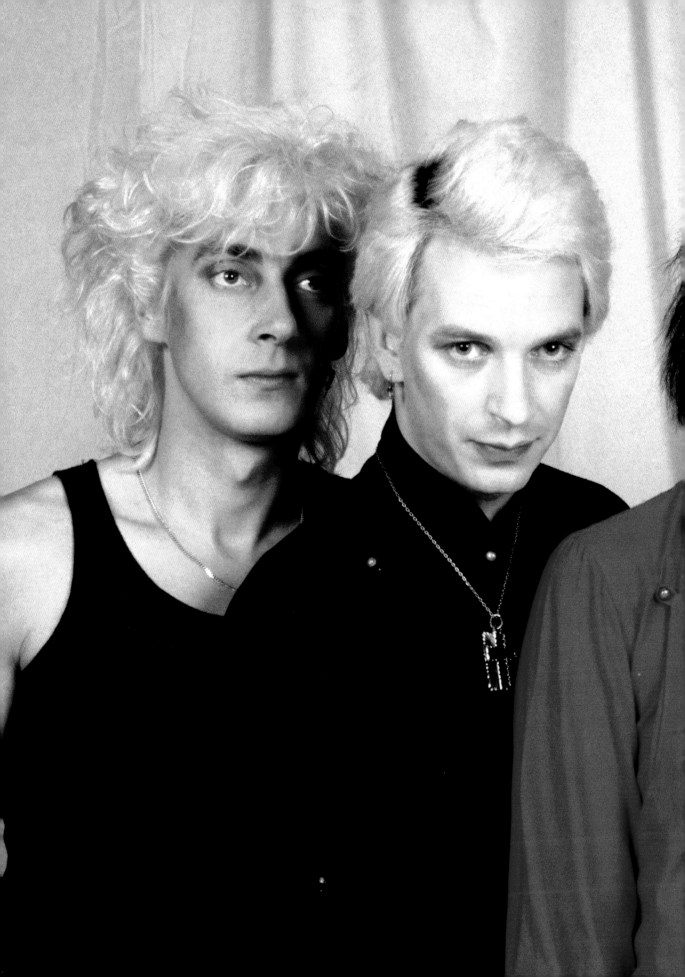

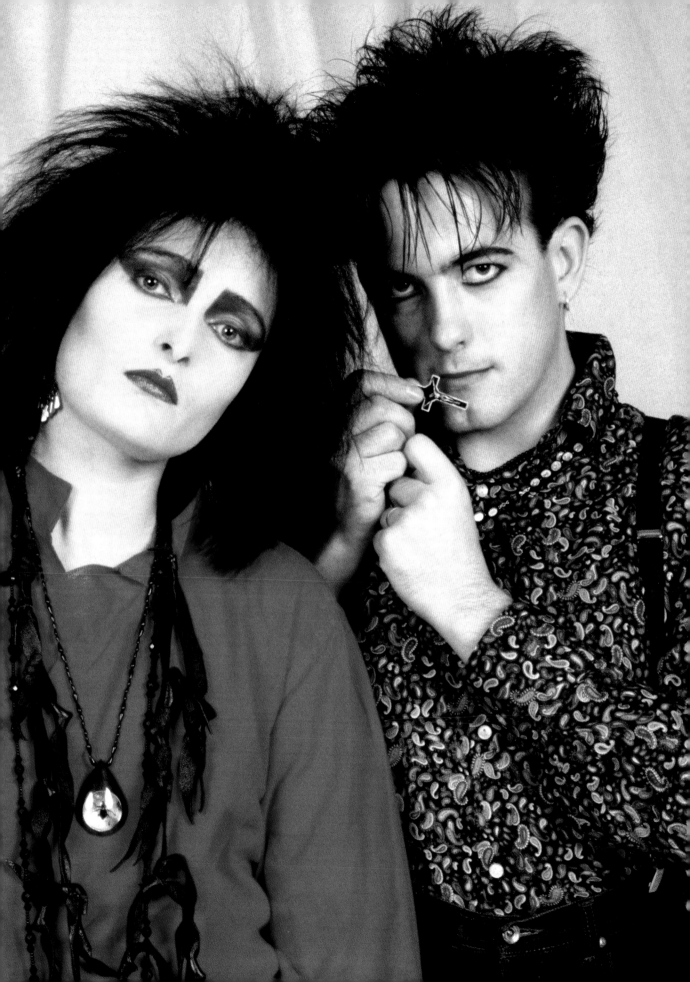

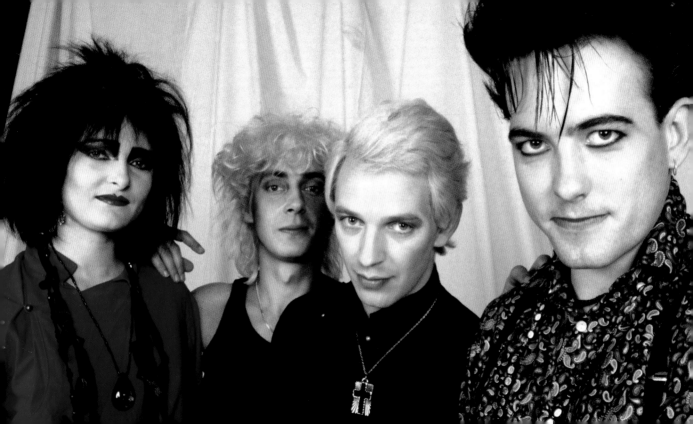

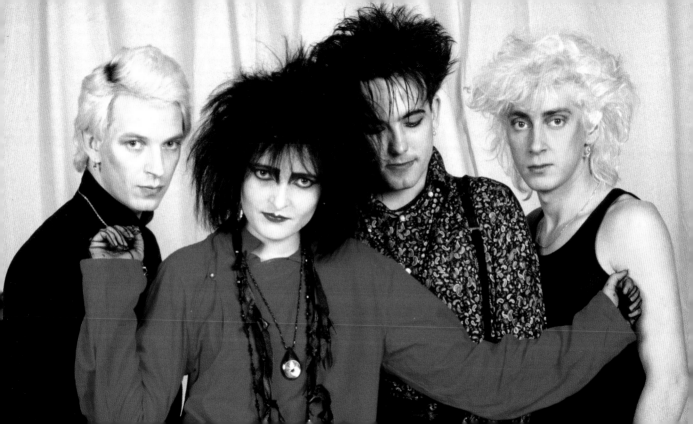

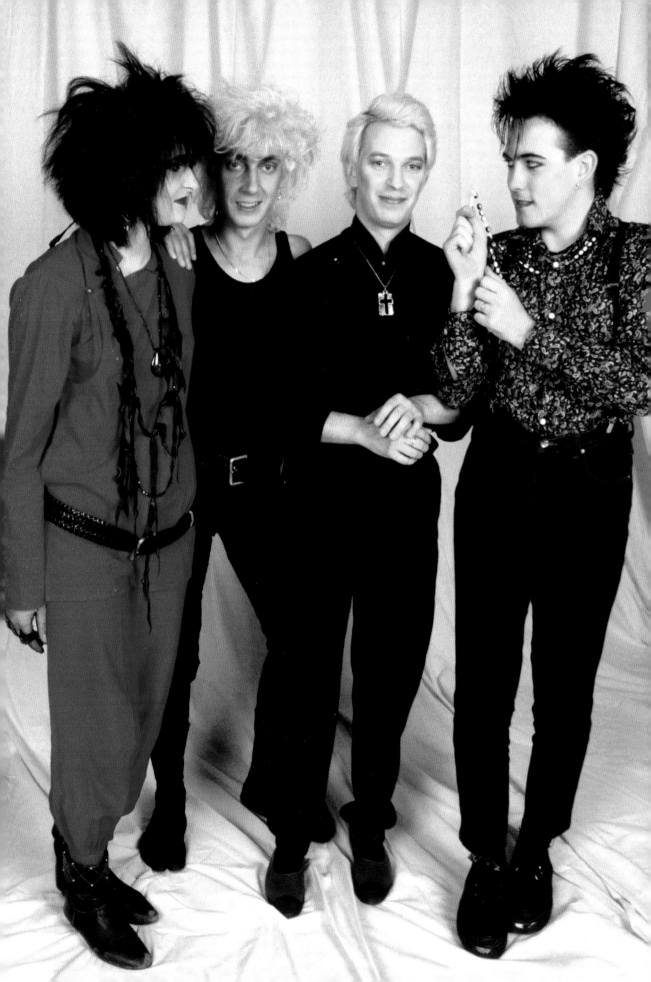

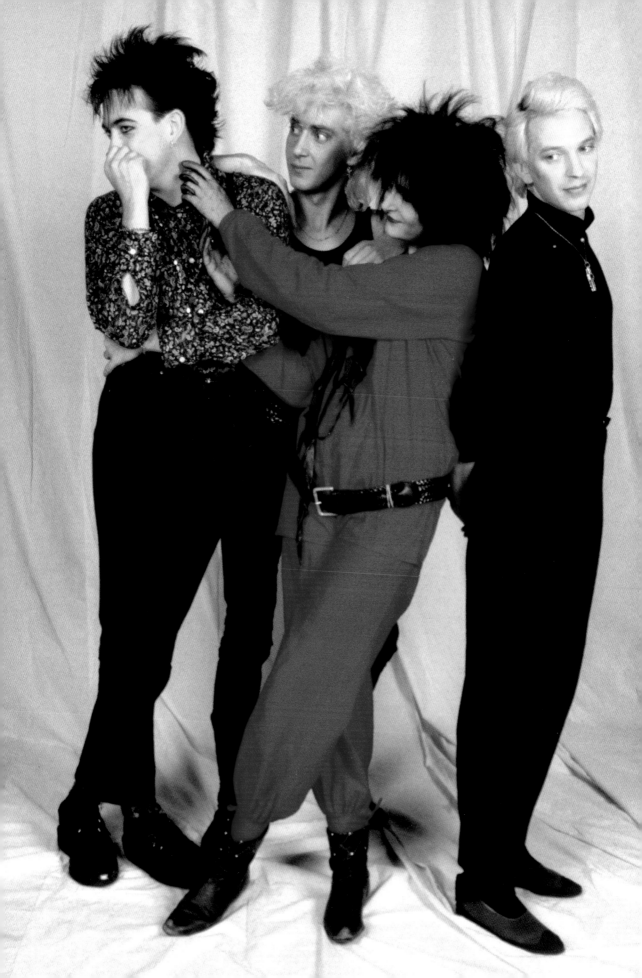

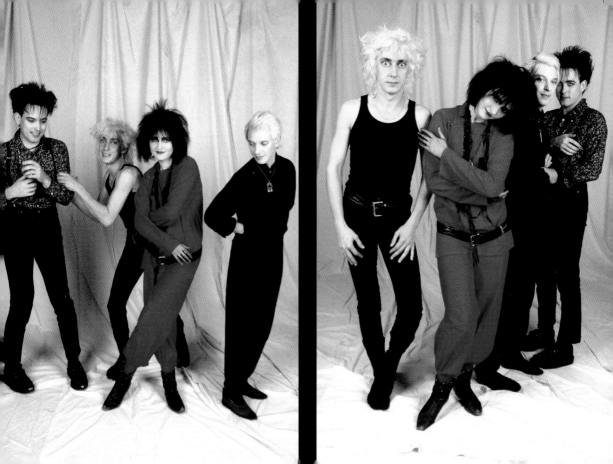

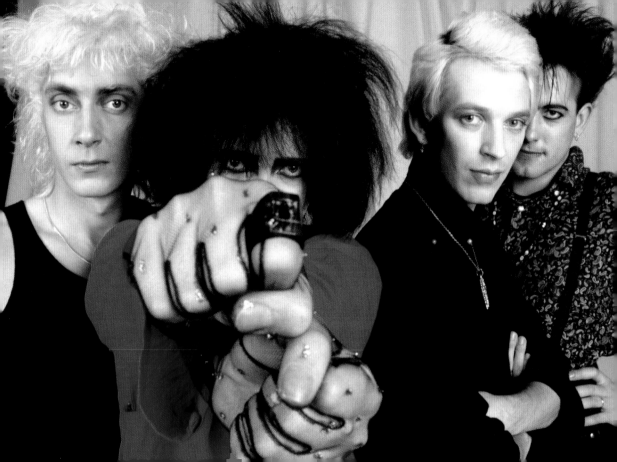

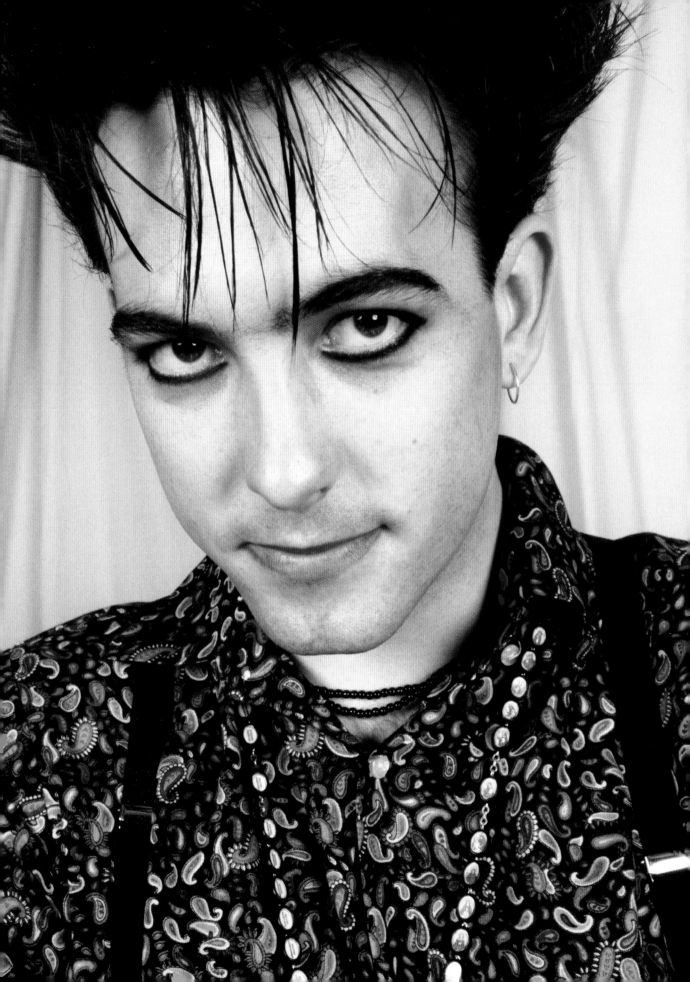

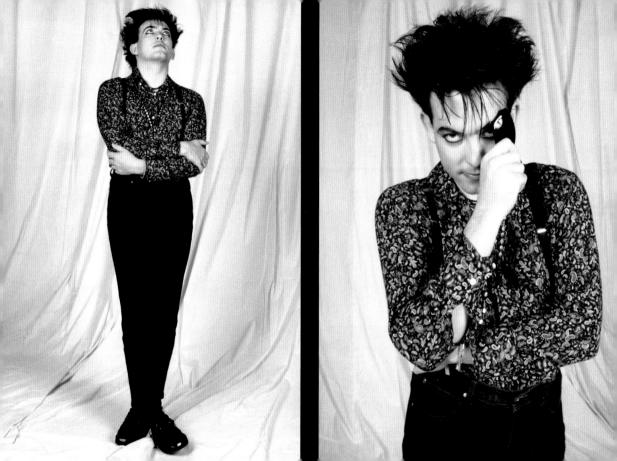

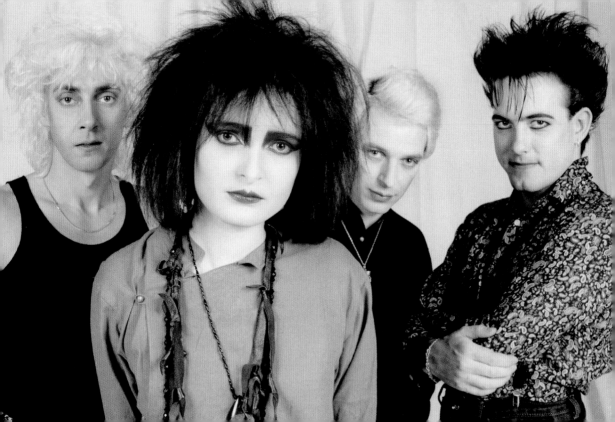

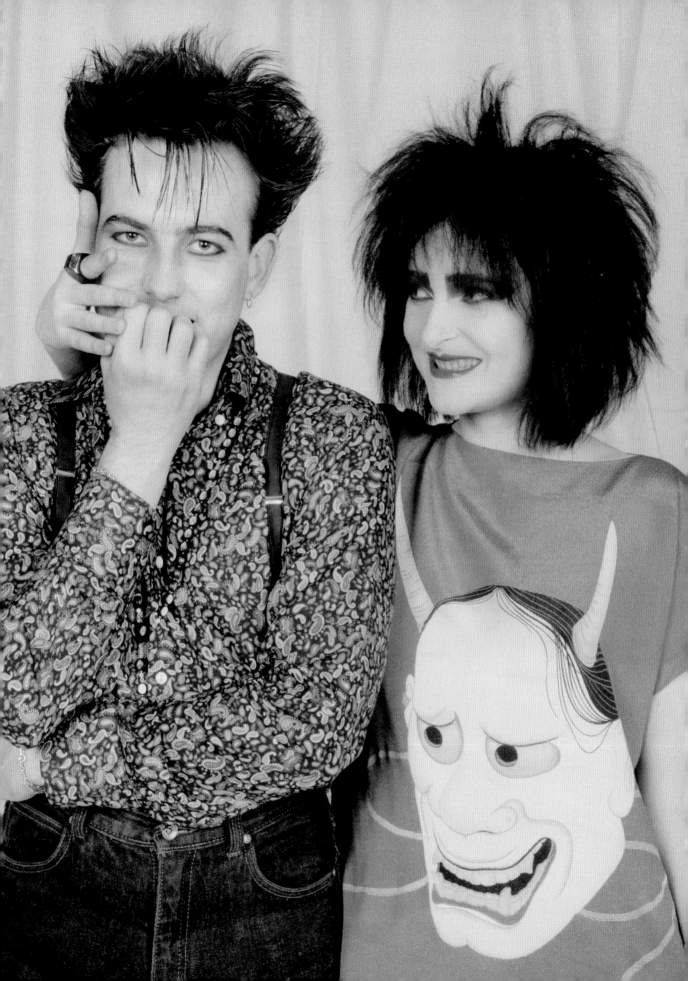

In August 1983 Robert was working on his side
project, The Glove, in collaboration with Steven
Severin from Siouxsie And The Banshees. I
love it when kindred spirits get together and
do their thing – artists working with artists.

I took some photographs around the
law courts at Lincoln's Inn Fields, then
we went back to the *Melody Maker*
offices, where I stood them in front of a
background I'd sprayed that morning.

THE GLO

VE 1983

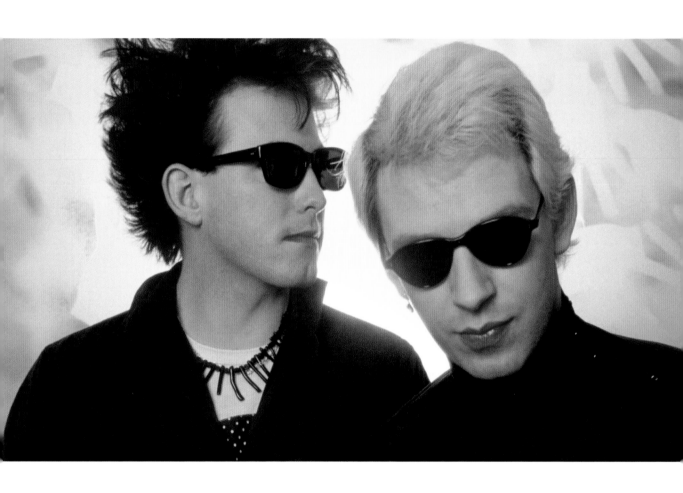

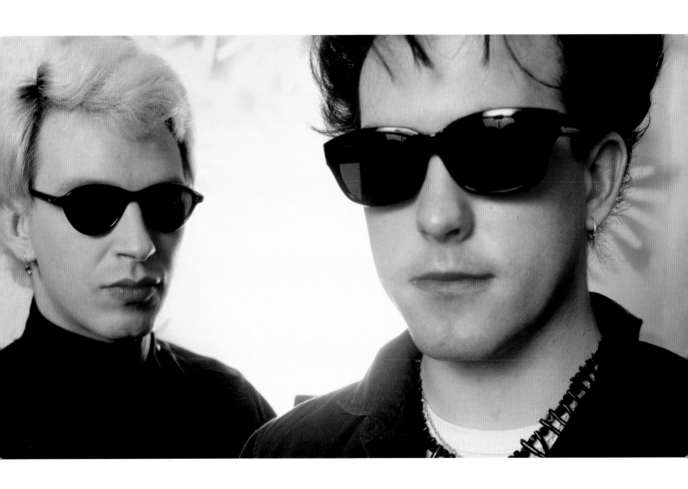

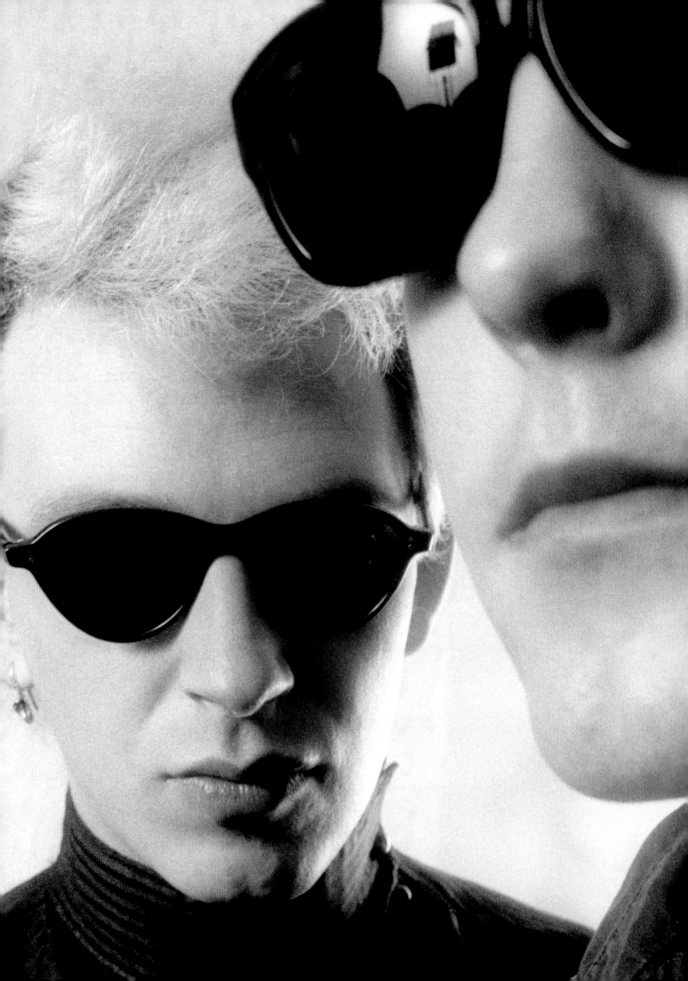

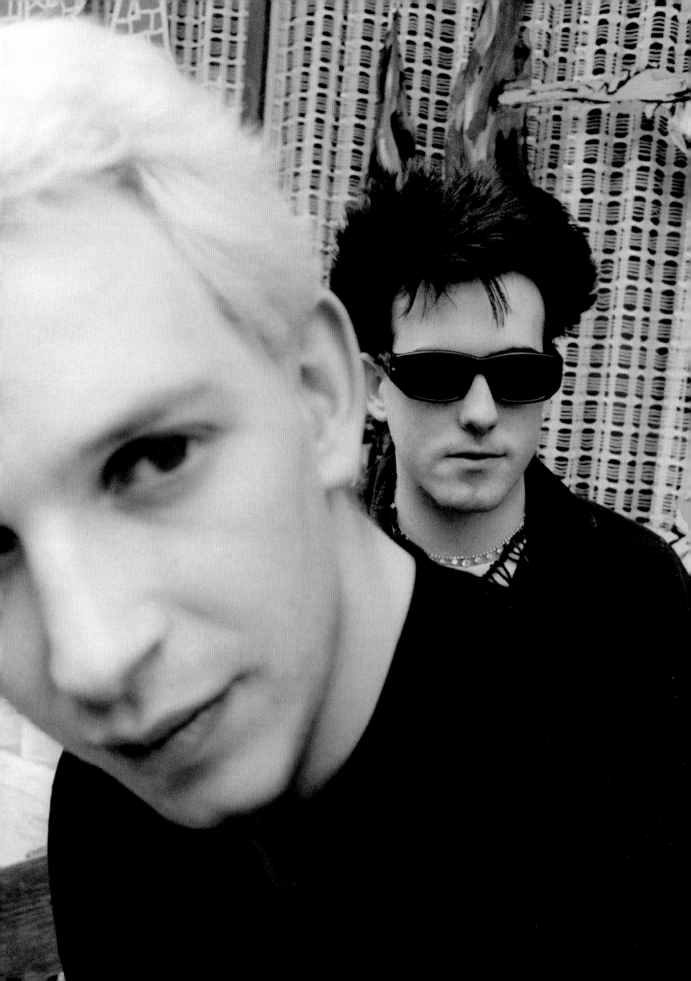

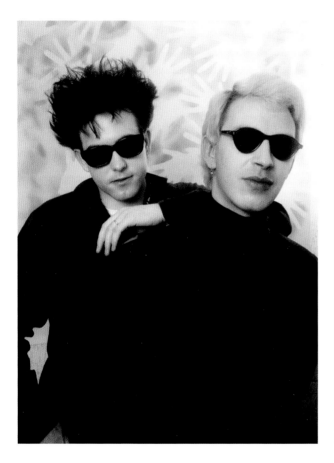

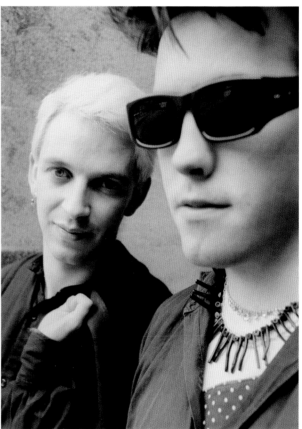

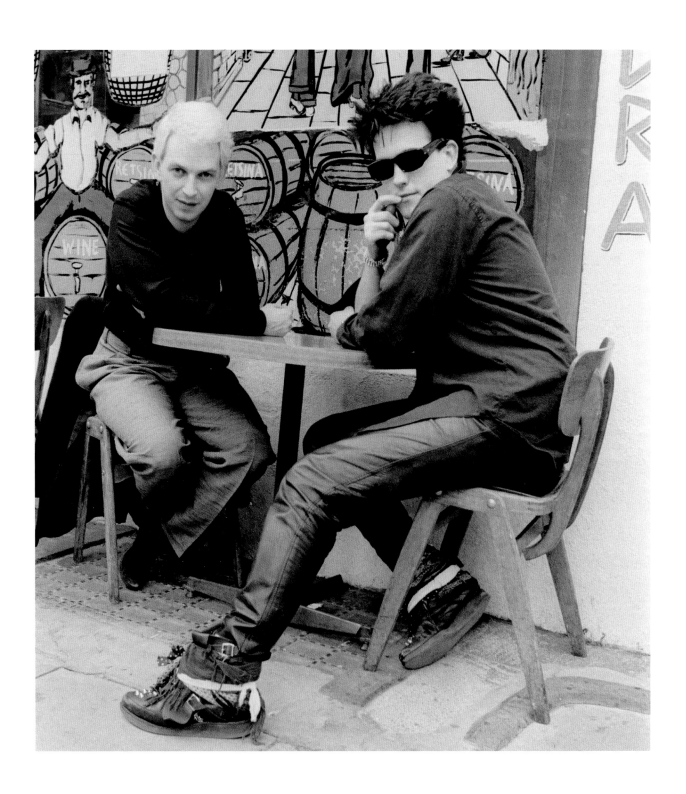

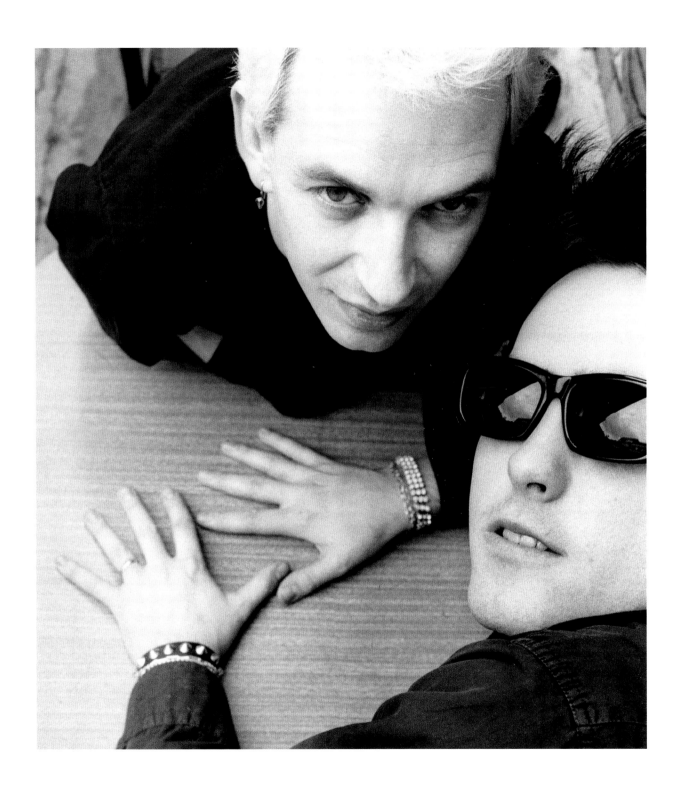

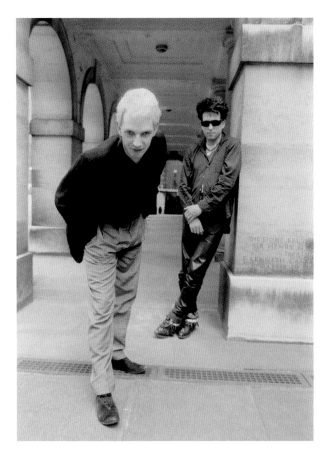 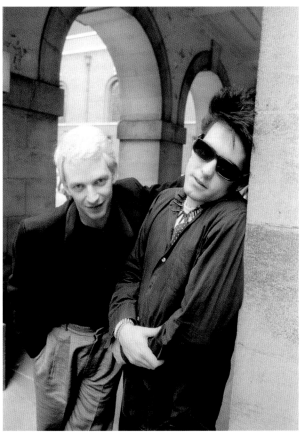

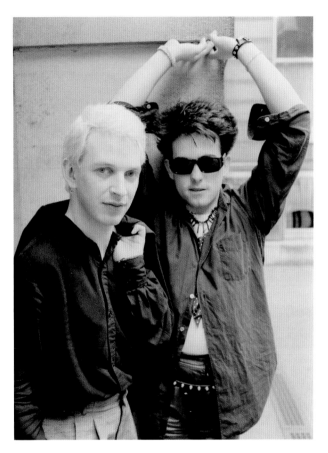

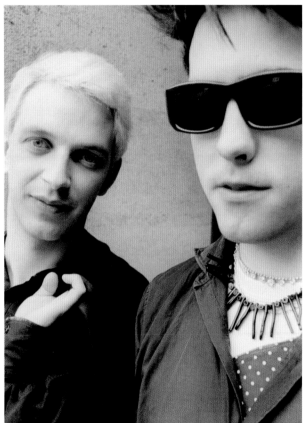

I joined the band for a couple of days on
the Italian leg of their tour in 1984, where
we ended up in Bologna, if memory
serves. Robert wasn't feeling too good at
soundcheck before the concert, lying on the
floor backstage, but you'd never have known
when it came to it – they played a great
show. We took a trip out the next morning
to take some photographs, the band still
a bit peaky from playing the night before,
but slowly warming up as time wore on.

For the shot with Robert and Lol, I was
a bit cheeky – they were shooting a
piece for a high-end Italian magazine,
and when they finished I hijacked the
lights and rattled off a few frames.

ITALY

1984

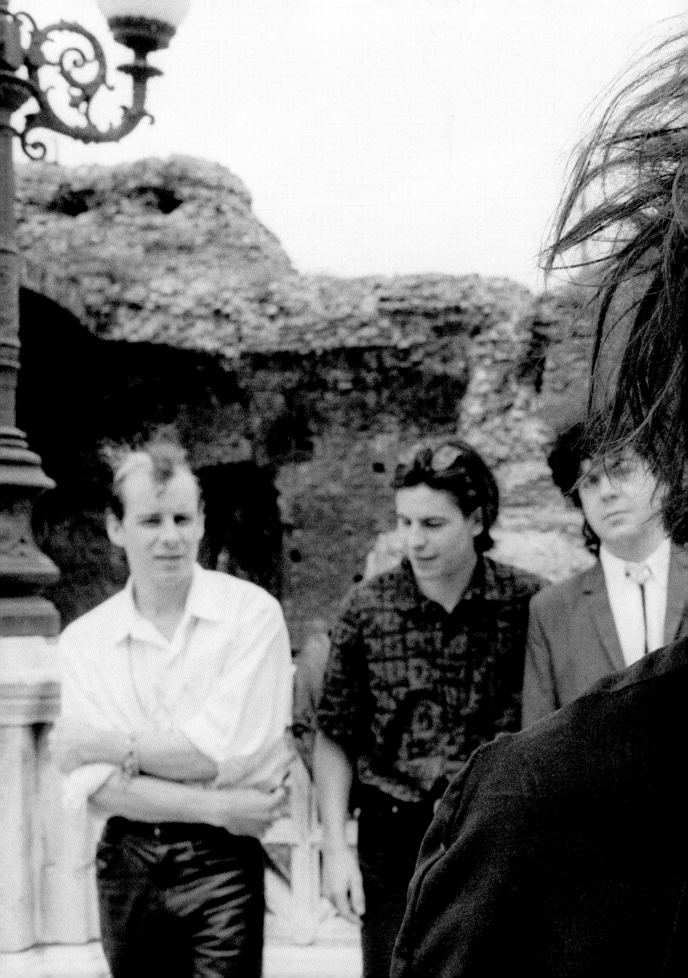

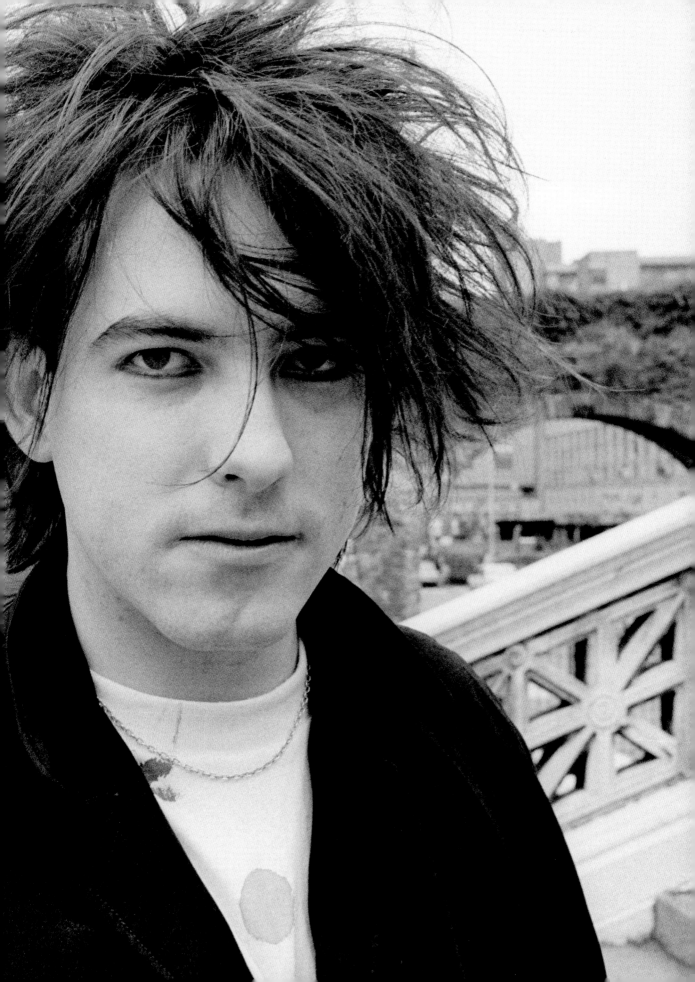

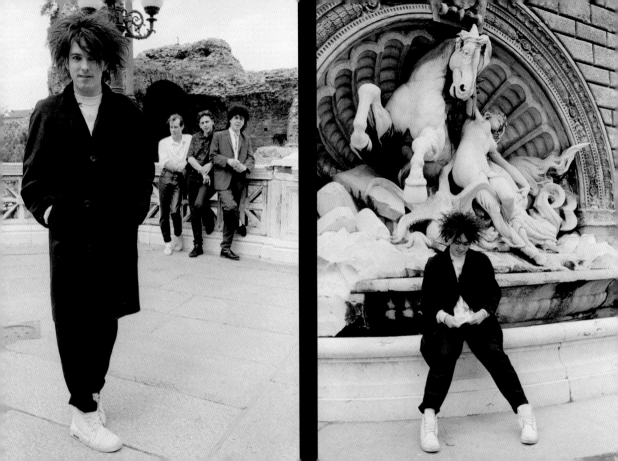

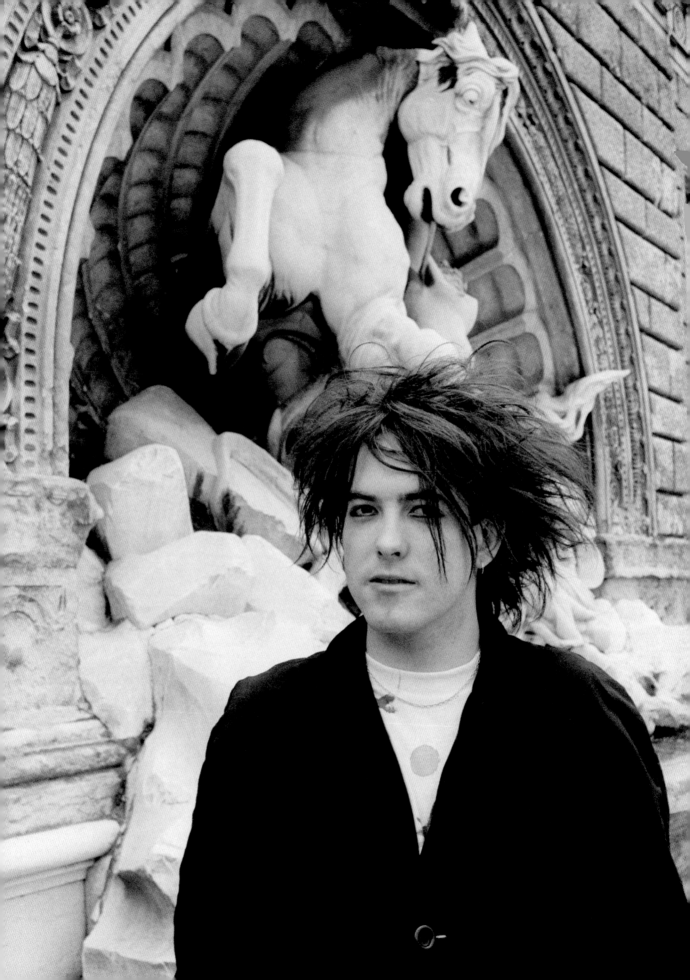

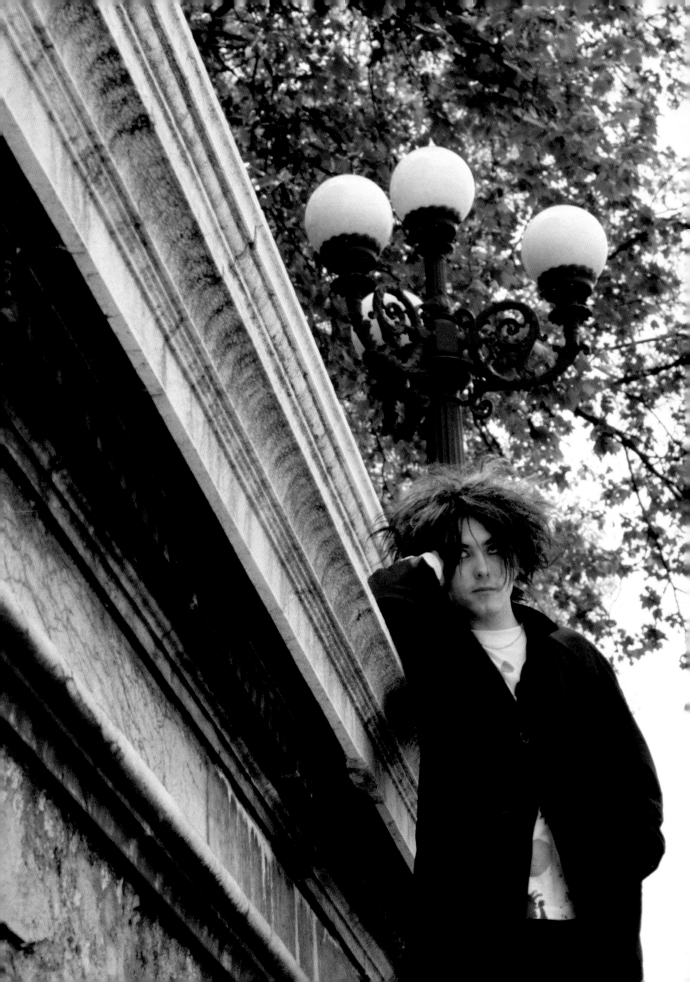

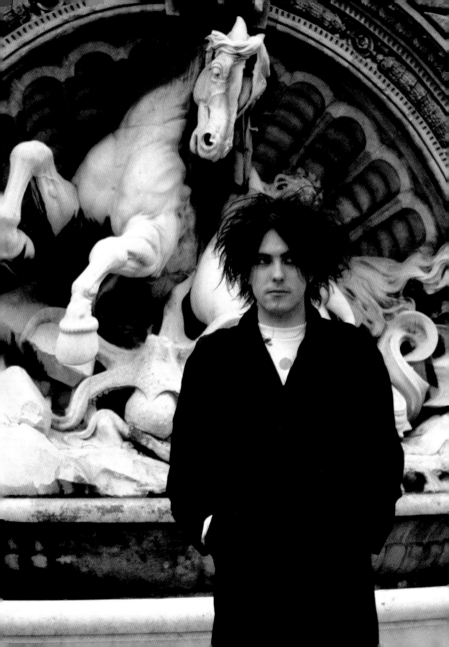

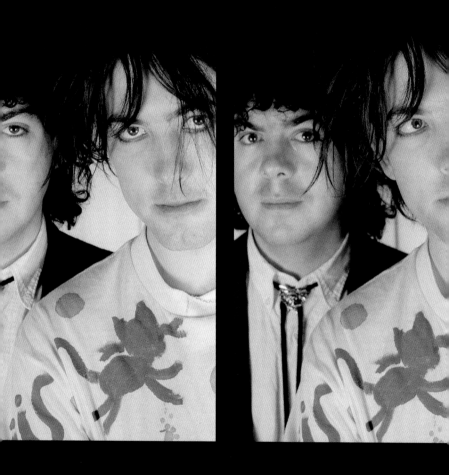

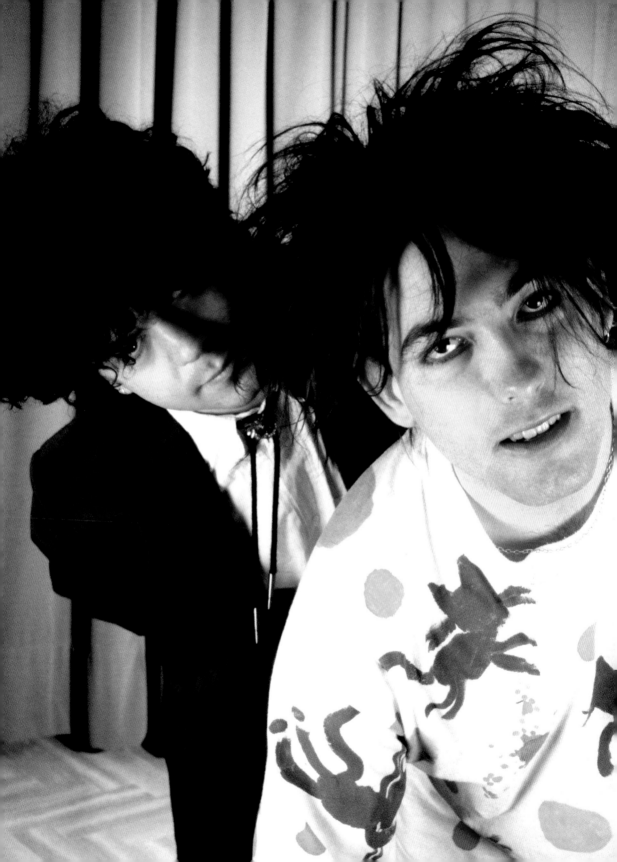

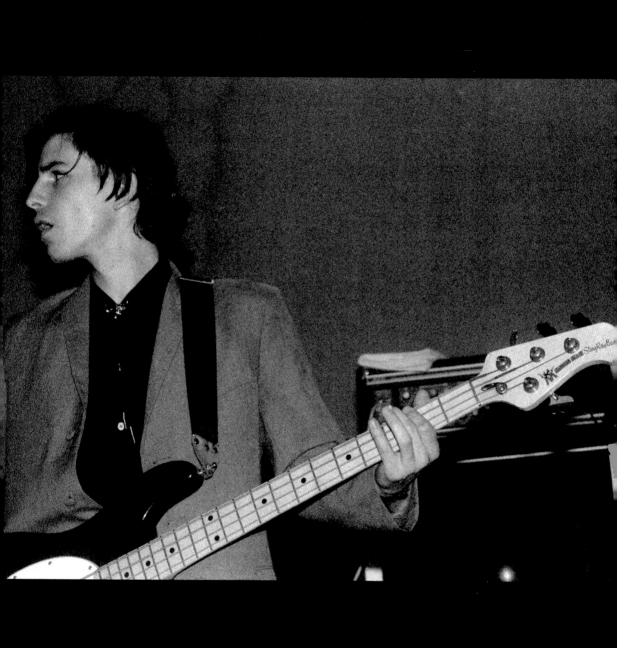

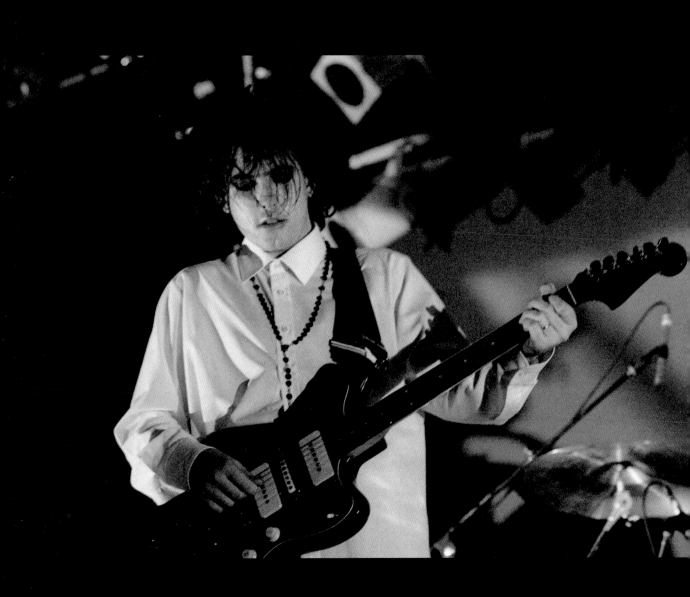

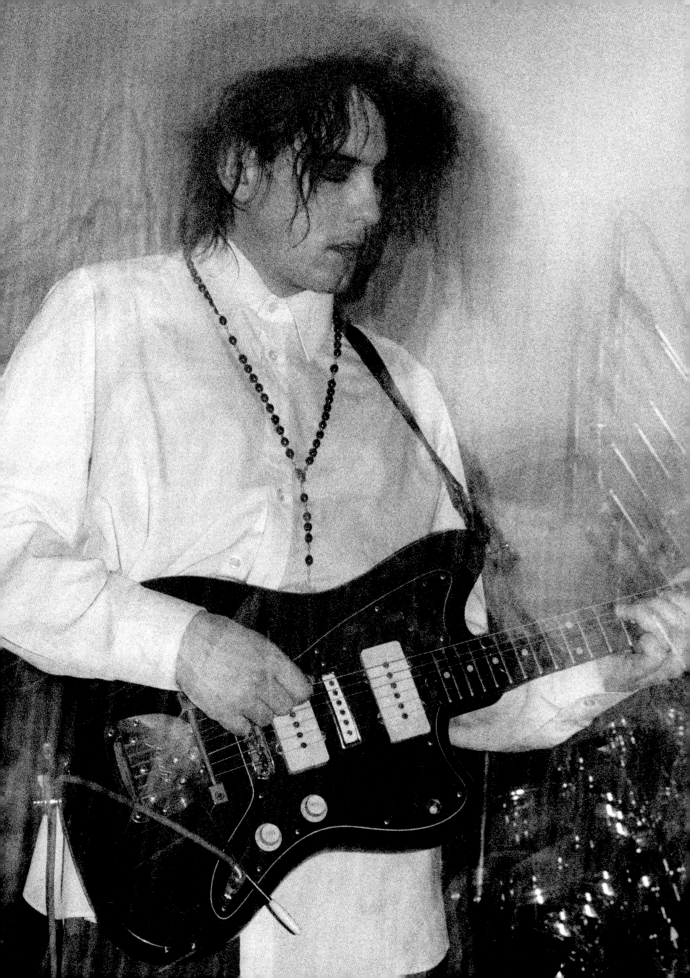

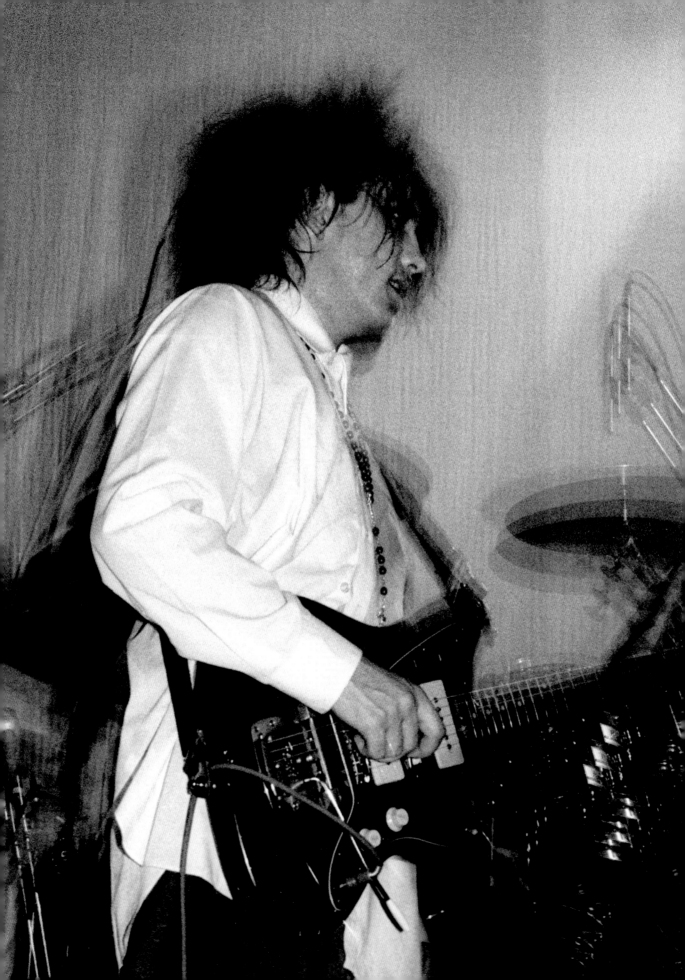

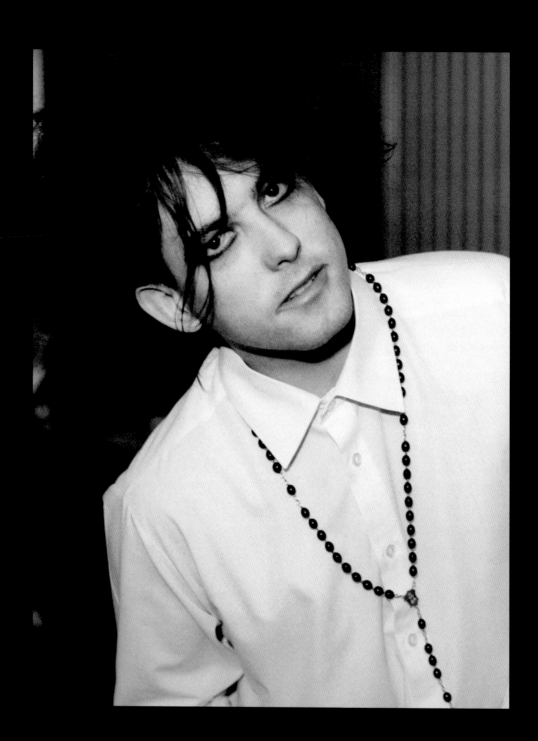

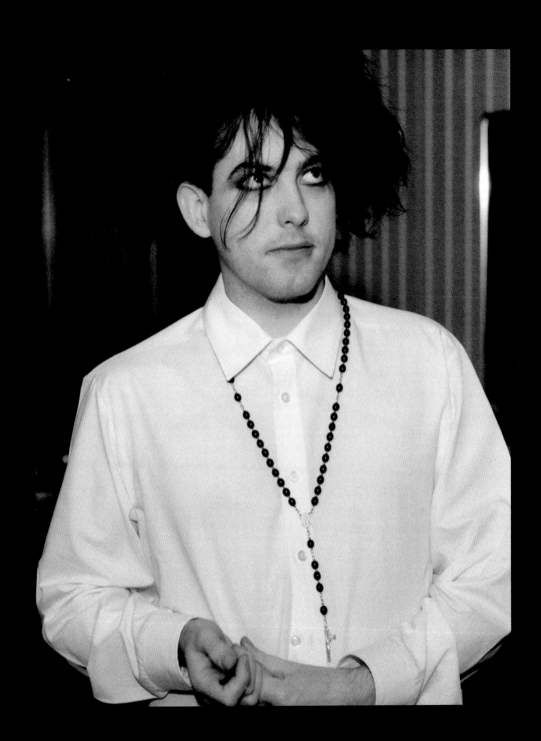

This is another time I 'borrowed' a studio.
It was a Thursday evening in August,
and Robert had just finished a shoot
with photographer Paul Cox. I rolled up,
saw the colour of his jacket and how
well it worked with the background, and
selected the lights, keeping it simple.

It's so pared back and graphic, with the
blending colour palettes, but it didn't need
anything more than that. Back then, you
weren't shooting with a committee – you
shot for yourself, with an eye on what was
required from the photograph. This wasn't
going to go on a gallery wall, it was going on
a newsstand, and you needed to be able to
see it clearly from the other side of the road.

FULHA

M 1985

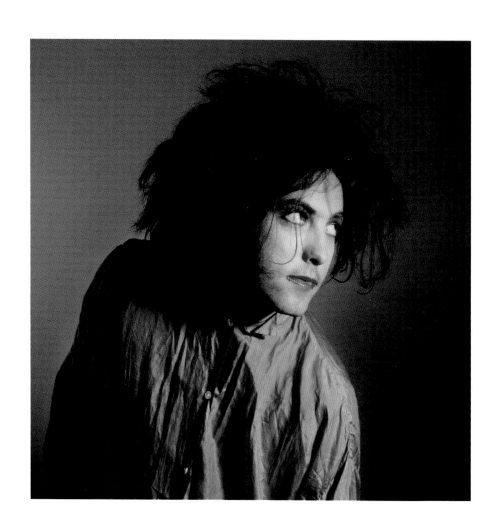

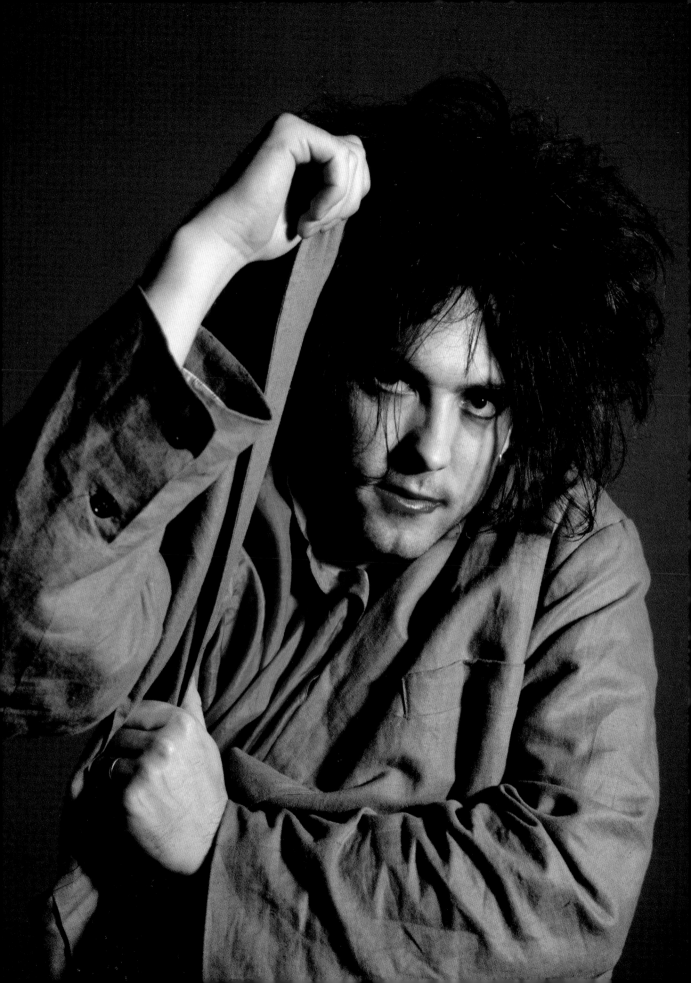

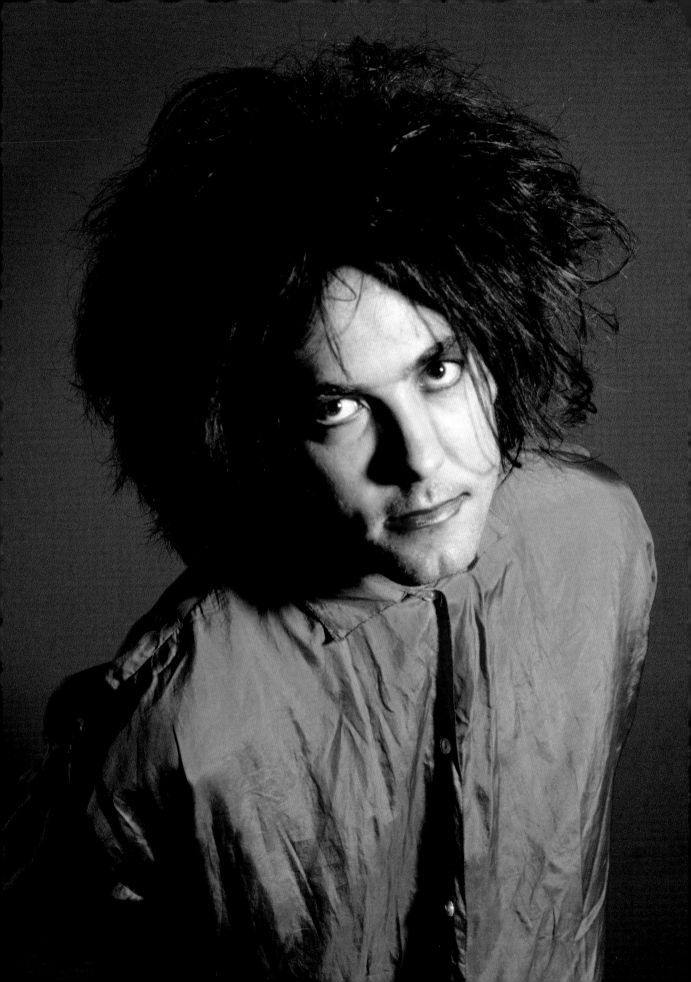

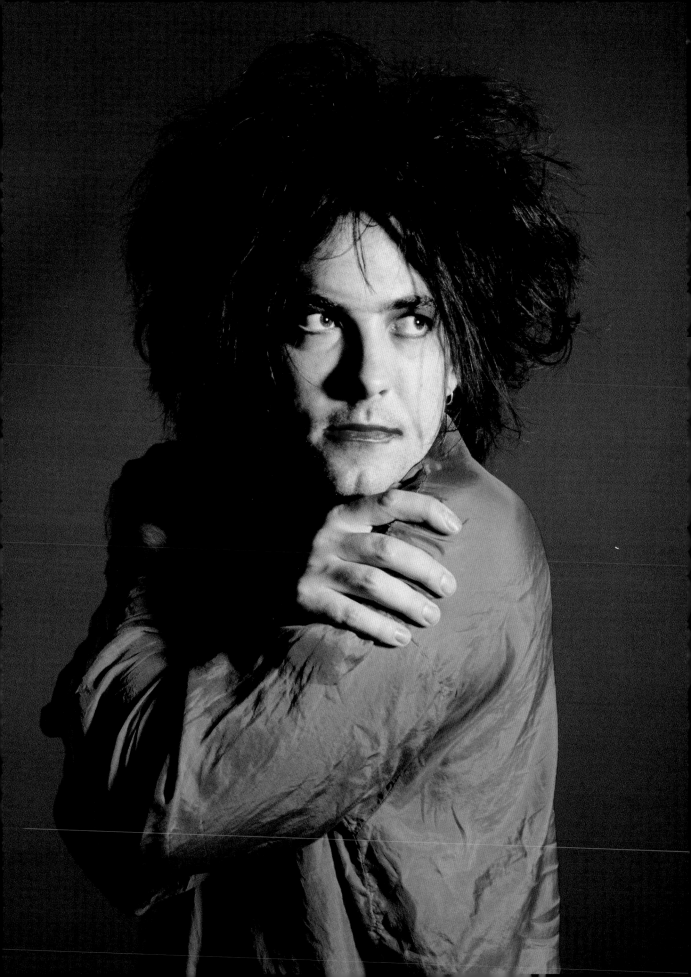

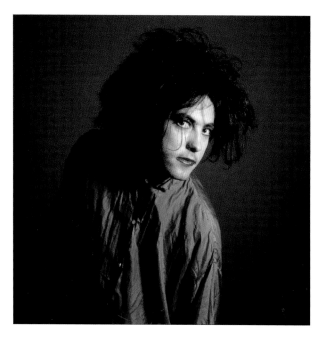
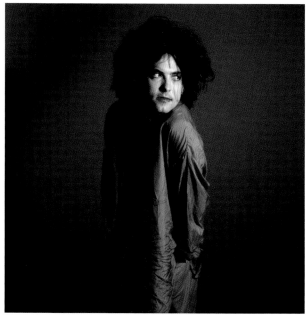

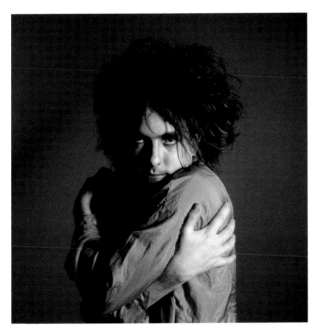
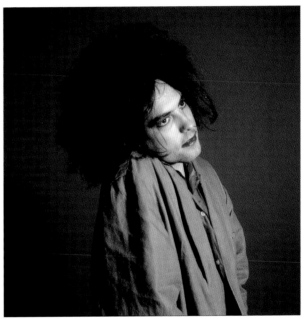

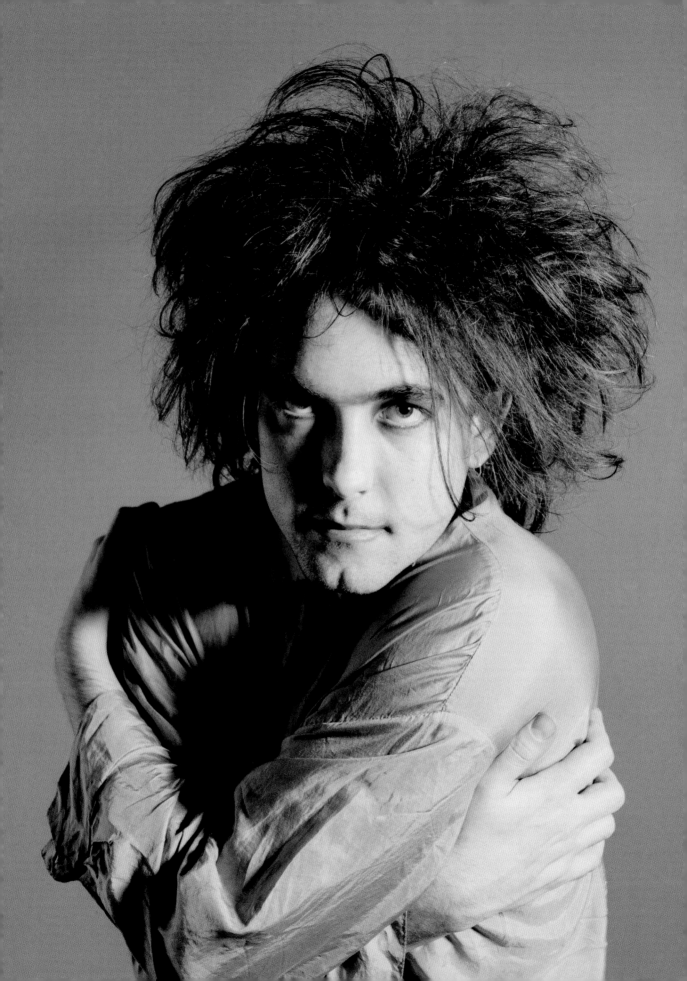

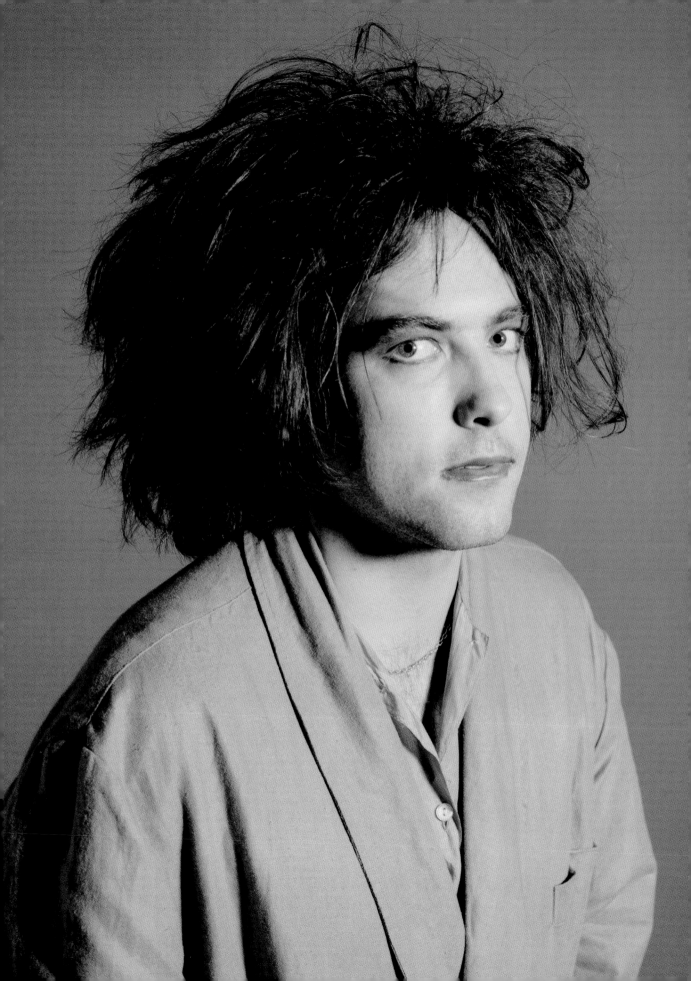

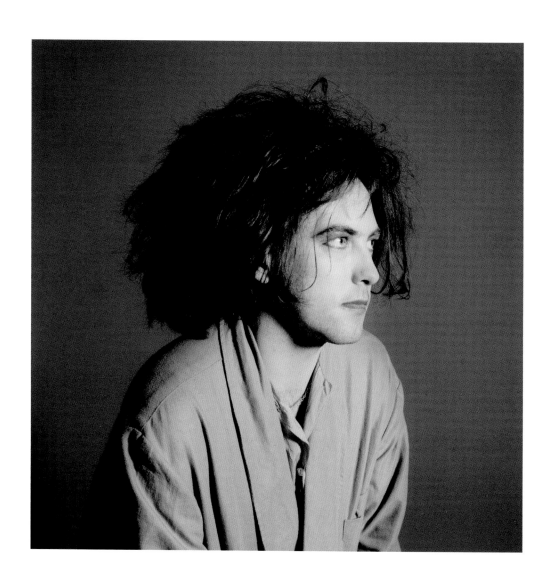

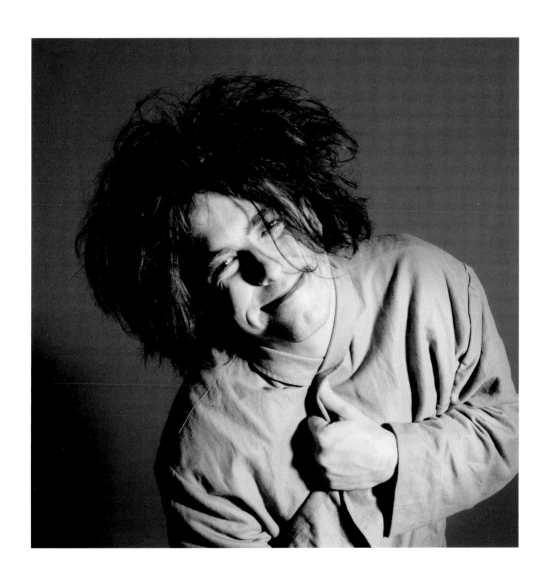

I was at the Camden Palace to see The
Cure play a charity concert in aid of
Mencap. The show was being beamed live
to the BBC to appear on *Whistle Test*.

CAMDE

N 1986

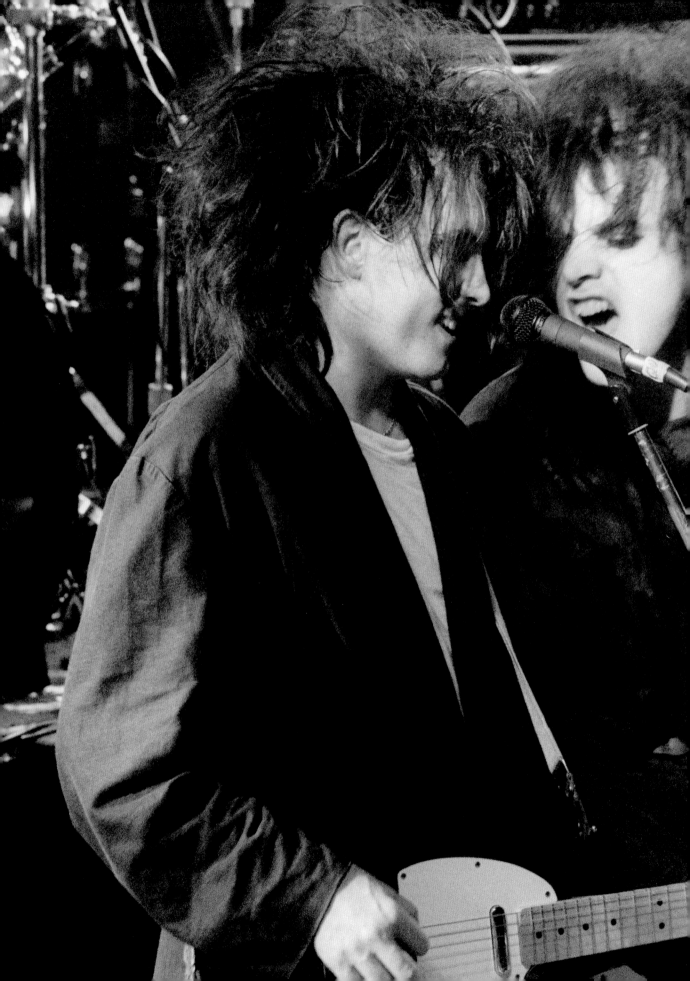

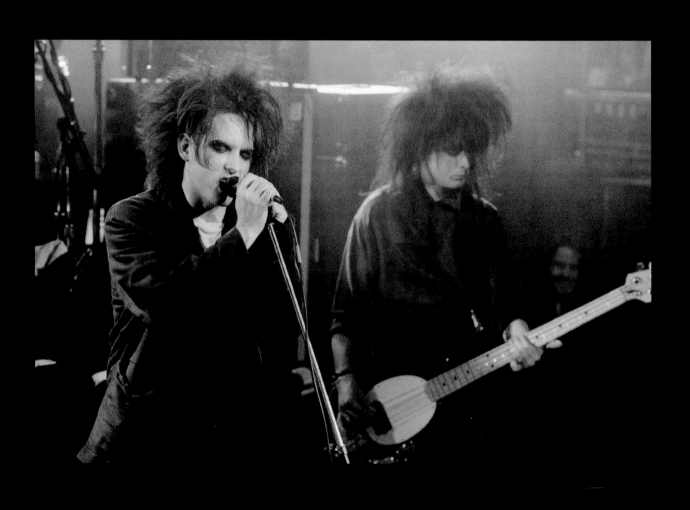

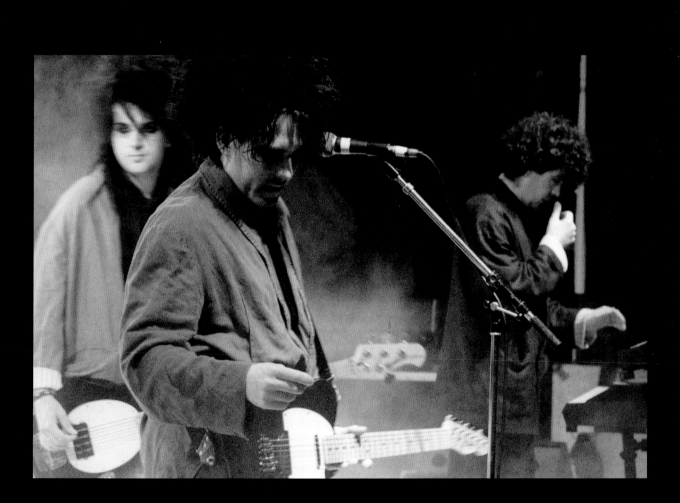

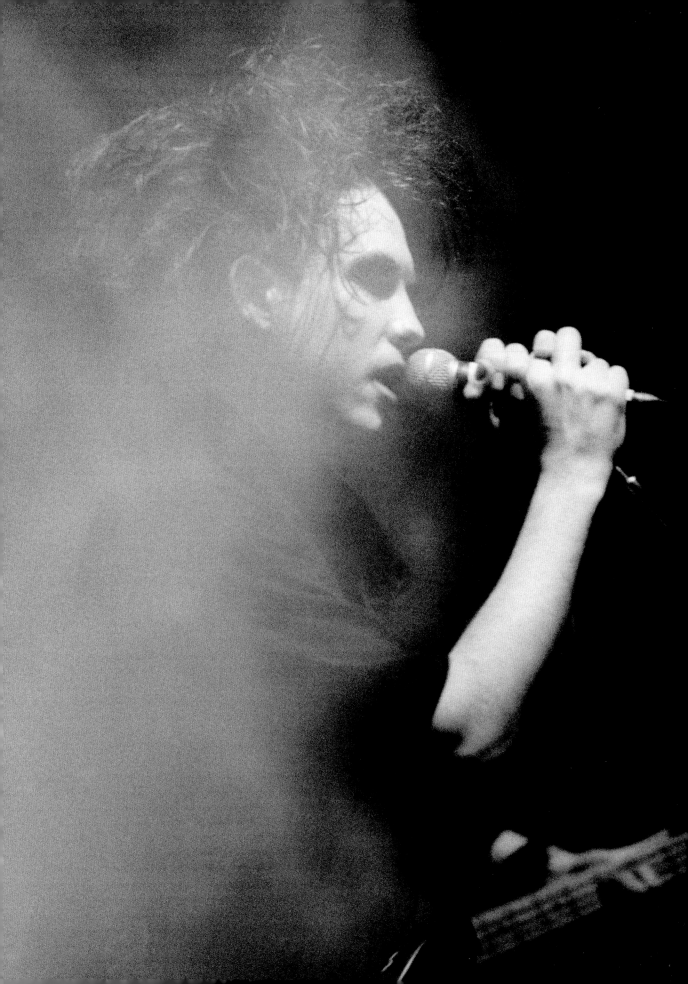

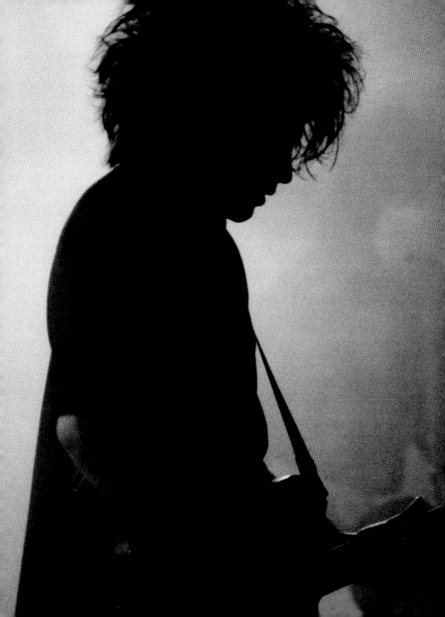

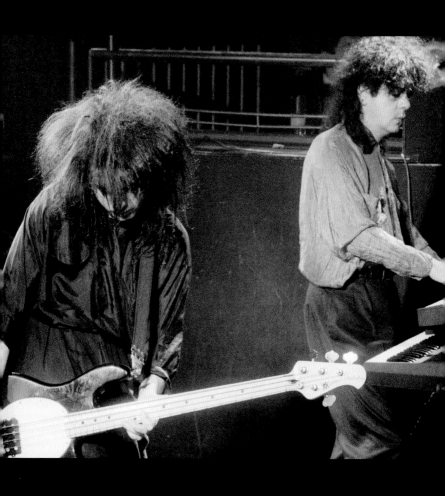

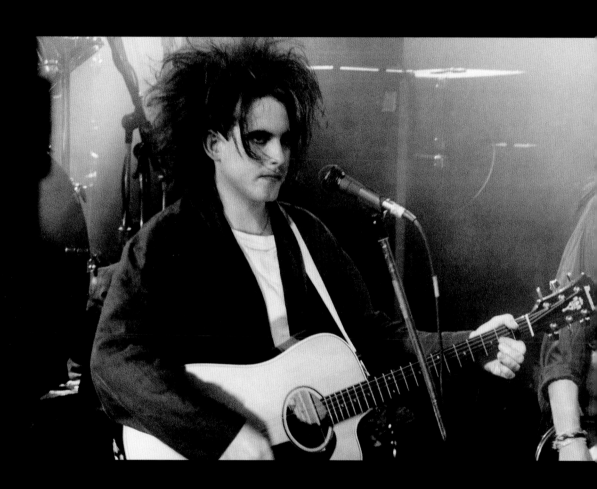

For the World Cup in Mexico in summer 1986, *Melody Maker* wanted to play up the rivalry between England and Scotland, so asked Robert and Stuart Adamson of Big Country to get involved.

The shoot was all done very quickly. Big Country were rehearsing somewhere in north London, so I jumped in a cab with Robert, we got there, nailed it and left. They both got straight into the spirit of it – this shoot wasn't about the band or the music, just about their love of the game.

WORLD

CUP 1986

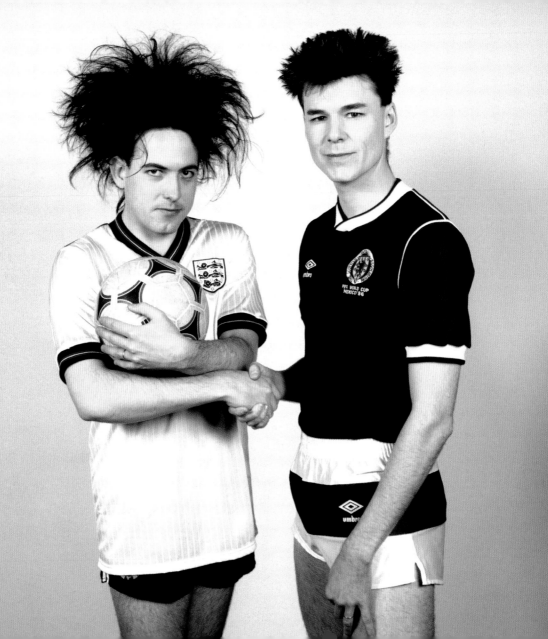

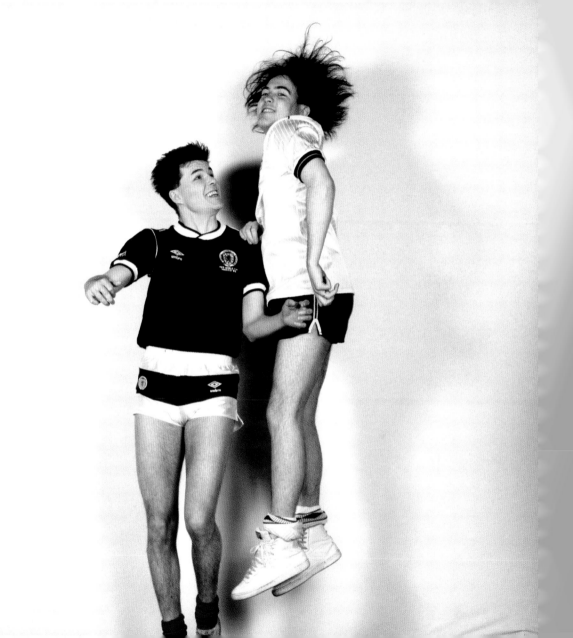

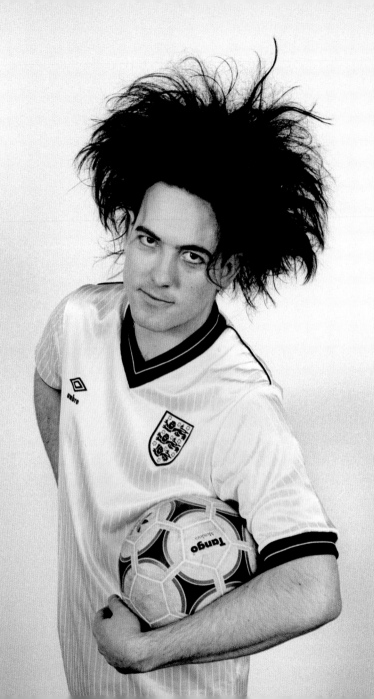

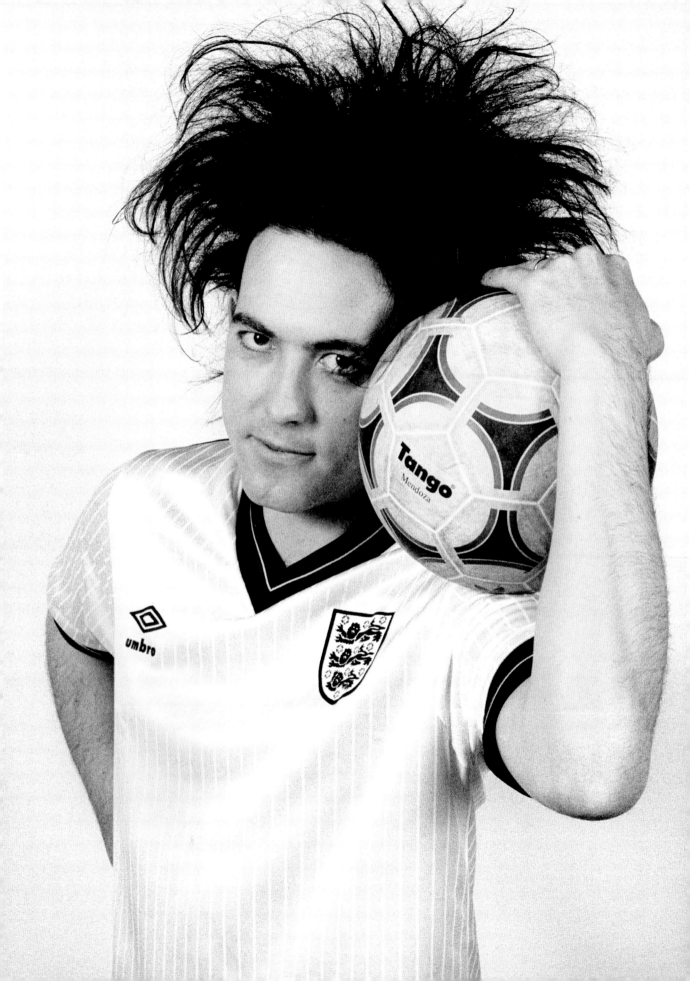

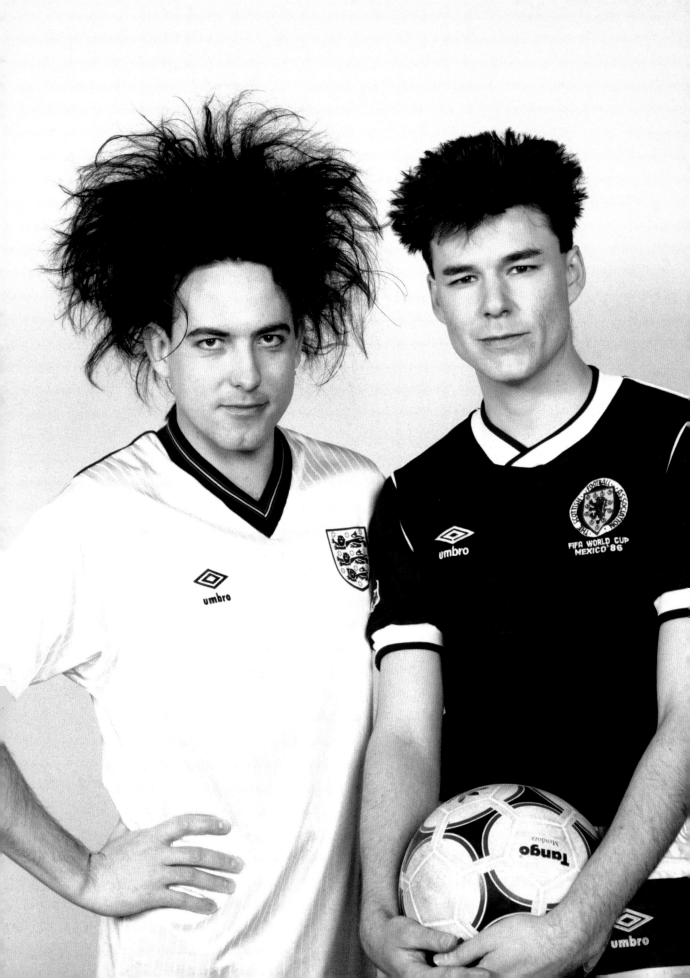

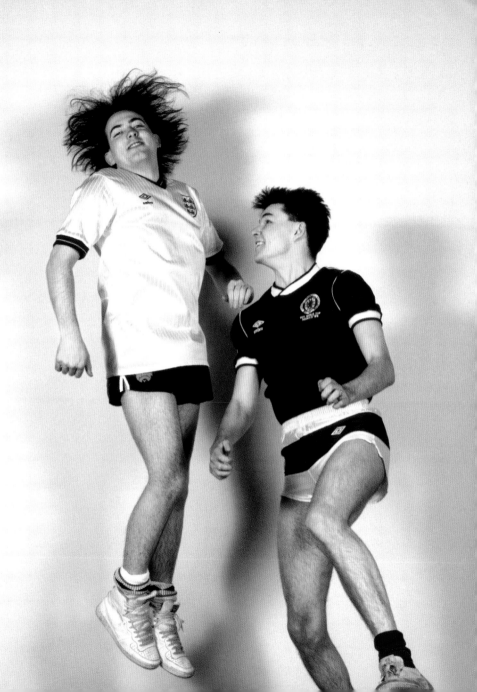

ter of the Eighties passes. Ian Curtis hangs
les marries Di, the *Belgrano* is sunk and Legs
o be. The Cure only narrowly avoid similar
mind and body they are down to the core
ety of Smith & Tolhurst. But in the fuzzy record
h are all anyone has as archaeological evidence
existed, they remain something else. In 1982,
association, are wrists jingling with a Slinky's
r bangles, strap-zip boots, bullet belts, skull
aze-catalogue bondage trousers and a button
uckly leather lapel beside others for Killing
thday Party, Bauhaus and Siouxsie And The
e tribal markings of their provincial apostles,
hair with a can of VO5 for another Saturday
and black at Spiders alternative nightclub.
fails to cultivate an image for themselves
r audience to colour in the void. Cure fans
nt: it's just that their only crayon is black.

stands why. You make an album which
esn't matter if we all die', and only an idiot
ut over the squashing throng in the stalls of
ayhouse expecting a sea of deely boppers.
obert who lives in a black hole, only his
ly sometimes. The best-kept secret in pop
t Robert Smith of The Cure isn't always a
stard reading books about mental illness:
nny bastard who loves Tommy Cooper. The
e to show the Eighties who he really is.

p. *Image.*

that summer, just as the old Cure spontaneously
ss Europe, when the brewing group psychosis
o a last hurrah of cosmetic lunacy. Hair like
ed a fork in an electric toaster, goggles of
ra and bright red lipstick that seems to have

part Dennis The Menace, part Robert's favourite se
Betty Boop. But it's definitely *a* look. And it's all his

Image © Robert Smith.

The Image gently blooms as the survival-mode two
Cure step away from the cemetery with giant stride
their next single, 'Let's Go To Bed'. Its voice is reco
Robert, its sound unrecognisably Cure: brassy syn
crisp electronic percussion and a danceable beat.
your ears and you could mistake it for a slightly leth
Soft Cell. He thinks of it more as an exercise in 'wri
something particularly stupid,' and if the song does
top marks for effort, then the video – their first thro
the image-savvy eye of director Tim Pope, hencefo
'Pap' – certainly does. Robert, serenading painted
and silver apples, and Lol, semaphoring robotics in
boiler suit, embrace the demands of the MTV gene
by cackling in its face. Is this a bluff or a double blu
The Cure taking the piss out of pop stars to prove t
don't want to be pop stars? Or simply pretending t
want to be pop stars by taking the piss out of pop s

Robert has no need to apologise for such japes, bu
those old checks and balances of 'integrity' twist h
into submission. He publicly confesses 'disappoint
that, for the first time, The Cure are deliberately inv
themselves in current trends and fashions, the very
they'd previously ridiculed on a single that got now
near the charts called 'Jumping Someone Else's Tra
Robert is convinced 'Let's Go To Bed' won't sell ei

'If it does I'll take even greater pleasure in
never doing anything like it again.'

It sells enough to reach number 44 and before they
themselves The Cure do something very much like

pop caper. It peaks at number 12 in a chart choking on the climate-warming squirts of Heaven 17 and Bananarama. Robert is obliged to mime to 'The Walk' on *Top Of The Pops*, twice, both times masked by black plastic shades. Yes, he can pose, but he can't hide. Music and the print media that oxygenates it is changing. The shiny pages of *Smash Hits*, *No. 1* and *Flexipop!* need filling, and it doesn't take their editors long to spot the fright wig and jammy-doughnut lips of Robert Smith as a perfect specimen.

Image? Yes, please!

And so, against best wishes, against all odds, against every cliché, against creeping out of Crawley, against being a Bob, against being a Smith, against not being Le Bon, against clubbing at the Batcave instead of Tramp, against shopping at Safeway, against his black bone necklace, against owning an iron but never plugging it in, against waiting for the death blow, against the desire to shove Steve Wright off a cliff, against spoiling fame's ballot paper at every twist and turn, Robert James Smith becomes a pop star.

He surprises himself and the rest of the known universe by being very good at it. It helps that the new Eighties pop press don't ask dull questions about integrity and authenticity, sooner celebrating pop music in all its beautiful absurdity as a runaway circus populated by mavericks, eccentrics, weirdos and fruitcakes. People just like Robert, a 24-year-old man who still reads *The Beano*, has nightmares about Noddy, goes for walks in parks at 3 o'clock in the morning, invents his own cocktails as an acronym for ITV's teletext service ORACLE,[1] likes wearing dresses while he's cooking curries and keeps his supply of Walkman batteries in a Snoopy pencil case.

'I'm the sort of person you could give to your niece for Christmas.'

As the nieces of Britain quickly strike Tiny Tears from their letters to Santa to make last-minute amendments, a few

weeks before Christmas 1983, The Cure finally smash a hit into the hallowed Top 10. 'The Love Cats' is the third in a trio of what Robert calls their 'fantasy singles'; in this case, the fantasy of trying to imagine how The Cure might sound if they made a jazz record, complete with Cab Callowayish scat chorus. In blackened bedrooms in Bradford there are gloomy wretches in winkle-pickers tearing up their copies of *Faith* in tears. But Robert will not be pigeonholed.

'I resent it, because they're trying to shrink me into a one-faceted person who's only allowed to produce one style of music.'

Hitting lucky 7, 'The Love Cats' stylishly outpurrs challenges by The Rolling Stones and former Hansa discovery Donna Summer. At no point does anyone accuse Robert of ripping off a song from *The Aristocats* because nobody believes he'd ever watch Disney.

The real shock isn't that he does but that he has a nanosecond spare to do so. For a man who says he likes staying in bed, for a man who says he hates to be defined as someone in a group, for a man not exactly renowned for giving it 'cheeese!' into popping flashbulbs, Robert has spent 1983 being contrarily busy and bafflingly prolific. Three groups, three identities, three images. He's been the leader of The Cure; he's been the supposedly 'stand-in' guitar player in Siouxsie And The Banshees, who now don't want to replace him; and, moonlighting for the fun of it – just because he can, just because fellow Banshee Steven Severin needs something to do as a tit for the tat of Siouxsie and Budgie's own Banshees spin-off The Creatures – Robert has been half of Severin's studio side project, The Glove. Three different groups making three different albums posing for three times the amount of photo calls. One of two as enigmatic silent partner in The Glove. One of four as psychedelic-shirted worker bee in The Banshees. Alone as The Cure: Image © Robert Smith.

1 'The ORACLE' cocktail. Ingredients: O(range juice), R(um), A(pple slices), C(alvados), L(emon juice), E(verything mixed up).

So who, then, *is* The Cure?

'I am The Cure,' says Robert. Which begs the question: who were those other herberts playing on stage with him as 'The Cure' at the recent Elephant Fayre festival? Three imaginary boys?

In a sense, yes. The unhappy hangover of what happened to The Cure the last time they were 'a proper group' still haunts Robert, forcing him into a peculiar state of mental self-preservation. The only reason he can conceivably continue making records as 'The Cure' is by convincing himself they are not 'a proper group'. Because if they're not 'a proper group' then he is not responsible for anyone else who plays with them. So if Robert and Robert alone *is* 'The Cure' then Robert only has to worry about Robert. In theory.

In practice, things don't quite work out that way. As the clocks strike thirteen for 1984, Robert yawns from his scratcher in the pyjamas he's been known to wear onstage, casts a bleary eye at his coming schedule and realises that out of the next 12 months he'll be spending the best part of ten on the road. His own utterly preposterous work ethic has conspired against him in a head-on collision of two tours to promote two separate albums by two separate bands. One is *The Top*, the fifth by the supposedly non-proper group called The Cure. The other is *Hyæna*, by his latter gainful employers Siouxsie And The Banshees. But as the old saying goes, you can please some of the people some of the time but you'll never please Siouxsie all of the time. After a few shaky months of setlist juggling, not knowing if he's coming or going, stage centre or left, swimming horse or caterpillar, Robert staggers out of The Banshees and into his sick bed, flapping a doctor's note for 'nervous exhaustion'.

It also means bursting his own self-deluding bubble. Come on, Robert, admit it: The Cure *are* a proper group, aren't they?

'I don't want a *group…*'

Oh.

'… I've been in groups before and I don't want to be in one anymore. This version of The Cure has been assembled just to perform live and that's how I like it. It's more like a school orchestra.'

But no kid wants a poster of a school orchestra on their bedroom wall and so, for the time being, the other sentient beings who join Robert onstage as 'The Cure' are spared immortality as the back-page pin-up of *Jackie* magazine. No such luck for Robert, who finally makes it there in the Live Aid summer of '85 in full Halloween drag; and a generation of teenage girls go to school the next day looking like Mary the punk from *EastEnders*.

This is the cost of being the Image of The Cure just as The Cure inflate their poppiness to Hubba Bubba proportions. Robert has never liked the idea of syphoning *two* singles off one album before, but the melodic riches of *The Head On The Door* demand it: the irresistible 'Inbetween Days', aka the flurrying, strummy one with the socks video; and the coquettish 'Close To Me', aka the fluty, clappy one with the wardrobe video. It also marks a reshuffle in the school orchestra, with the return of old pupil Simon Gallup, last seen limping off the battlefield of the *Pornography* tour, as the non-proper group of four become something like a proper group of five. Even Robert starts to speak of The Cure as a 'them' again: even though he, alone, is still the Image. Case closed is The Cure's first solo cover of *Melody Maker*, the magazine responsible for getting him into this whole 'recording star' mess in the first place. In the eight years that have passed since his monochromatic 18th birthday, it now prints in colour. Robert, crumpled blue and kissable red, brings the Image. Tom Sheehan, not for the first time, shoots him into History.

The doomy purists who forsook The Cure are not missed as the *Head On The Door* tour takes them into arenas, ice rinks and exhibition centres, where Robert gazes out over the squashing throng and sees thousands upon thousands of… Robert Smiths?

'I look less like me than most of the people coming to our concerts.'

And there's the thigh-slapping punchline. The Image he had to create in the vacuum of the one supplied by his audience finally becomes the image of his audience.

Hair. Make-up. *The Cure.*

In August 1986, I went to shoot The Cure at
their concert in the Théâtre antique d'Orange,
a huge amphitheatre in the south of France.
The concert was being filmed on Saturday
night, but the band also used the Sunday
to film extra material for director Tim Pope
and his camera crew. They had home-
made rigs with cameras swinging about
on ropes, but the group were very relaxed,
despite the size of the gig and the crew.

The actual concert itself was great, just
to see them perform in such a grand
location. I believe I have a small walk-
on part somewhere in the film, if it
wasn't left on the cutting room floor.

ORANG

GE 1986

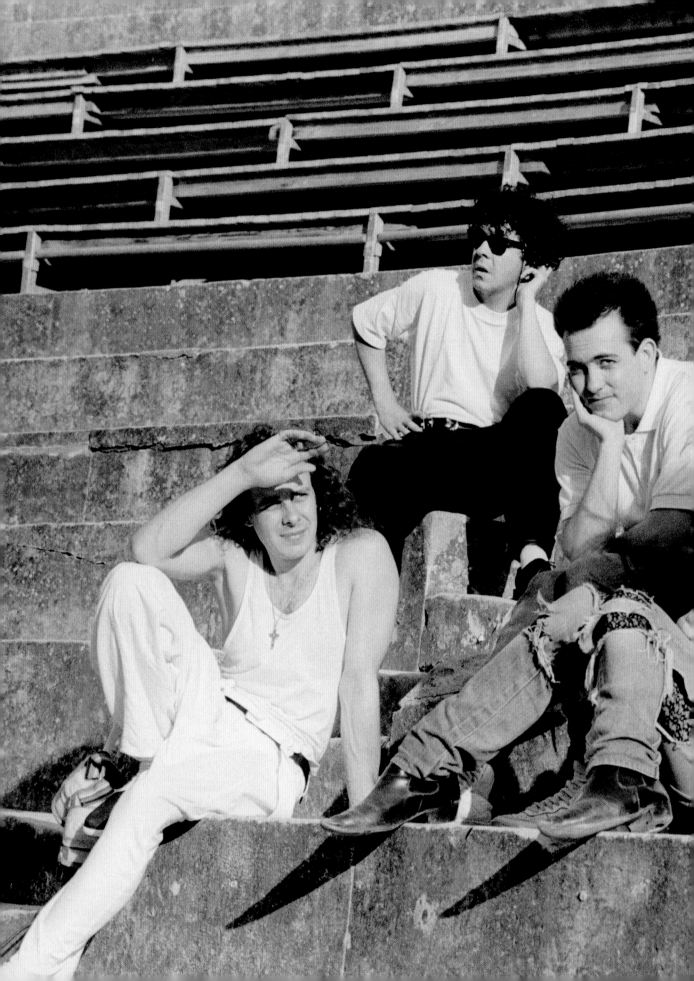

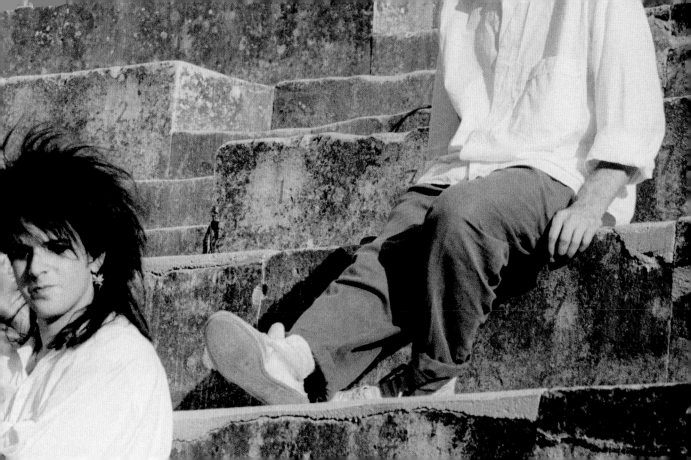

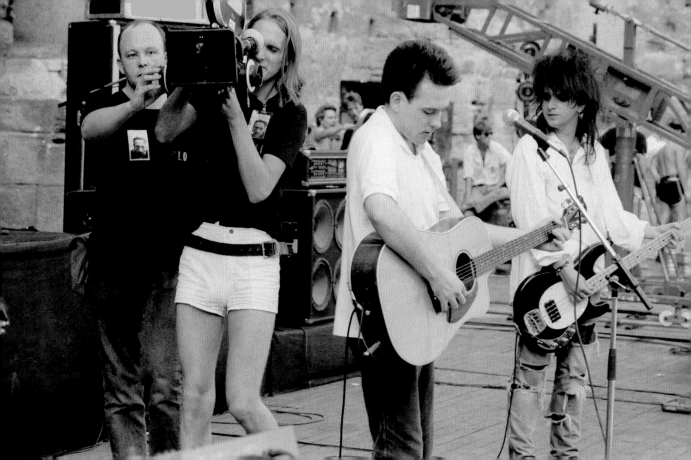

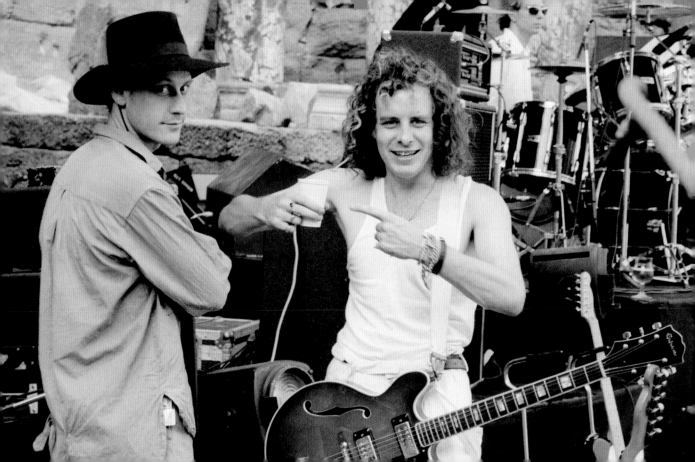

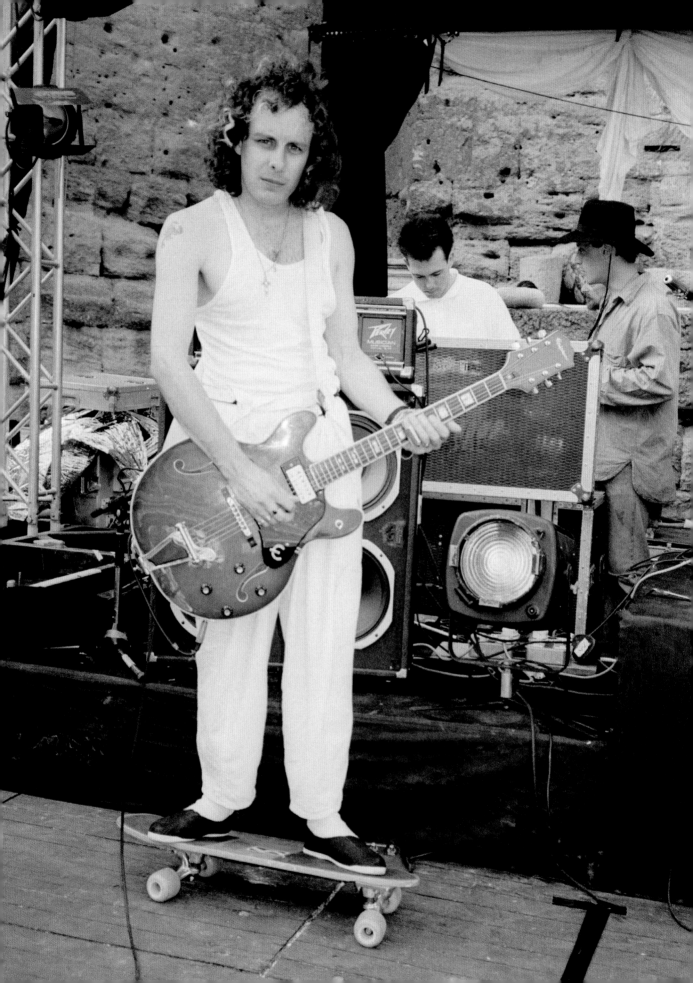

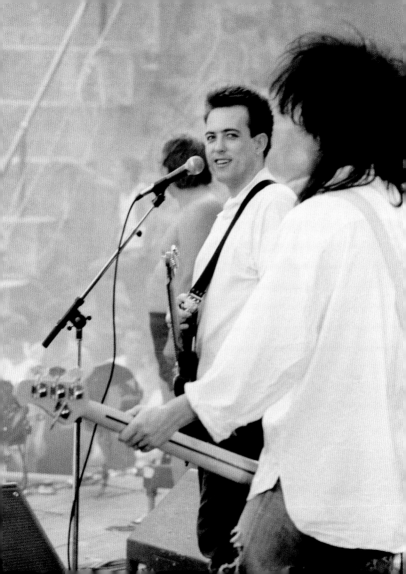

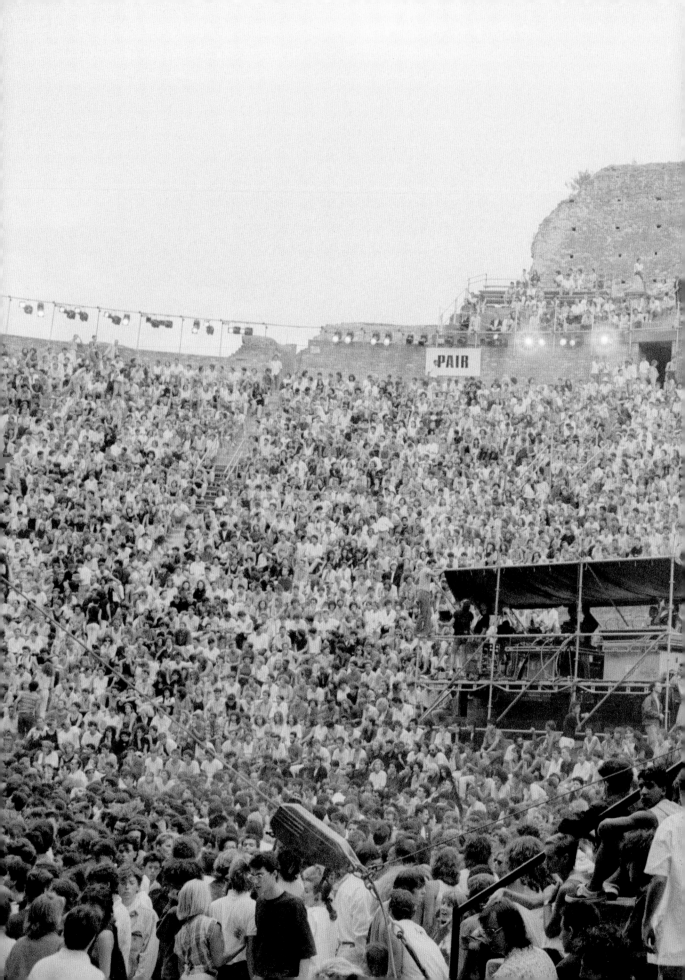

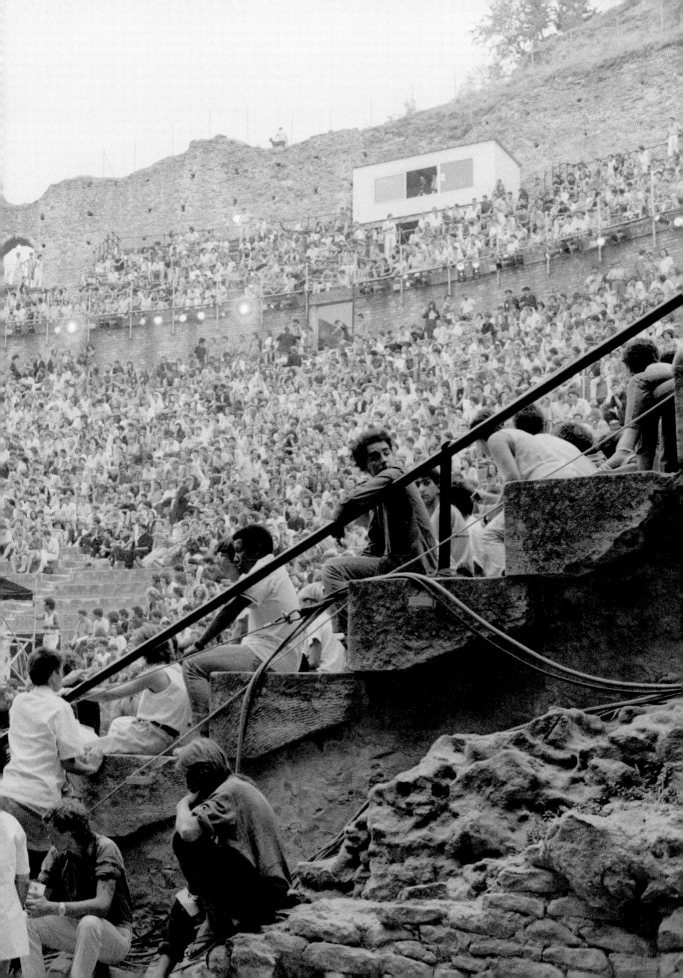

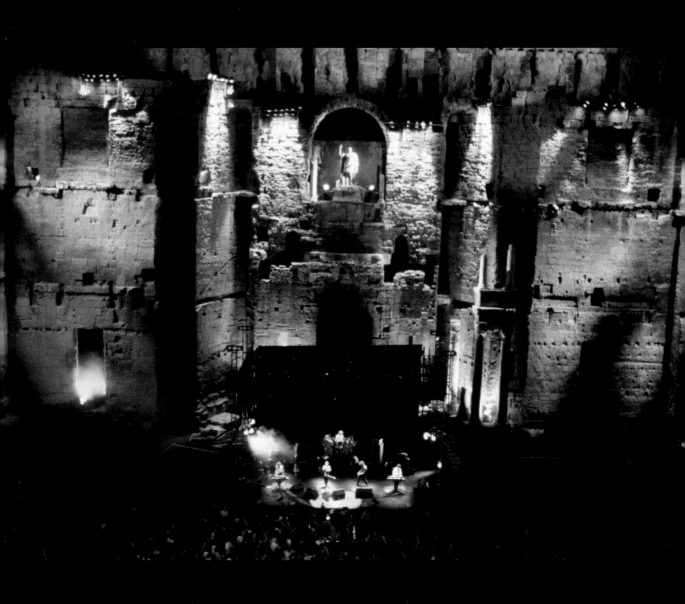

These are some of my favourite photographs of Robert, taken on the roof of a hotel in misty rain and fading light on a late afternoon in November. It brings back happy memories, but also anxious ones, waiting for him to get out of bed and get ready before we lost the light for the day and before my evening flight back to London – time was tight. It's a battle to get them to do what you need sometimes, but it's a fun photograph. I love how the architecture and the rooftop vantage point make the background look like a toytown.

They'd played a great show at the Vorst Nationaal the night before, and we shot some images backstage – very graphic, making sure I left space for the magazine logo and headlines too.

BRUSSE

LS 1987

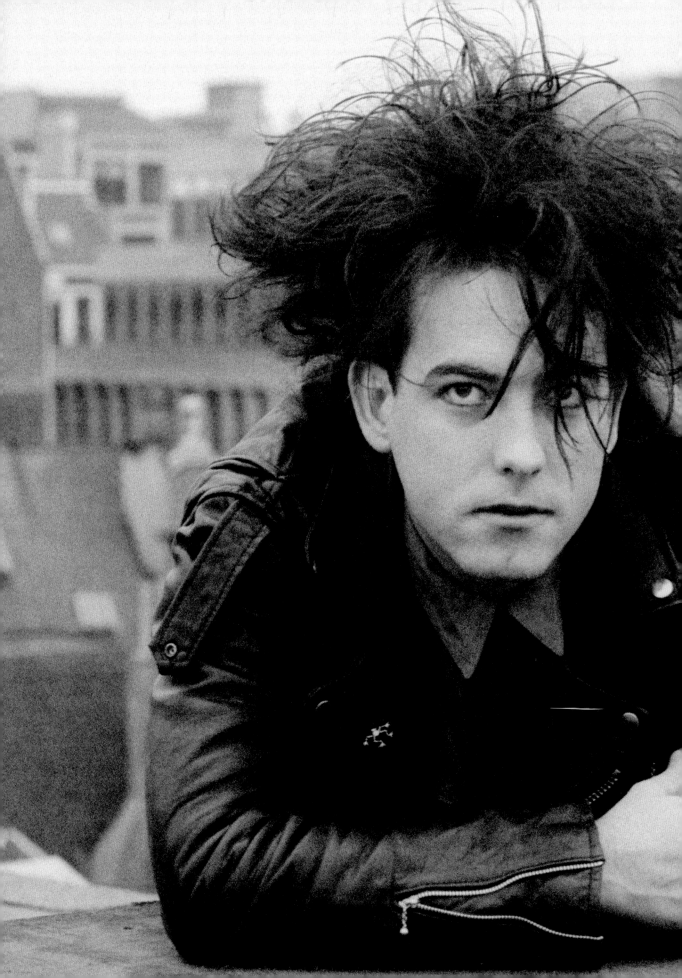

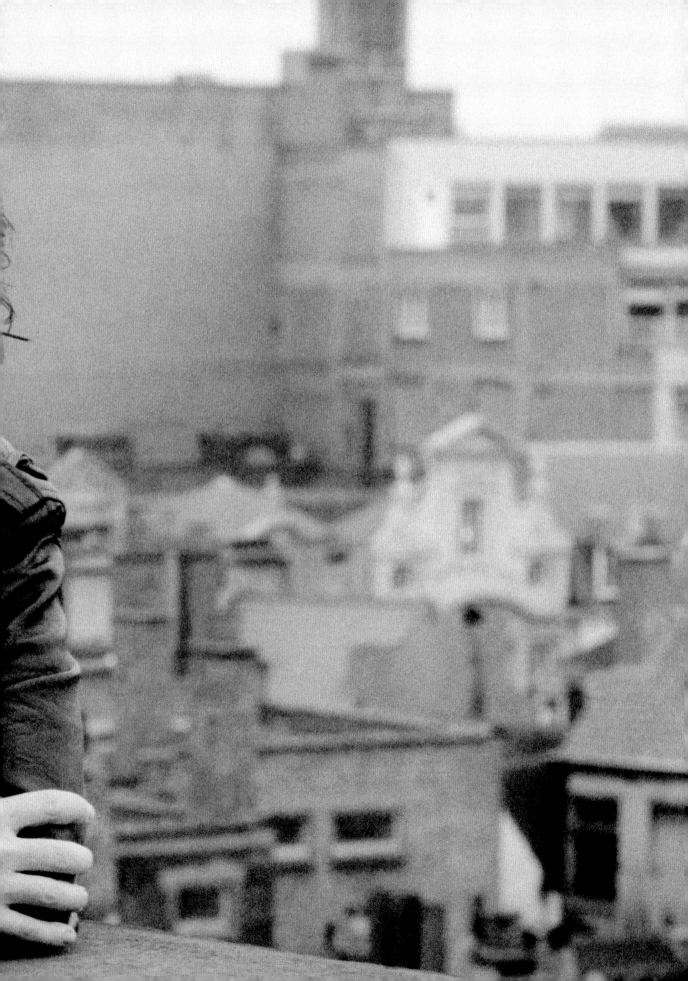

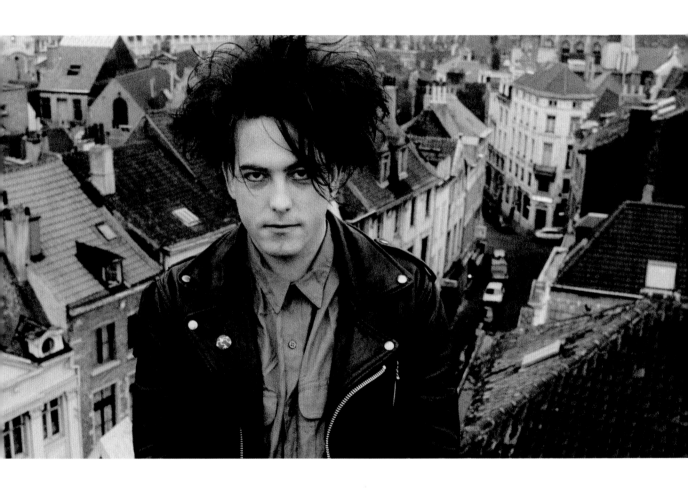

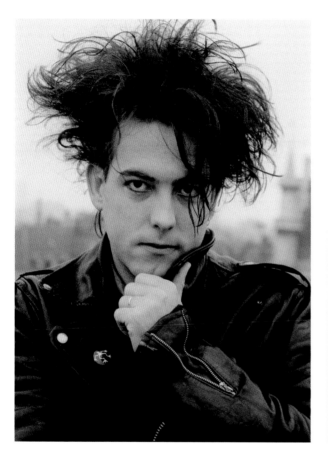

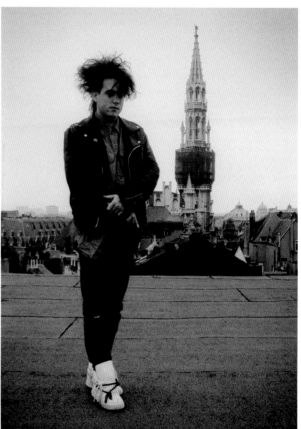

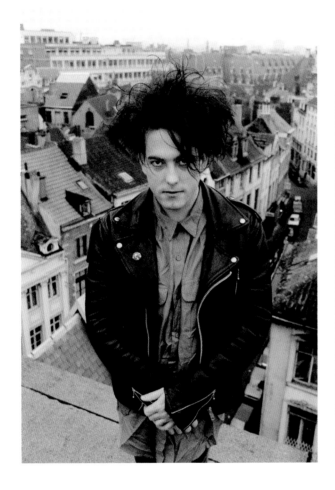
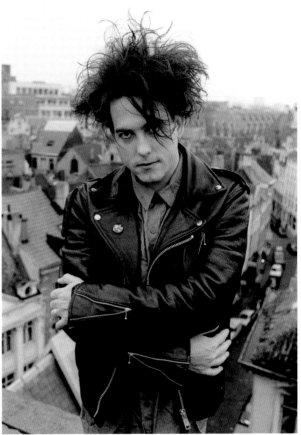

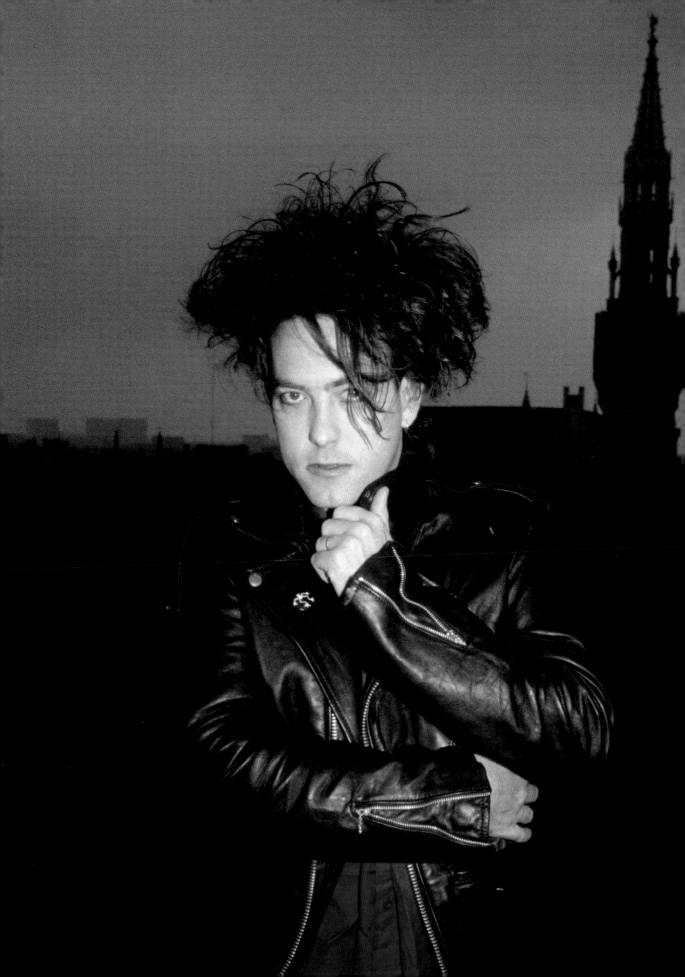

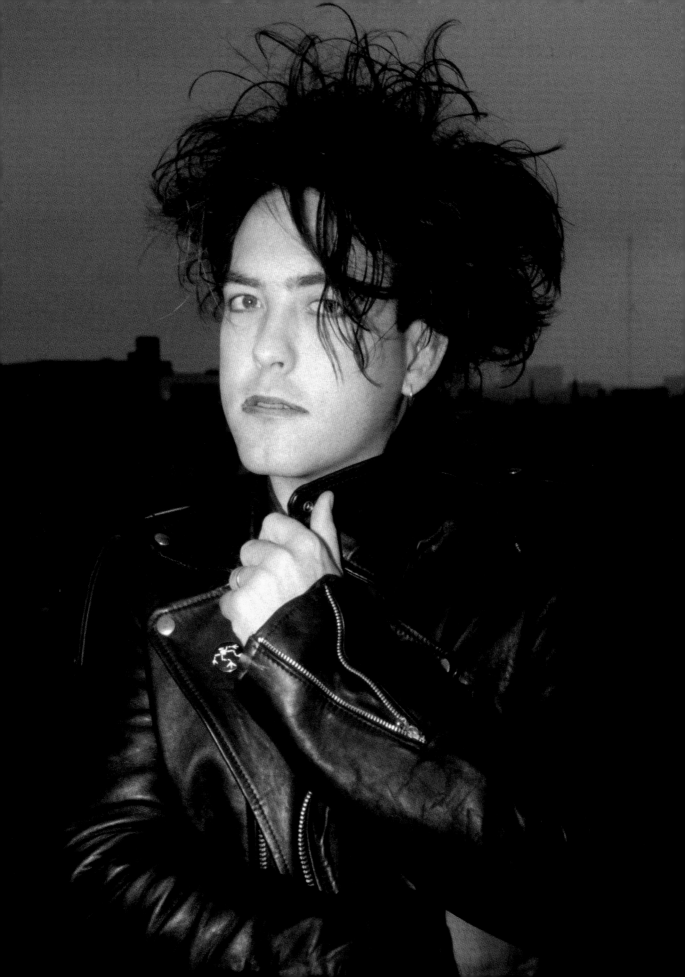

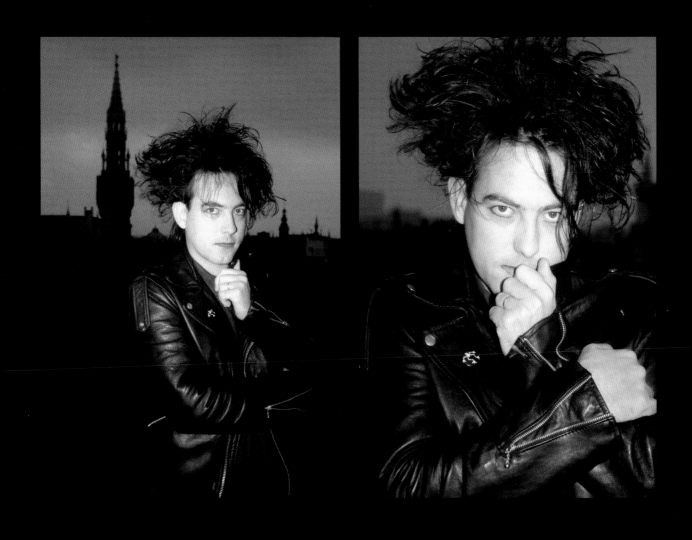

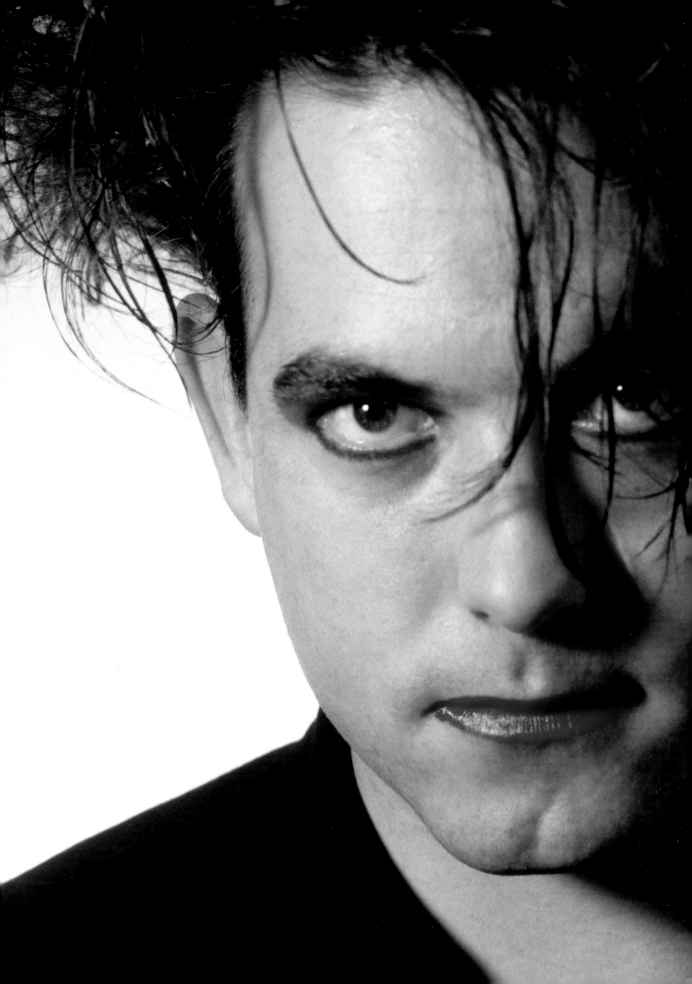

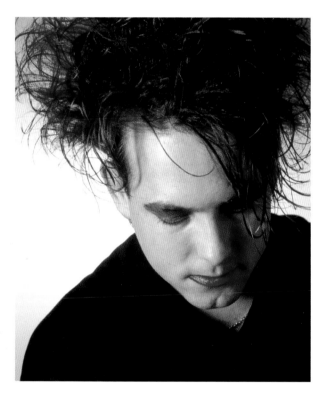
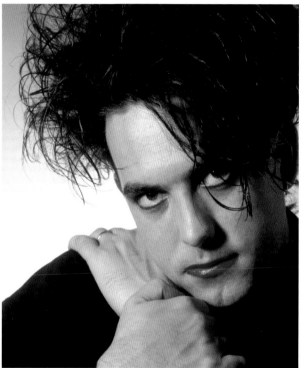

We met for a shoot at a studio in Valentine Place, near Waterloo in London, in April 1989 – always a fun month, as Robert has his birthday then, the day before mine.

What was great with this shoot was how Robert turned up with different outfits, ready to go. It was quite a wardrobe and made it so much easier to get a variety of shots, which is always appreciated.

WATER

OO 1989

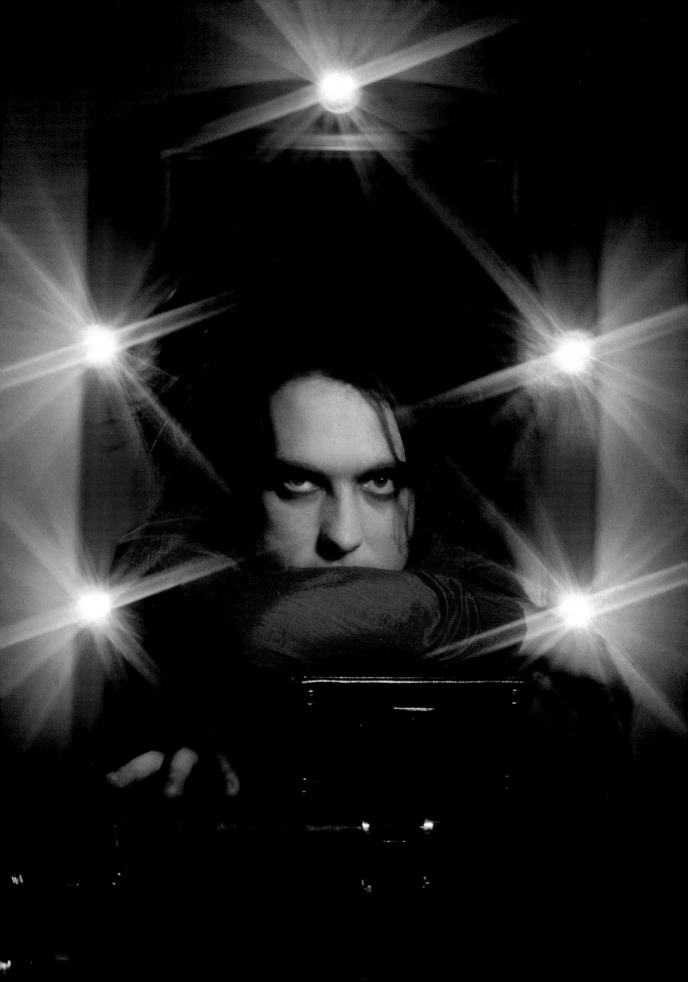

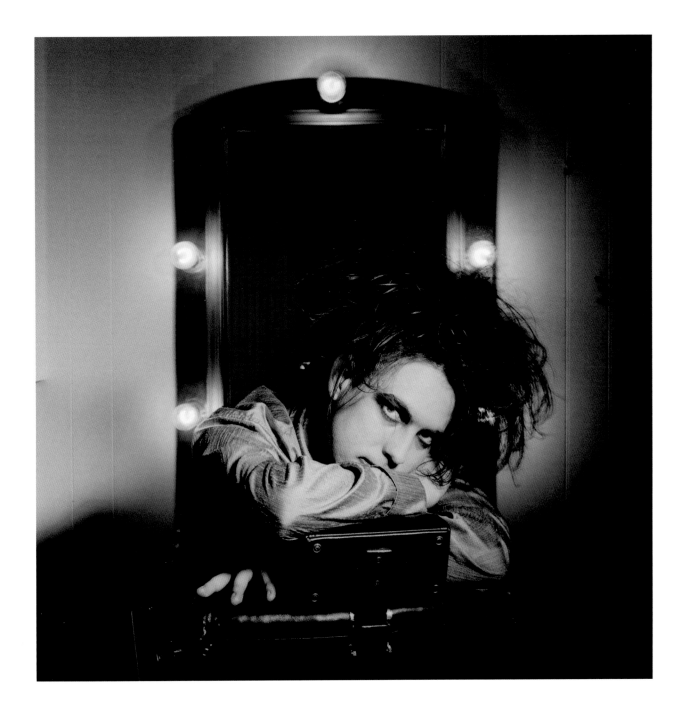

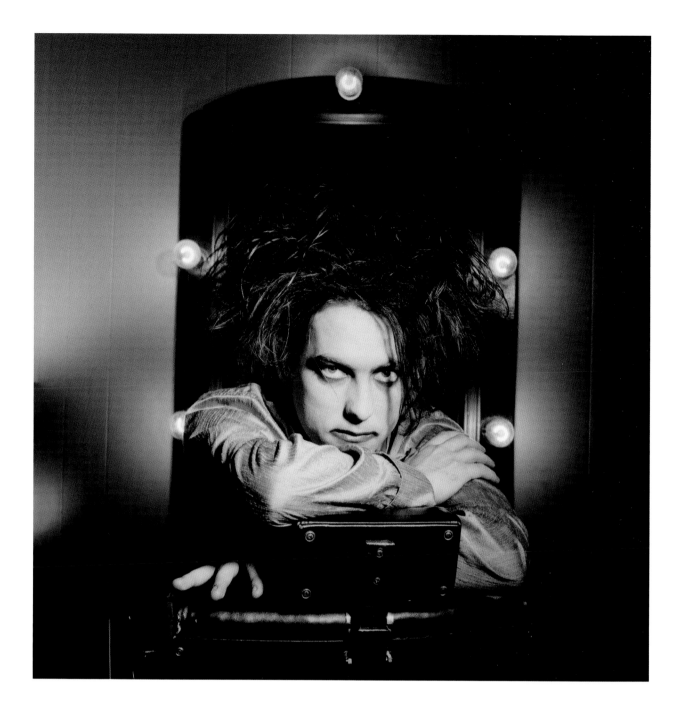

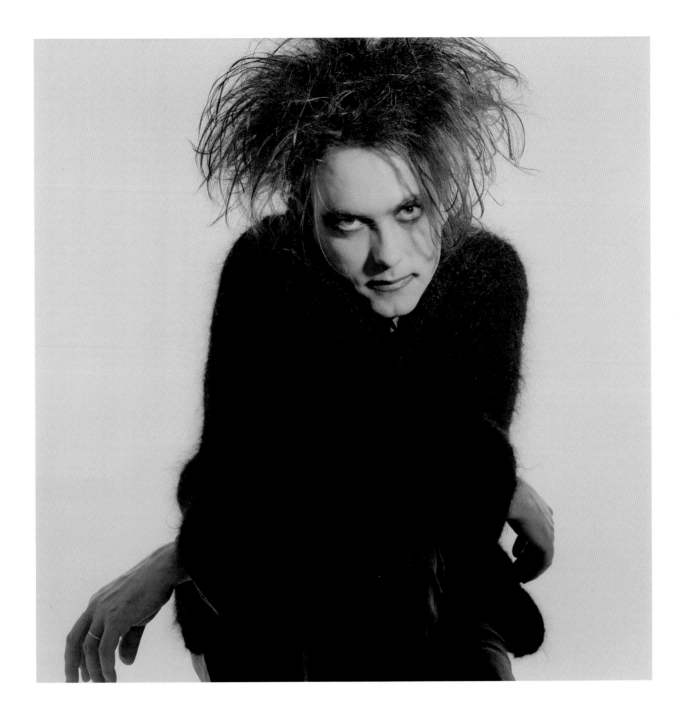

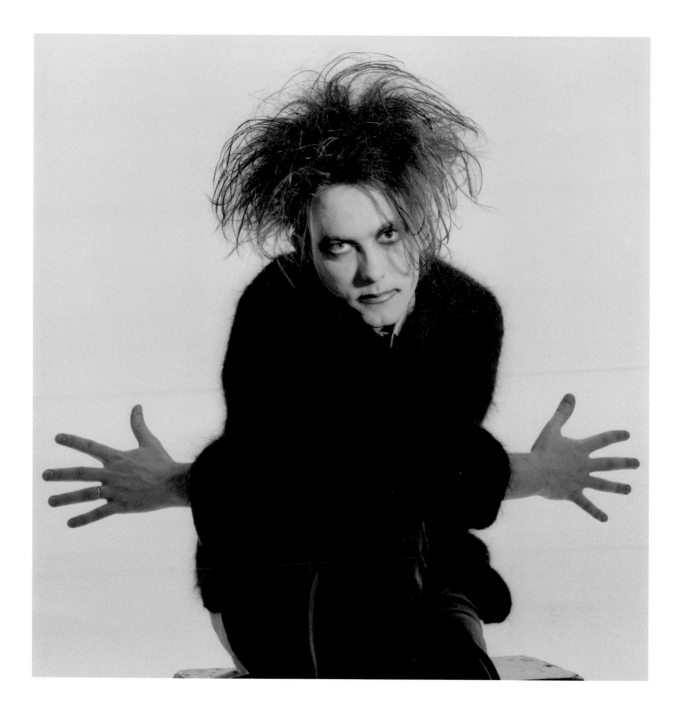

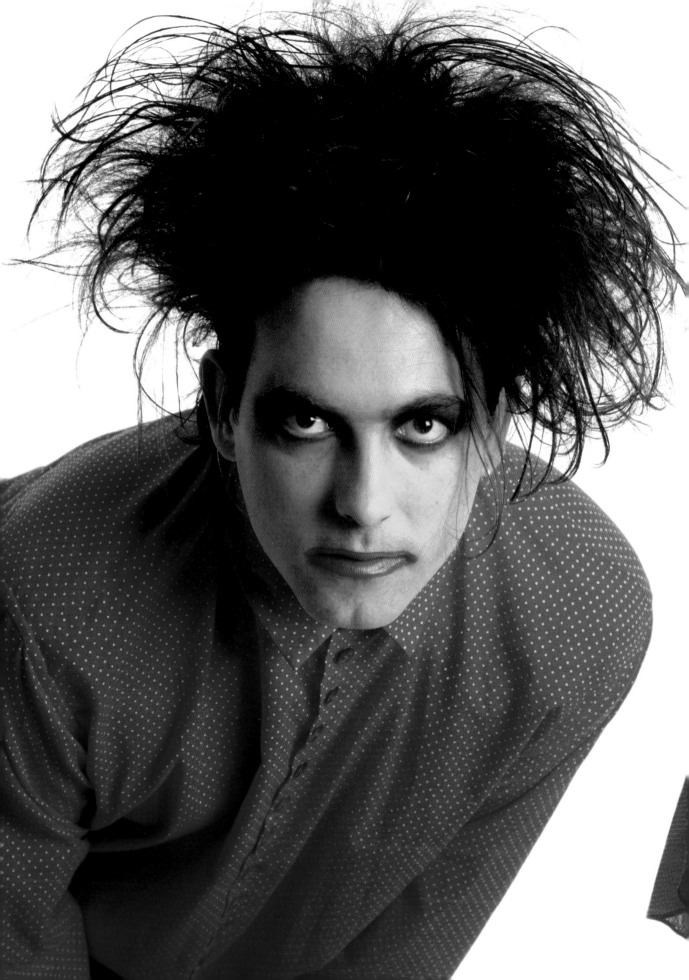

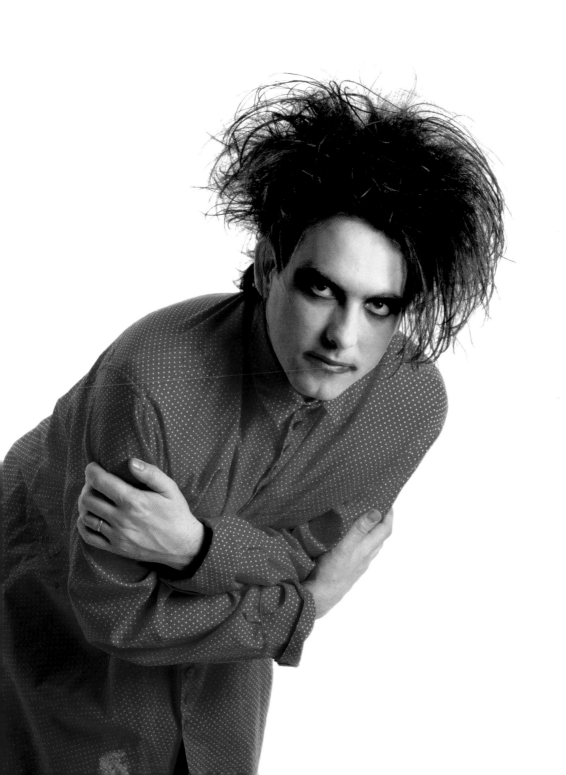

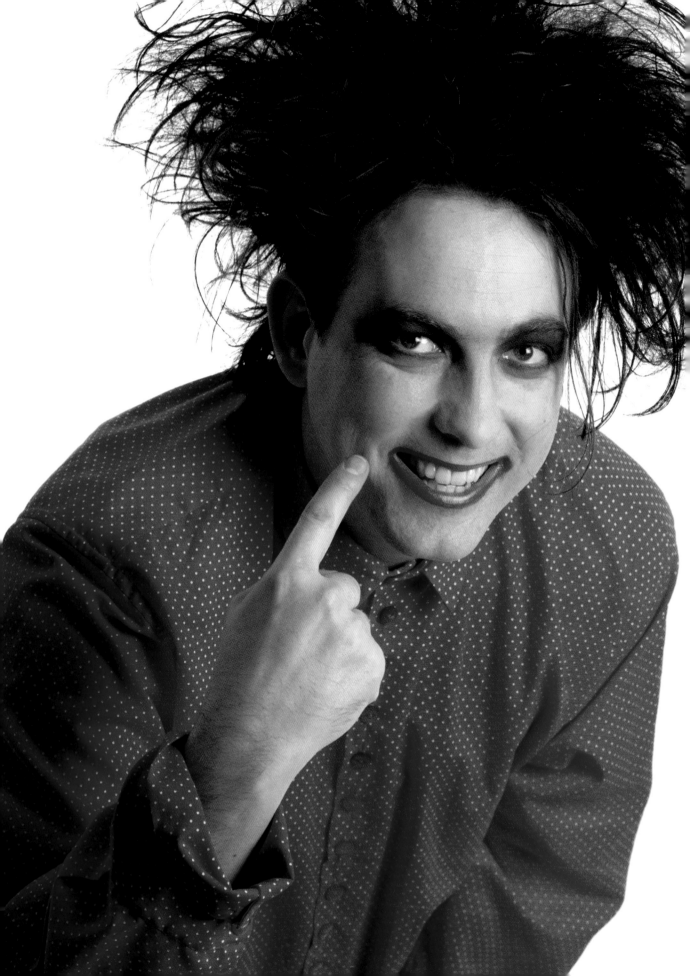

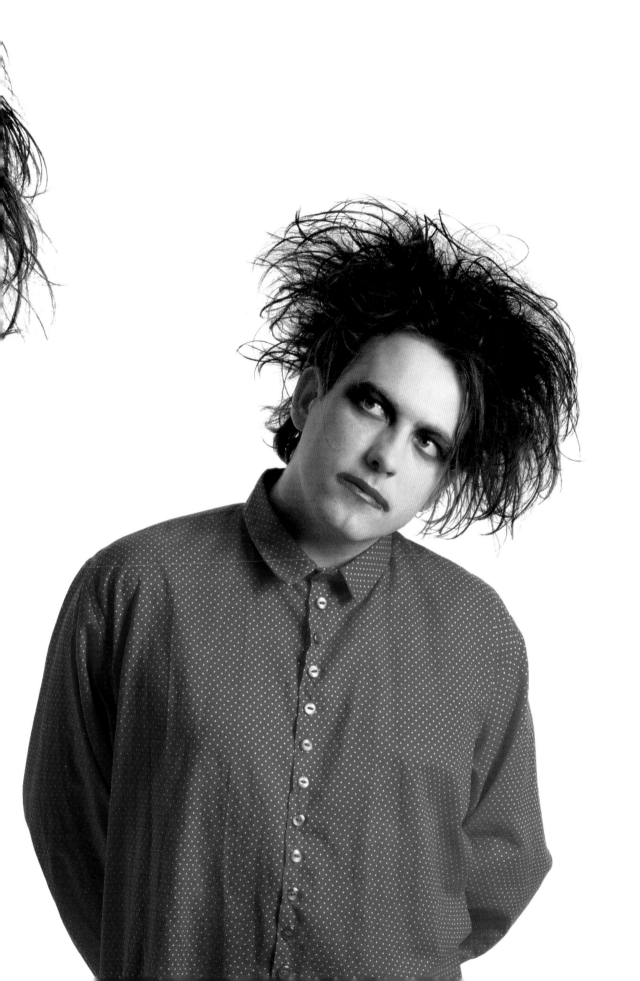

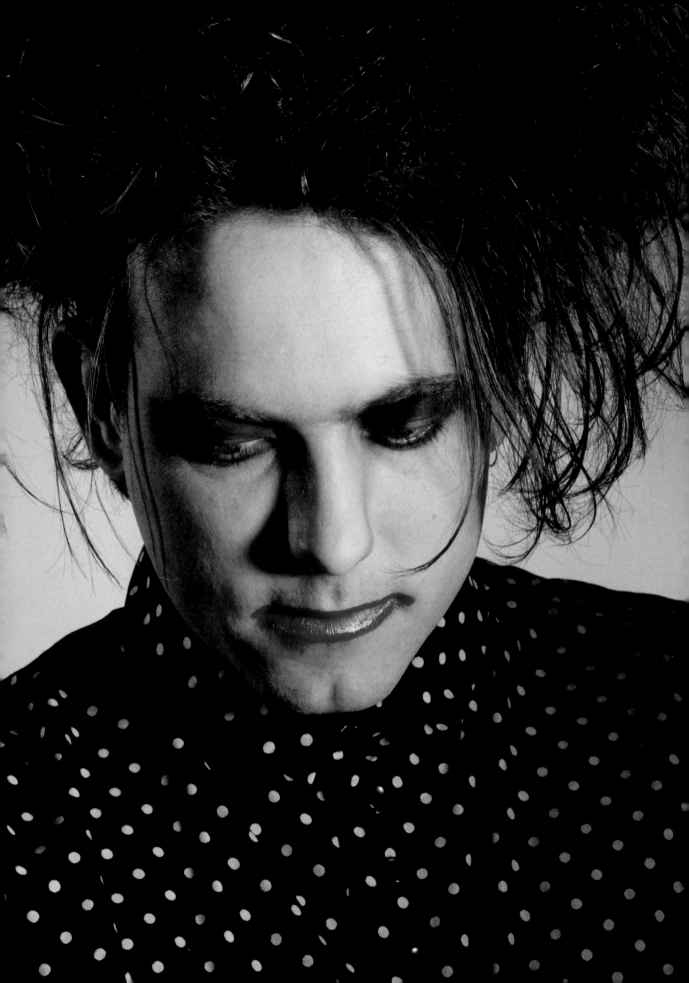

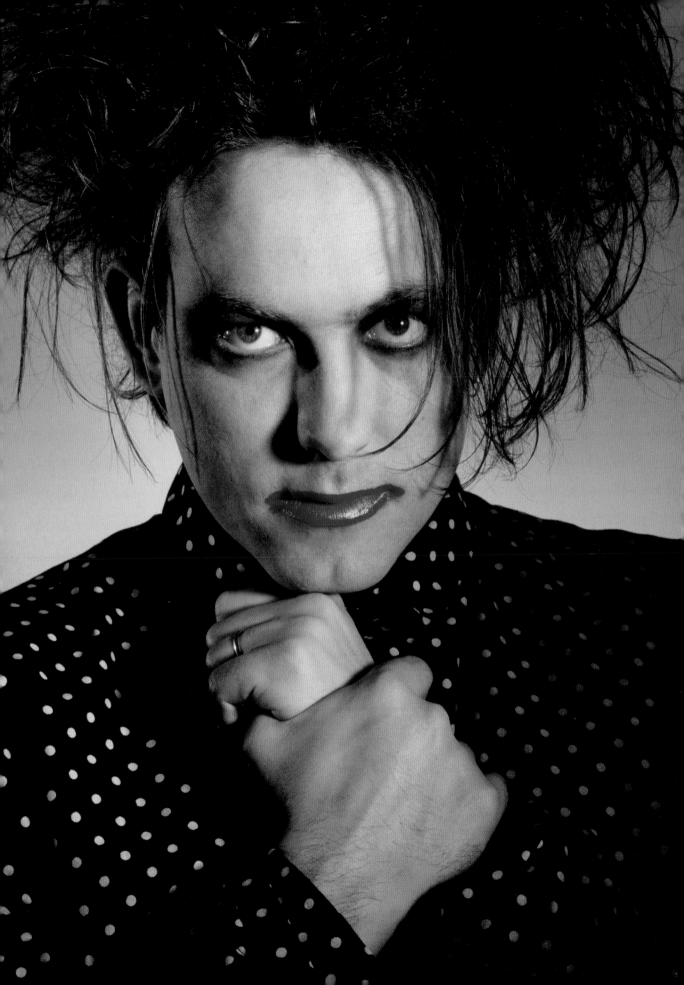

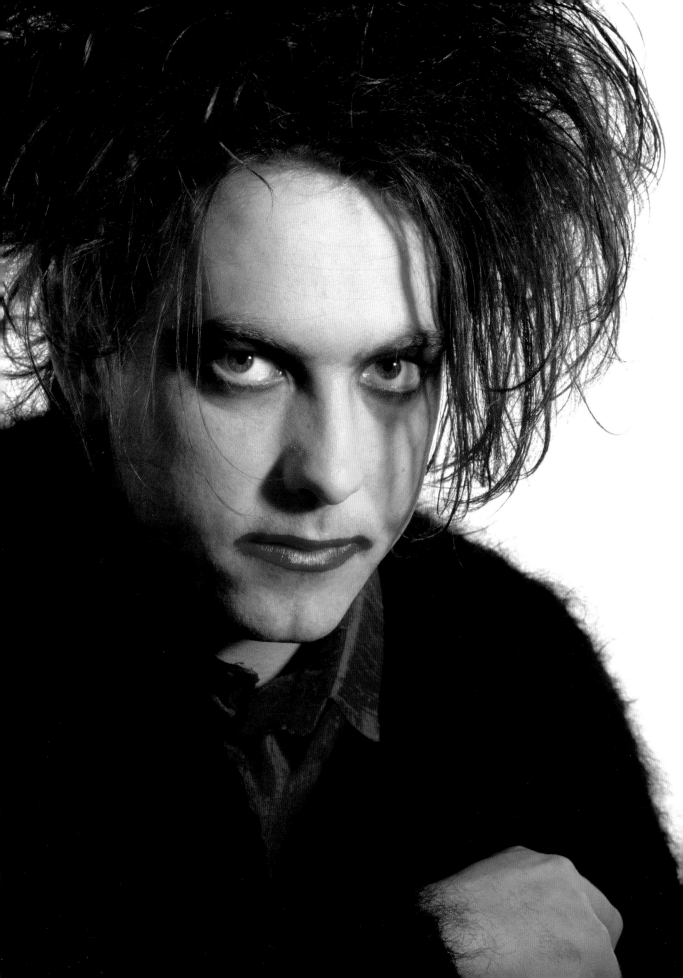

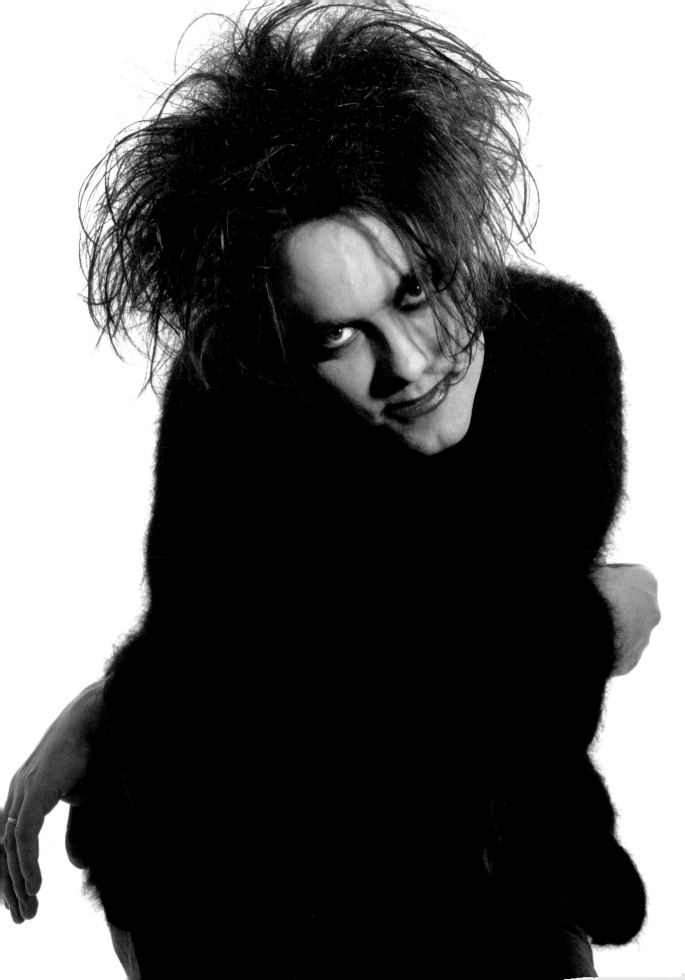

PICTURES OF THEM
(Always: 1986–1989)

The second half of the Eighties and all the wooden horses are safely inside the gates of Troy. Nobody has been able to stop it because nobody could have ever foreseen it happening. That the sort of groups who formed in the bleak midwinter of the late 1970s because they wanted to make music like The Velvet Underground, or Kraftwerk, or Bowie's *Low*, whose initial expectations probably stopped at the invite to a lone radio session for John Peel, who had to start their own record labels because they knew if they didn't put their songs out then no one else would, who subsisted in a provincial universe funded by the DHSS and wallpapered by the *NME*, who sang about first-hand despair and second-hand existentialism, that *these*, of all haircuts, of all raincoats, of all cocky eyelids and cagey lips, of all lunatics scheming to take over the asylum, would become the kind of British groups who would end up causing riots at packed stadiums in South America. That this could ever happen to a New Order, the band who once were sombre, scrawny Joy Division, or a surly, swirly Echo And The Bunnymen, or a skinny, spotty Depeche Mode?

That this could ever happen to *The Cure?*

It happens to The Cure. They become big. *Silly* big. The once mistily invisible nobodies are now ubiquitous, visible somebodies. 'There's pictures of us in the middle of magazines,' observes Robert, still trying to process how things have reached a stage where the group that sings 'Killing An Arab' make the colour centrespread of *Barbie*. Yes, that Barbie, the blonde plastic doll who, thanks to IPC, the same publishers of *Melody Maker* and the *NME*, has 'her' own fortnightly rag, which features regular 'Barbie Rock Star' pin-ups, including The Cure. All five of them: Robert, Lol, Simon, Porl and Boris. A proper pin-up of a proper group – with an extra heart-shaped drop-in of Robert in the corner. Swoon.

In France, The Cure are even bigger than silly big. They're *énorme! Plus grand que grand! Gigantesque!* To-them-what-feels-like-Beatlemania big, pelting between limo and hotel as gendarmes ferociously baton back *les armies* of lookalikes de *'Robairt Smeeth'*. The French adore the

man, and he doesn't even like garlic. Much less fame.

'I've experienced it to a small degree in France, and it's cack…'

Eh… pardon, monsieur? Qu'est-ce que c'est le 'cack'?

'…not being able to go out without people coming up and going, "You're Robert Smith." You become less than human.'

And so Robert stays more than human by being less than the Image of Robert Smith.

Hair? *Make-up?*

No, Robert can't stop wearing make-up; he's still working his way through the box of 30 Mary Quant Crimson Scorcher lipsticks he bought three years ago, now so intrinsic to his sense of self he keeps one on a string attached to the mirror by the door in his basement flat in Maida Vale so he never leaves home without a good splurge. But he *can* cut his hair.

The tumbleweed is shorn down to a stump prior to their 1986 summer tour of America, where The Cure fill the 17,000-capacity Forum in Los Angeles. Before they get to strum a note, among the crowd a 38-year-old topless desperado wearing a cowboy hat stabs himself in the chest with a 7-inch hunting knife in an apparent act of hara-kiri. It turns out he wasn't even bothered about hearing 'Boys Don't Cry', but there are surely ways and means of expressing such things that don't involve paramedics. Mercifully, they save his life, and The Cure from the stigma of starting a self-disembowelling death cult. Almost. In New Zealand an investigation into a double teenage suicide sends grieving parents and vulturous press seeking answers in the victims' cassette collections. Some contain words and music by Robert Smith. The tragedy is as unspeakably sad as the inference of blame is insufferably wrong. Fame really is hell and, oh, how its flames flicker.

Away from the heat, Robert's tenth year as/in The Cure amounts to a lap of honour marked by the singles collection *Standing On A Beach*, crowned by a European tour finale at the ancient Roman amphitheatre at Orange on the Côte d'Azur. The concert is filmed by Pap and later released as a feature, plainly titled *The Cure In Orange*, which makes it sound uncannily like *I Am Curious (Yellow)*, even if fans of vintage erotica will be disappointed to discover it's really a *Pink Floyd: Live At Pompeii* with better tunes.

Despite all the distracting blood, Barbie dolls and his beloved QPR's first away defeat to the newly Fergusoned Man Utd, by the end of '86 Robert exhibits a hitherto alien aura of contentment.

'I would rather be in this particular Cure than any of the other ones.'

His confidence in this particular Cure extends to a new experiment in creative democracy when plotting their next opus. Every member is asked to make a tape of potential tunes, riffs, ideas, vibes, plinks, plonks and paradiddles, which he then submits to a blind group Jukebox Jury. Without announcing whose tape is whose, everyone has to mark every track out of 20, excluding their own. Sixty demos later, once the votes have been meticulously adjudicated, what's left are the melodic flesh and rhythmic bones of the 18 tracks of what will become 1987's audacious double album *Kiss Me, Kiss Me, Kiss Me*. They record it in France amid the infinite bonhomie of the vineyards of Provence: within five days the studio wine cellar is 150 bottles lighter than when they arrived. Thus The Cure begin their belle epoque as they mean to continue.

'I would be horrified if The Cure were as big as U2 or Simple Minds,' says Robert, obliviously parking himself in the same stadia dressing rooms pungent with the mulleted musk of previous Bonos and Kerrs. Their first concerts of '87 are two sell-out nights in the football ground of Club Ferro Carril Oeste in Buenos Aires, where The Cure find themselves

one of the first British rock bands to play Argentina since Galtieri was stripped of his epaulettes and thrown in chokey. This might explain why their reception is that of heroic freedom fighters come to liberate the oppressed peasants from the shackles of dictatorship with dry ice and flange pedals, and why the first night is a bloody ruckus between security and a crowd of 23,000. Conflicting reports reach backstage from dozens trampled to dead security dogs, fans setting fire to seats and a hotdog vendor who dies of a heart attack when his stall is toppled over. Robert gulps, walks out into the spotlight, sings, '*Wake up in the dark,*' and a revolution is won. Until the next night, when a well-aimed iron crucifix smacks him in the face mid-song. And he'd not even said anything about the Hand of God.

Safety being in numbers, come summertime The Cure swell to six with a new keyboard player, Roger. His arrival is an obvious warning shot for their current 'keyboard player' Lol, Robert's oldest friend and formative member, whose function, or lack of, is now reduced to backstage whipping boy and brandy-soaked liability. There are dark clouds gathering on the distant horizon but, until they burst, Robert boards another plane bound for America, closes his eyes and calms any spooks in his brain listening to *Under Milk Wood* read by Richard Burton.

'Time passes. Listen. Time passes…'

When he opens them he's back in the same Los Angeles arena where, last time round, a cowboy with a hunting knife tried to fillet himself. Benevolent history does not commit the same atrocity twice.

While staying at the Four Seasons, the blessing-curse of loathsome 'celebrity' results in a local lunch invitation with one of his favourite authors, Ray Bradbury. Robert's hand is on the doorknob, ready to go… when at the last minute he withdraws. A dreamer who doesn't want to be anyone's hero is much too wary of meeting his own. Out of courtesy, he invites Ray to come and see his band at

the Forum instead. Ray, age 66, declines on the grounds 'I would hate it' and fobs Robert off by sending in his place an autographed copy of *Something Wicked This Way Comes*. Everyone's nose is rudely knocked out of joint and Robert bitterly goes back to his bedside Voltaire.

> *'I have wanted to kill myself a hundred times,*
> *but somehow I am still in love with life.'*

Ah, *Candide*! That's the spirit. Voltairian optimism, cheering bleachers and Almay eye pencil buoy The Cure to the triumphant end of '87, from New York's Madison Square Garden to three nights at Wembley Arena, climaxing with the Image of Robert Smith onstage, singing a cover of Slade's 'Merry Xmas Everybody'. And this is the bloke some sections of the press call 'the Messiah of Angst'?

'The more The Cure go on, the more I think we're unique,' glows Robert. 'I honestly don't think there's anything The Cure couldn't do.'

The only thing The Cure don't do in 1988 is gig. They rest, they regroup, they write, they record, and somewhere between they stand in the congregation of Worth Abbey in Sussex and watch Robert tie the knot with Mary. There are 150 guests at the wedding of Mr and Mrs Smith, including *Melody Maker*'s Tom Sheehan, the sole representative of the UK music press, there on official business as the couple's invited photographer. As a present for his new wife, Robert gives Mary a cassette of a simple love song he's written called simply 'Lovesong'. He's not sure if it will ever be a Cure song; he's been speculating about a possible solo record, something quiet and acoustic with piano and cello, a bit like Nick Drake. He doesn't know exactly when he'll do it, even though he's written most of it, or what it will be called. He only knows what the sleeve will be.

'The real reason I want to do a solo album is that Tom Sheehan took a photograph of me three years ago, the *perfect* photograph of me. And I'm never going to use it unless I do a solo thing.'

The perfect photograph is never used. Instead, some of the songs that would have been Robert's solo thing, including 'Lovesong', end up on *Disintegration*. The finality of the title of The Cure's last album of the Eighties is deliberate. By the time it comes out two weeks after his 30th birthday, the six-man Cure has crumbled back to five again. Though charitably listed on its credits as 'other instrument', Lol has been dismissed for his own sobering good as much as the band's. So the clouds burst and the hard rain falls.

The record itself is the moment The Cure's wooden horse finally spills open and Troy perishes in a toxic plague of flesh-eating tarantulas. All those years, all those magazine covers, all those larky videos dressed up as polar bears, all those *Top Of The Pops*, all that playing the hits for the screaming arenas and then to drop the kind of long-playing downer The Cure haven't made since the glum old days of waiting for the death blow and sleeves designed to make them look like 'if Marilyn Monroe's corpse had been left decomposing on satin sheets for a few days'. And the maddest and most brilliant part of it all is that it *sells*: over 2.5 million copies, reaching number 3, higher than any Cure album so far, only kept off number 1 by the fair dinkum of Jason Donovan and the moonlit nicht of Simple Minds. Which means Robert has no need to feel horrified since he's stayed true to his aim of *not* being as big as Jim Kerr. Which means The Cure have image *and* integrity. Which means The Cure have *won!*

So why does Robert suddenly decide to stop?

Why, when just a few months ago he'd said, 'I want people from other groups to look at us and wish they were in The Cure'? Why suddenly radiate pessimism like an apocalypse-scented Glade air freshener, telling every journalist that the *Disintegration* 'Prayer Tour' is going to be the band's last? Why say, 'I'd break my hands not to do it anymore'? Why finish the final encore of the final scheduled gig by saying, 'Thank you very much and good night, and I'll

never see you again,' like he actually means it? Because surely The Cure can't end? Not *now*, in Jive Bunnying 1989, before anyone knows what the internet is, before televised Glastonbury, before iPods, before the death of the weekly music press, before a baby girl in Tottenham is old enough to listen to her mum's copy of *Disintegration* and destiny sows its seed to make 'Lovesong' part of the best-selling album of the 21st century when she grows up to be Adele?

Can a band that's wanted to kill itself a hundred times somehow not still be in love with life?

A week after the Waterloo session, still in April 1989, *Melody Maker* ran a feature with Dinosaur Jr. but we weren't sure how popular they'd be as cover stars. Because they'd just released a cover of 'Just Like Heaven', and because we had so much material from our previous issue's Cure feature to carry over as a 'part two' of that same issue, I suggested we get the bands together and shoot them both.

Robert has always been very kind with his time and so agreed to make it happen. Dinosaur Jr. had flown in from the US on the red-eye that morning, arriving at 6:30 a.m. or so. They grabbed some shut-eye and we drove them straight out to the shoot at Bray Studios, where The Cure were doing stage rehearsals.

THE CURE/DIN

OSAUR Jr. 1989

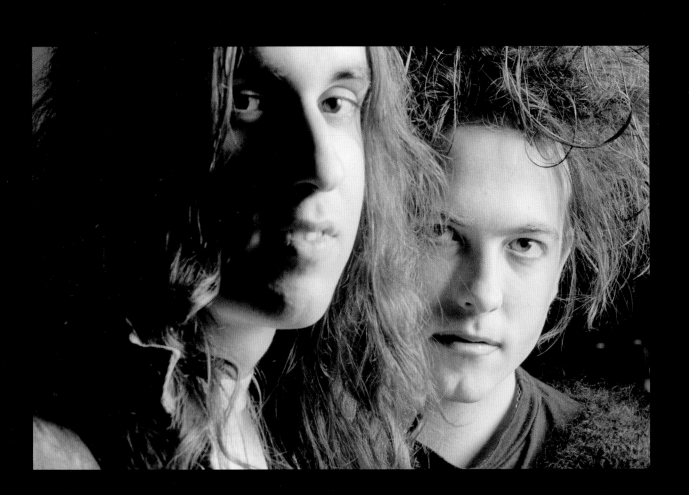

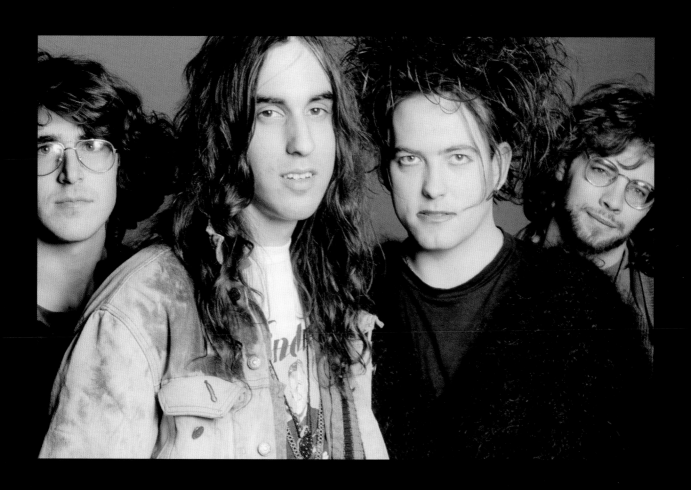

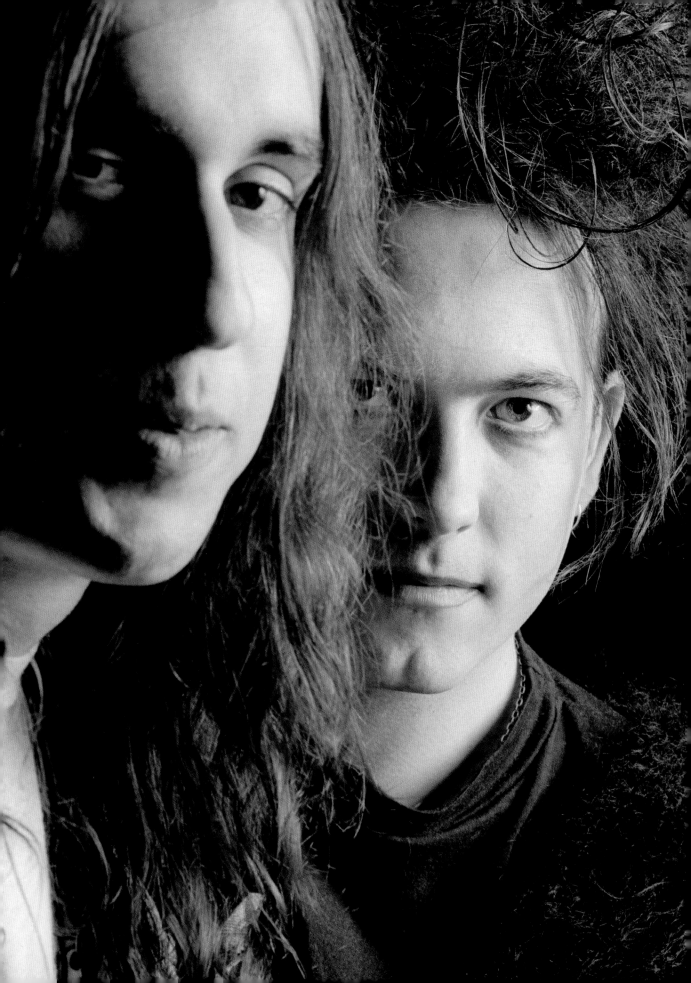

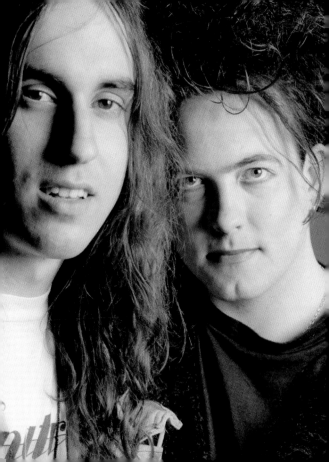

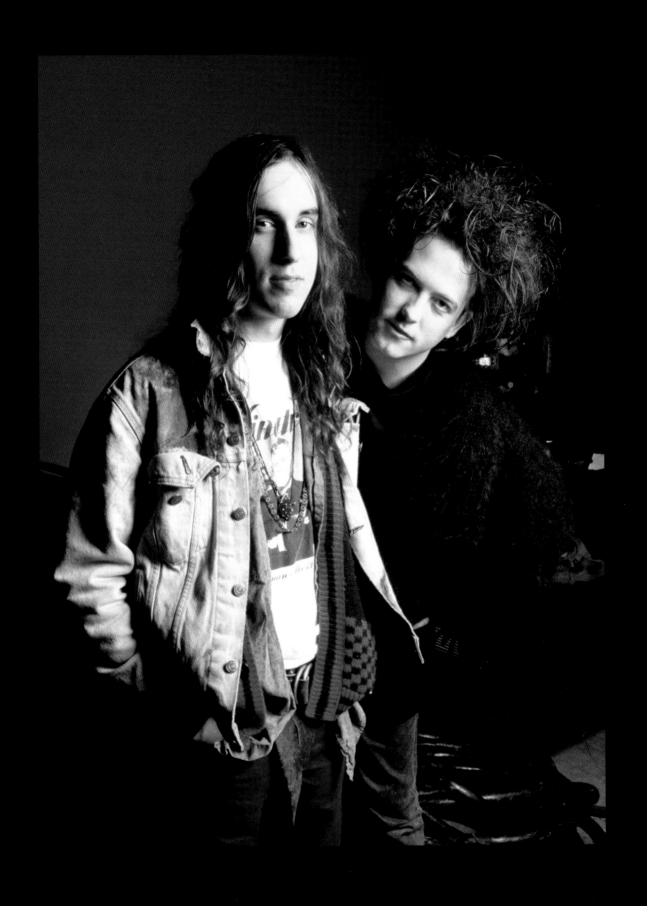

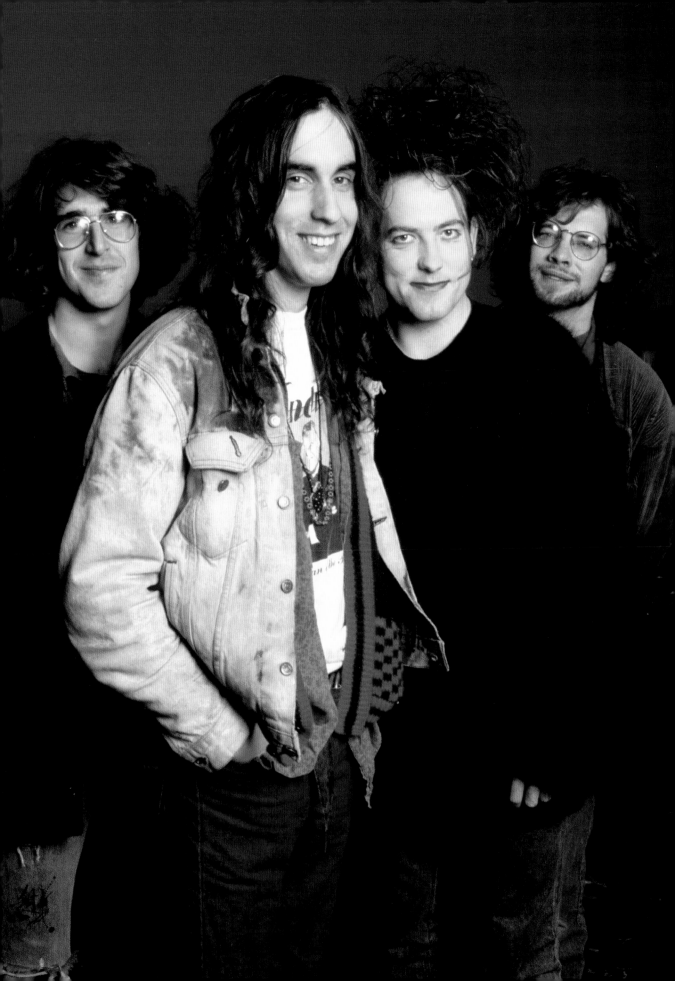

The band were touring and of course they
have their own agenda that you need to fit into:
travel, soundcheck, show, sleep. I took a few
snaps backstage before a concert, some solo
ones with Robert and a few with the whole
band crammed into a tiny dressing room. Then
they were on to the stage and out to perform.

FRANC

E 1989

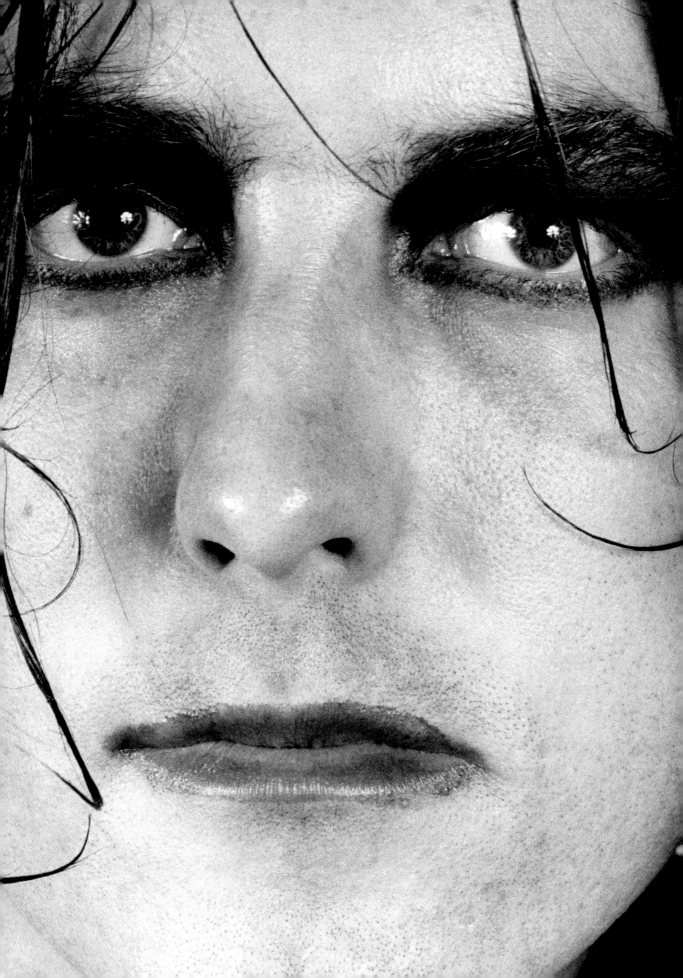

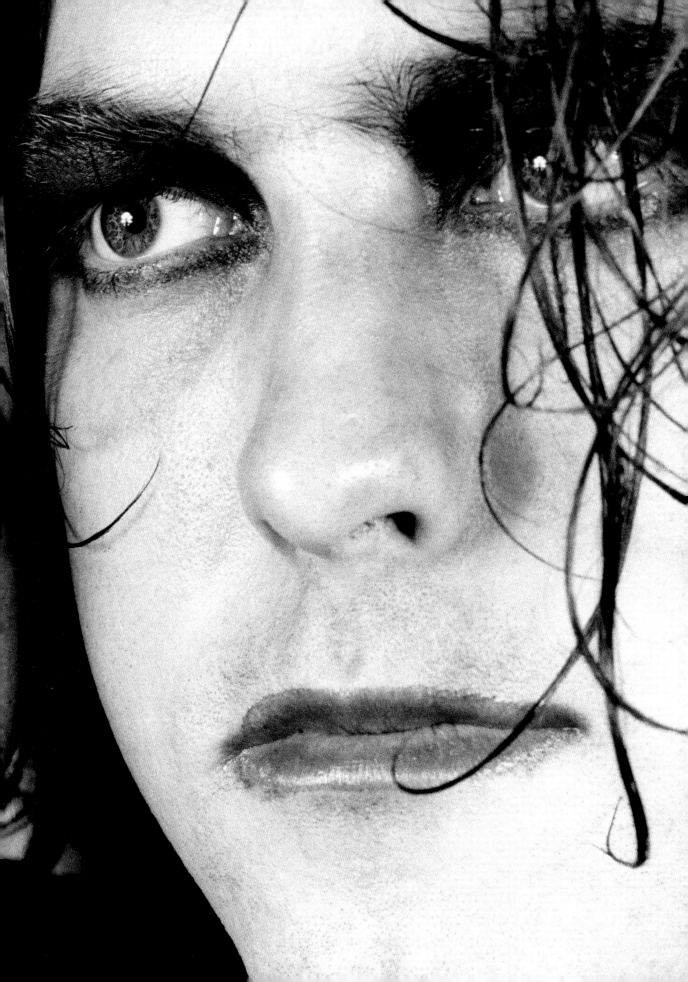

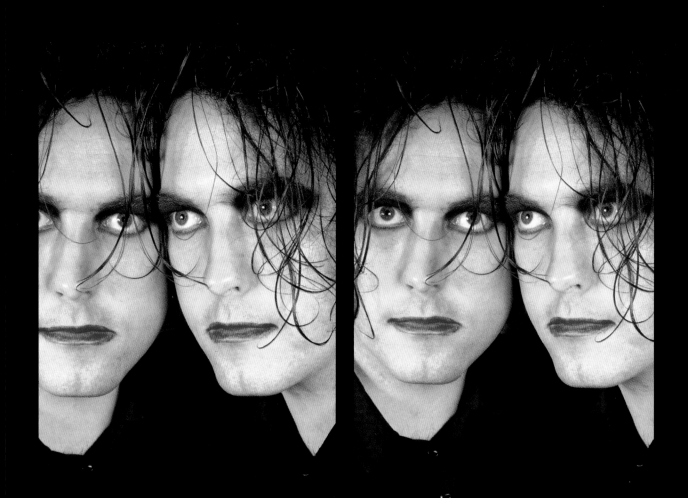

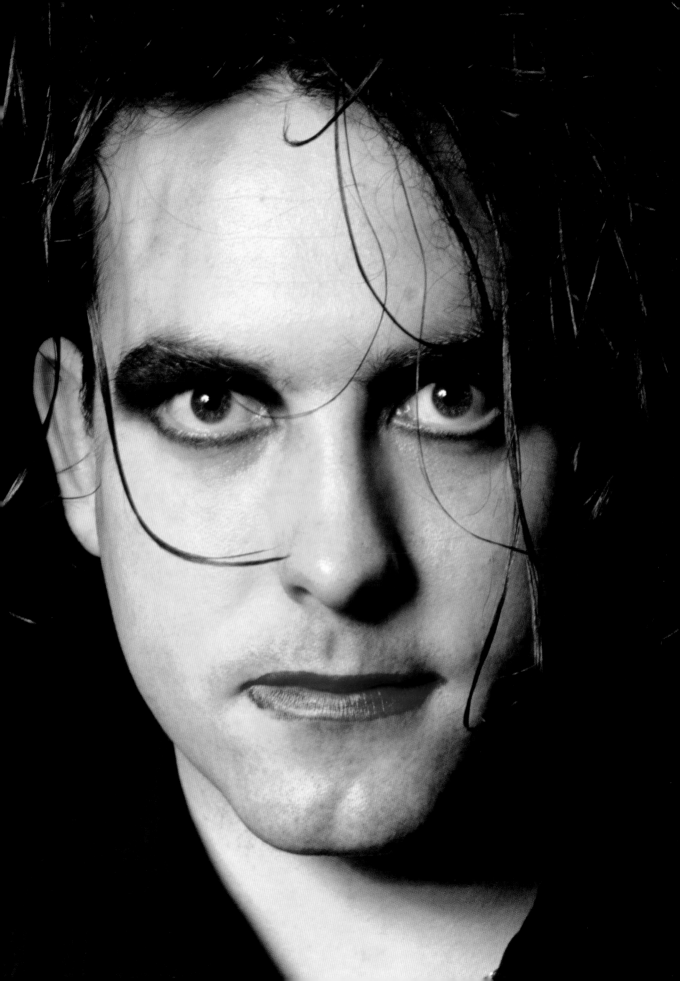

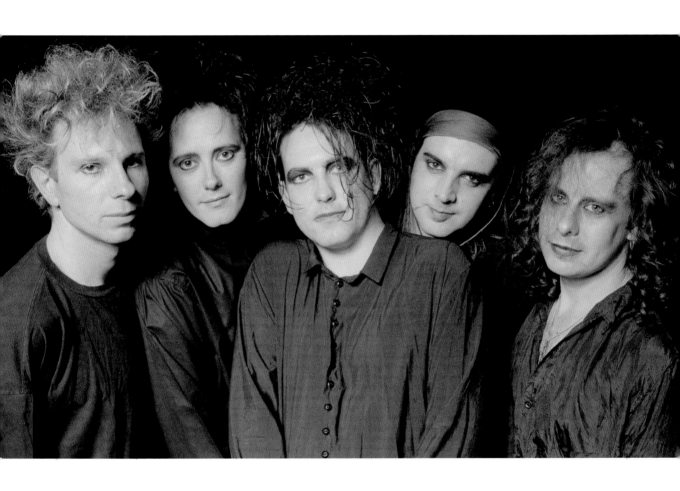

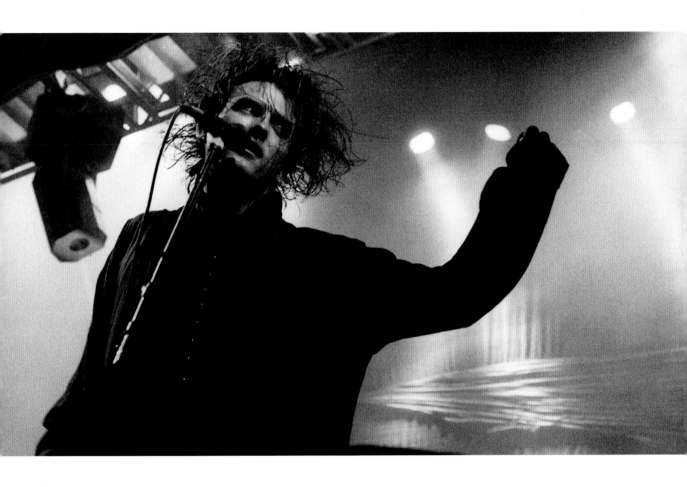

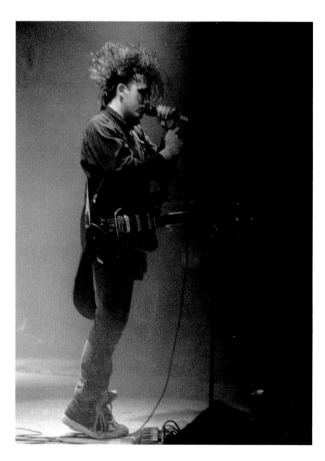
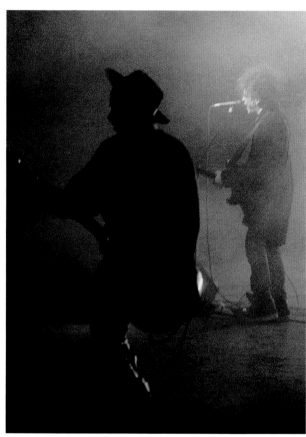

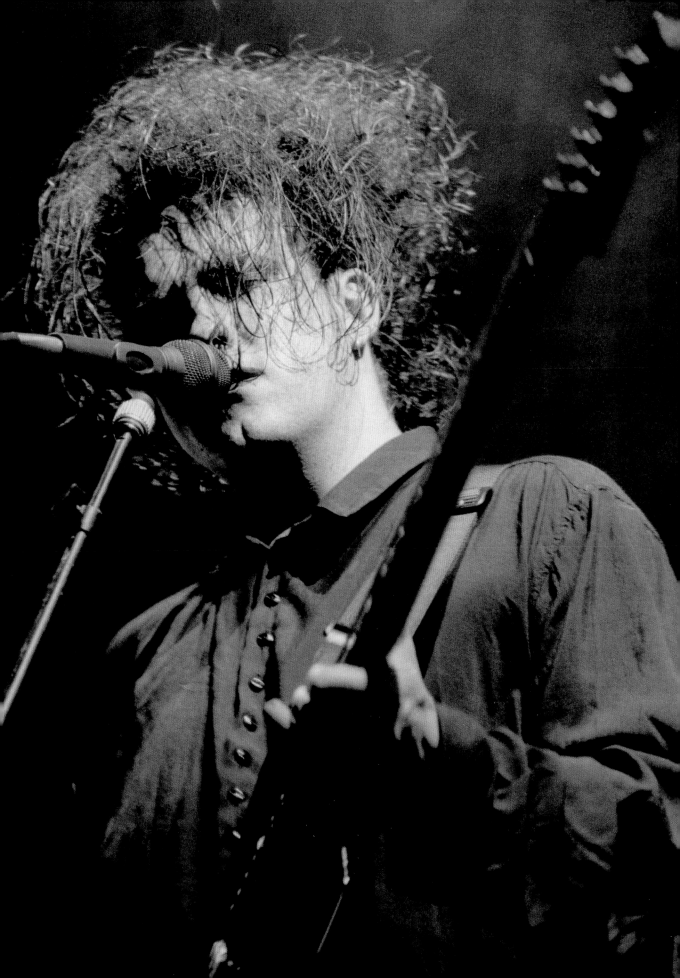

In June 1990, the band were staying and rehearsing at a big country house in Buckinghamshire called Beel House when I went to photograph them for a piece in *Melody Maker* to promote their upcoming appearance at Glastonbury. We had a friendly working relationship by this point and they kindly allowed me into their space, along with the journalist who was writing the piece.

While I was there, I found out that the house had previously been owned by Dirk Bogarde, a fact Robert seemed to like when I let him know.

BUCKINGHA

MSHIRE 1990

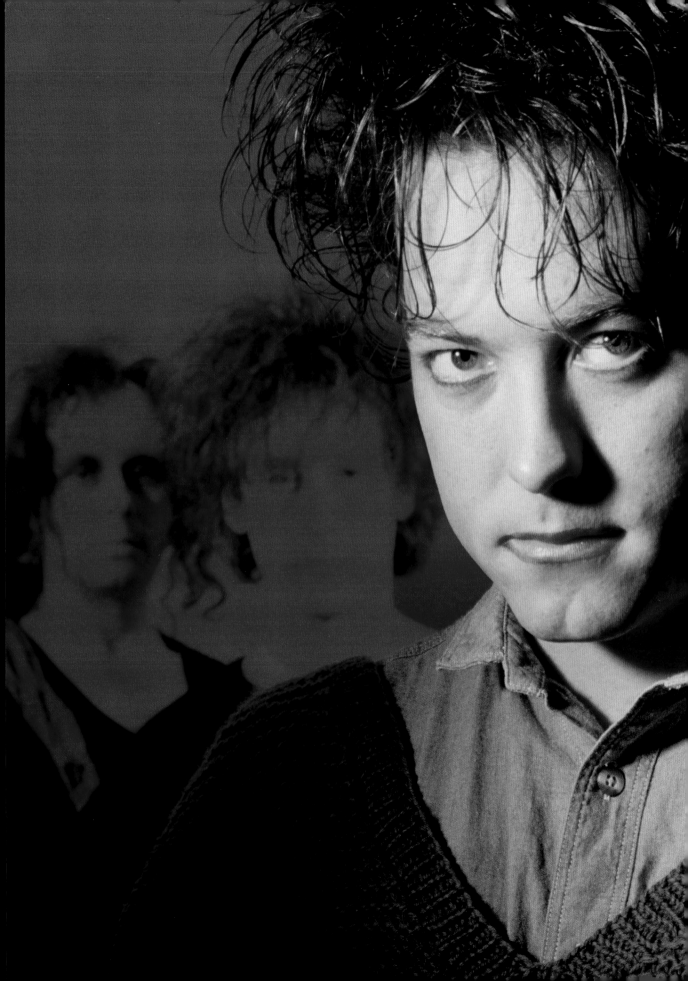

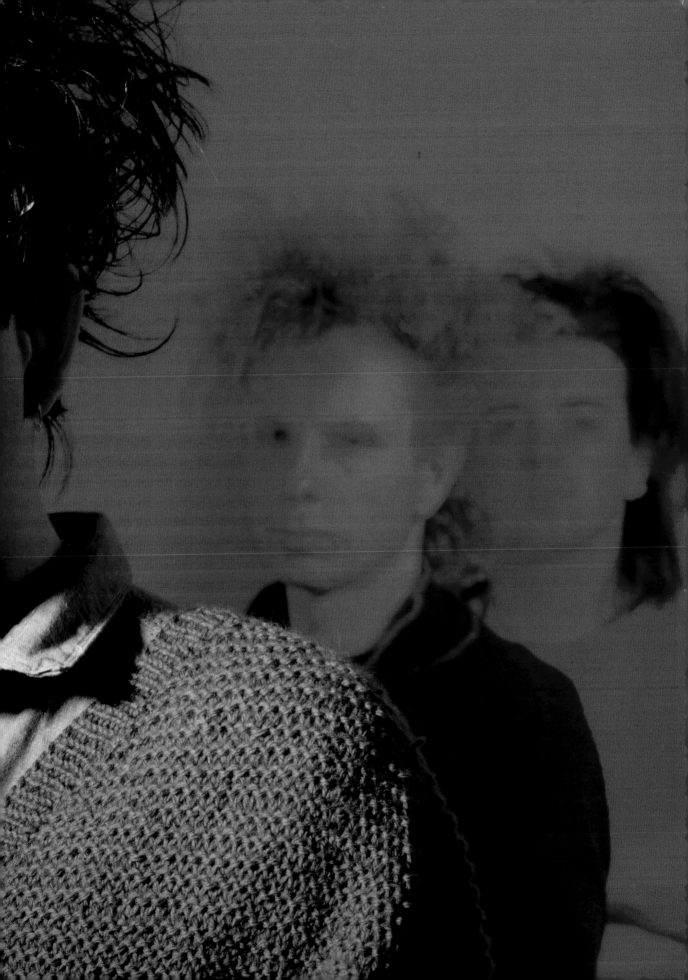

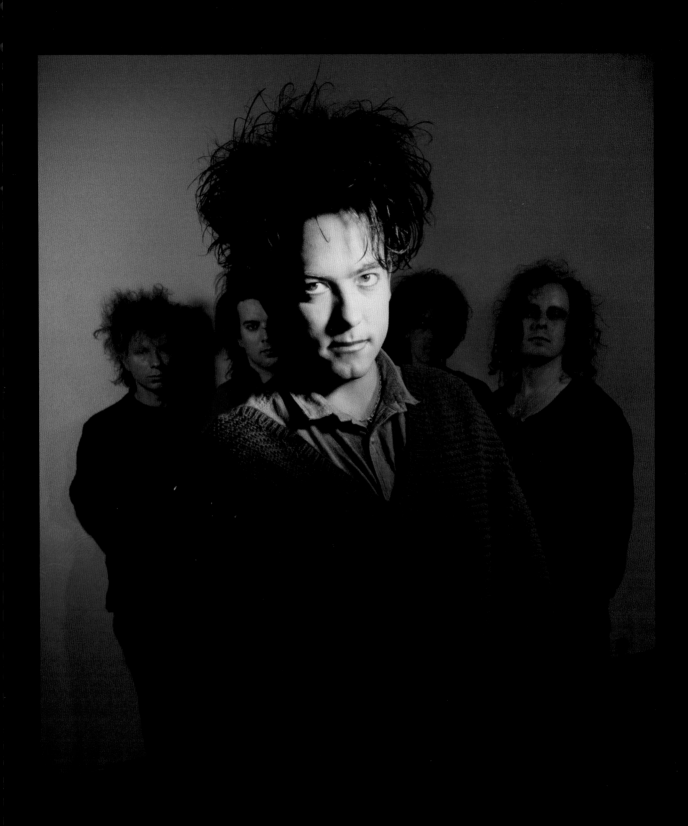

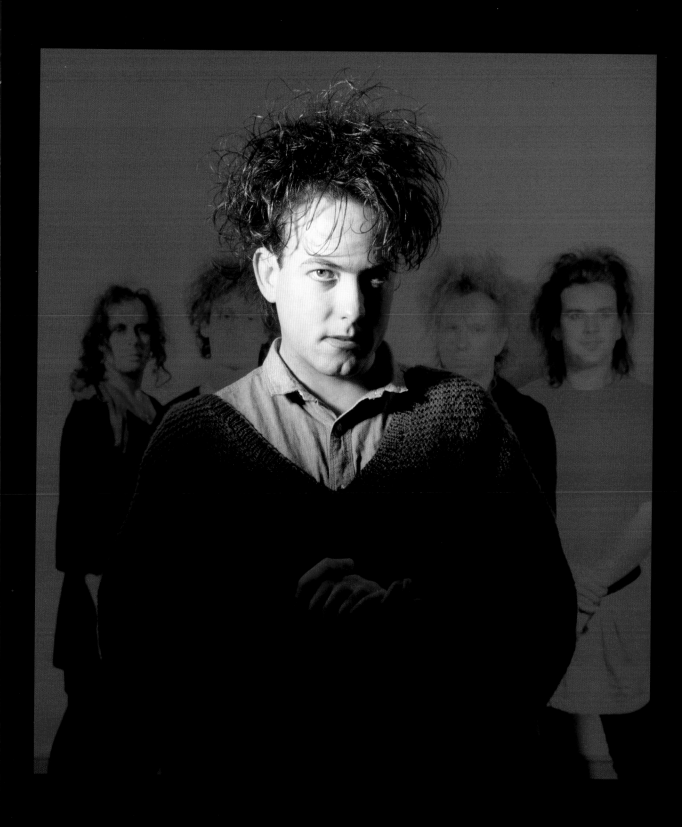

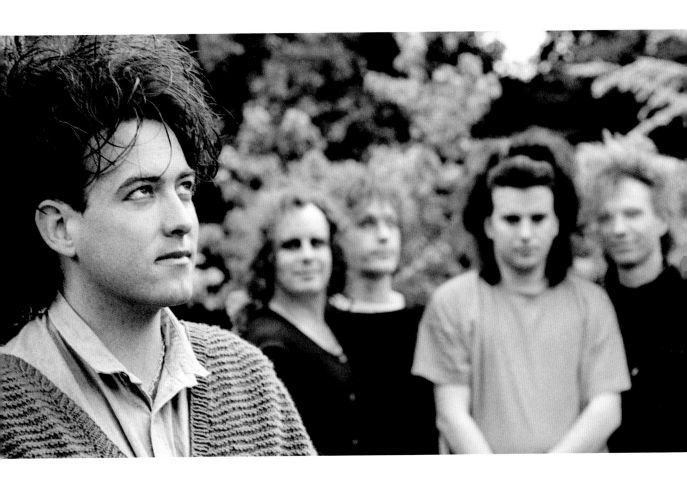

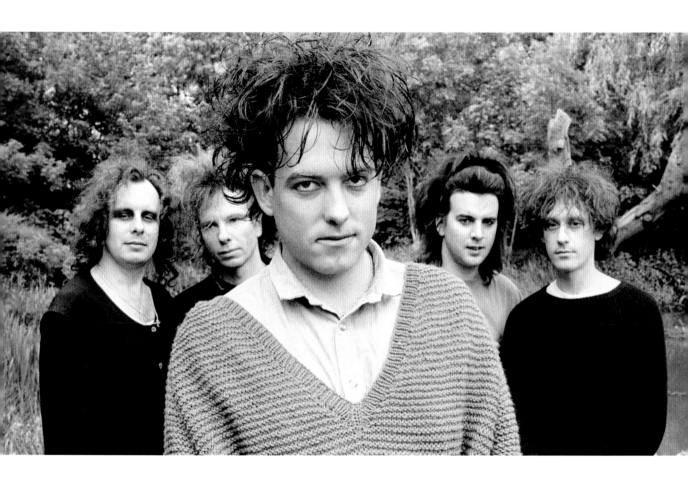

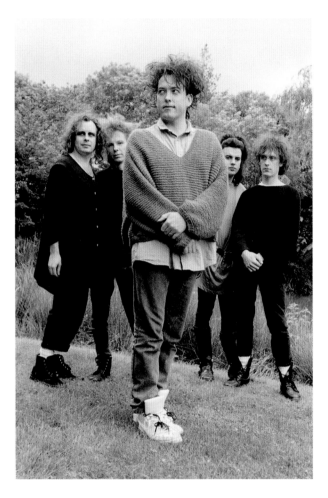
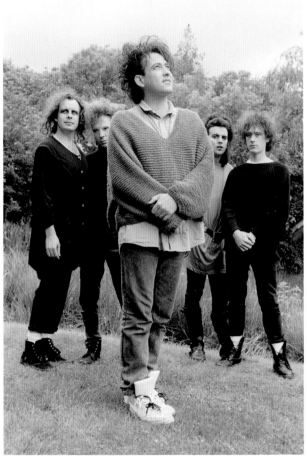

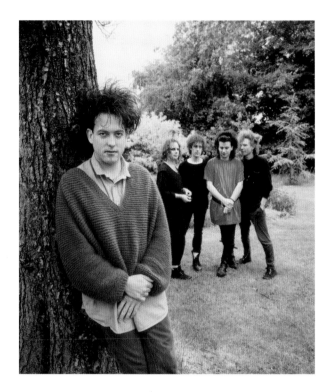
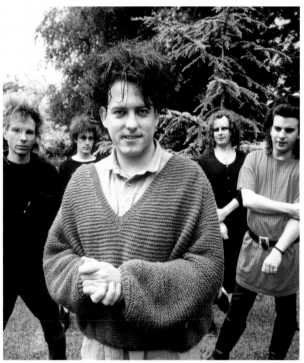

When the band launched the video *Picture Show* in 1991, they held a press conference in a hotel in Mayfair to promote it, with a press Q&A with Tim Pope and Robert. The giant octopus behind Robert is the one used in the 'Close To You (Remix)' video.

PICTURE SHOW

LAUNCH 1991

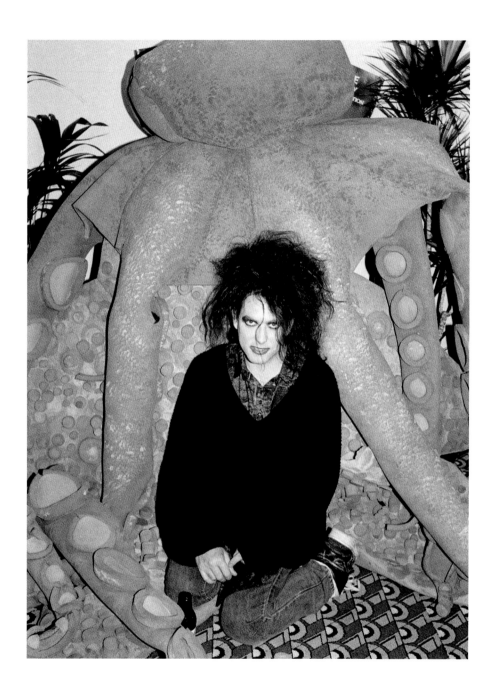

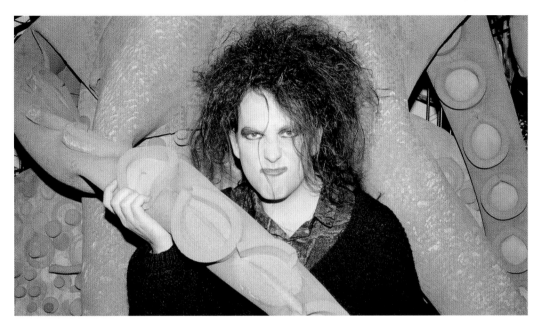

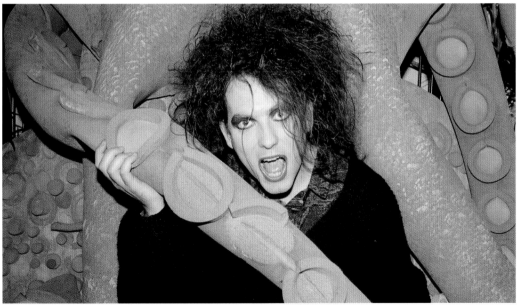

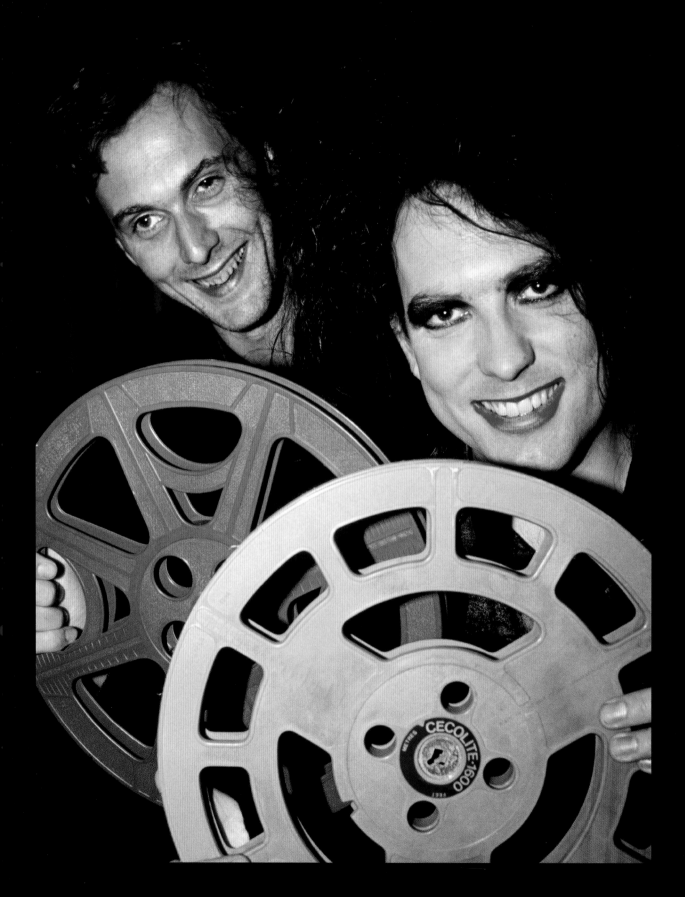

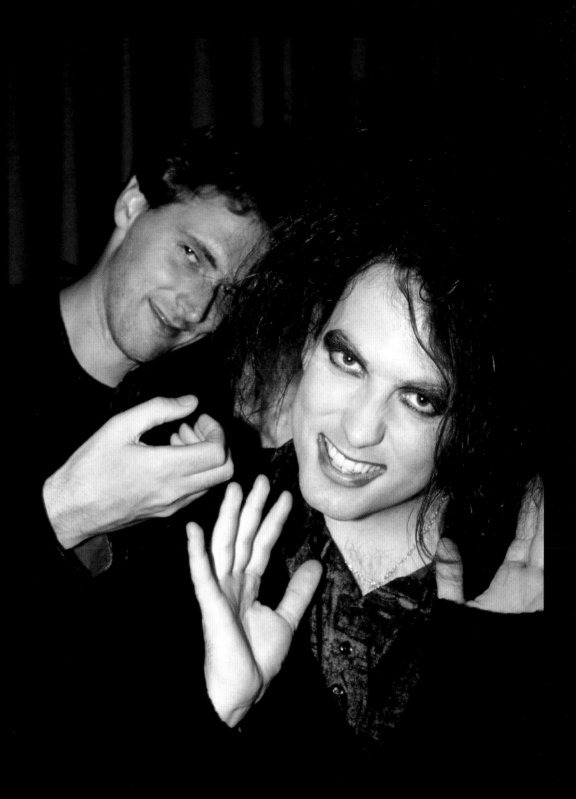

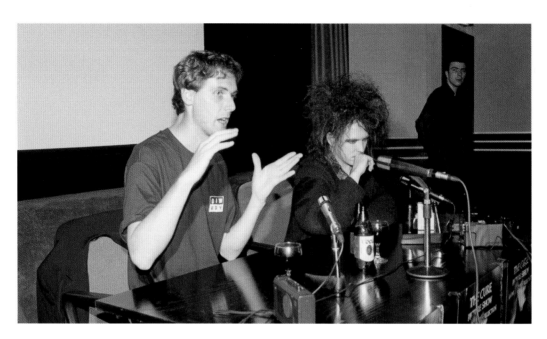

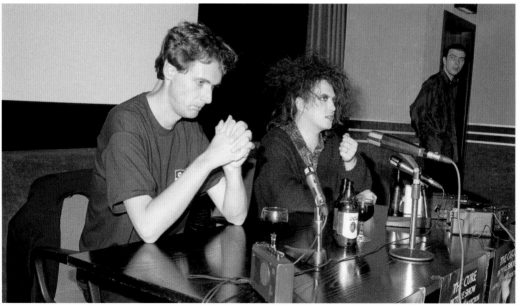

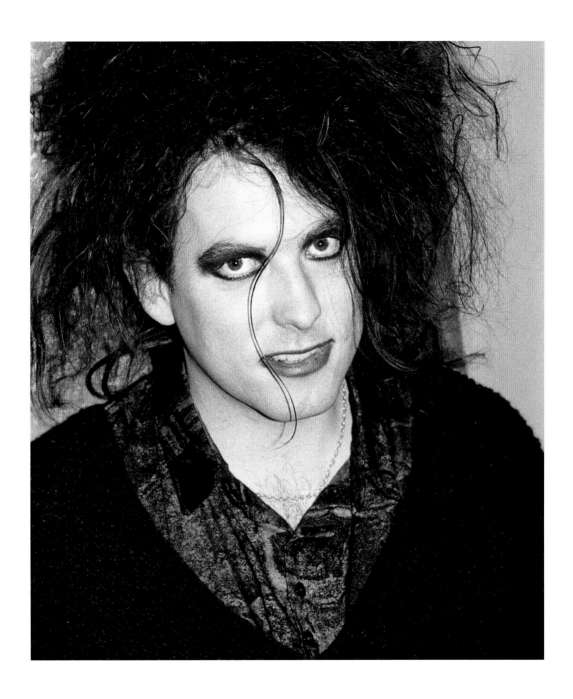

The Manor was a big studio in Oxfordshire, set in lots of land with a lake, and was where The Cure recorded their album *Wish* in 1992. When we arrived they were still busy recording, so we left them to it, found a pub and waited for the call to say they were ready.

When you shoot with a band you do it on their agenda, especially when they're working on their music. There was no PR involved here, I was working directly with them, but their endeavour is obviously greater than yours. It's about mutual respect and understanding.

THE MAI

IOR 1992

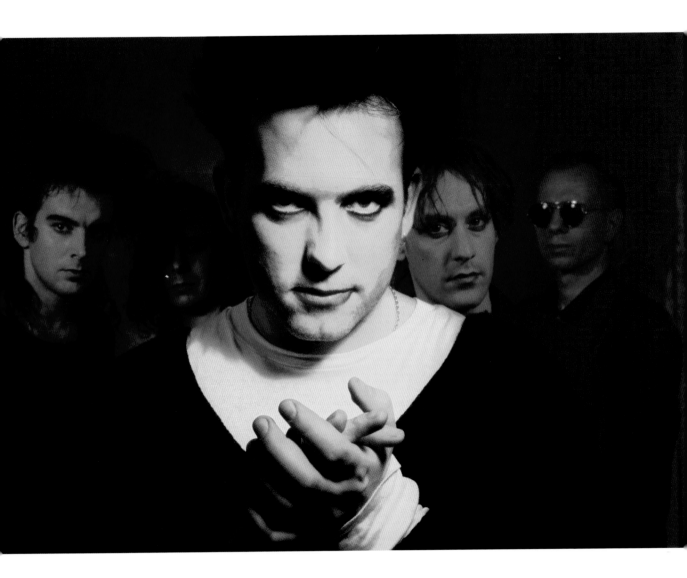

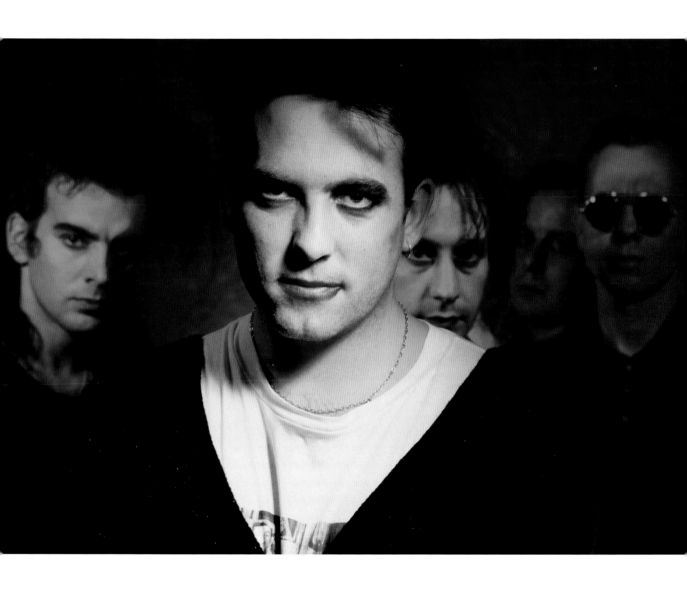

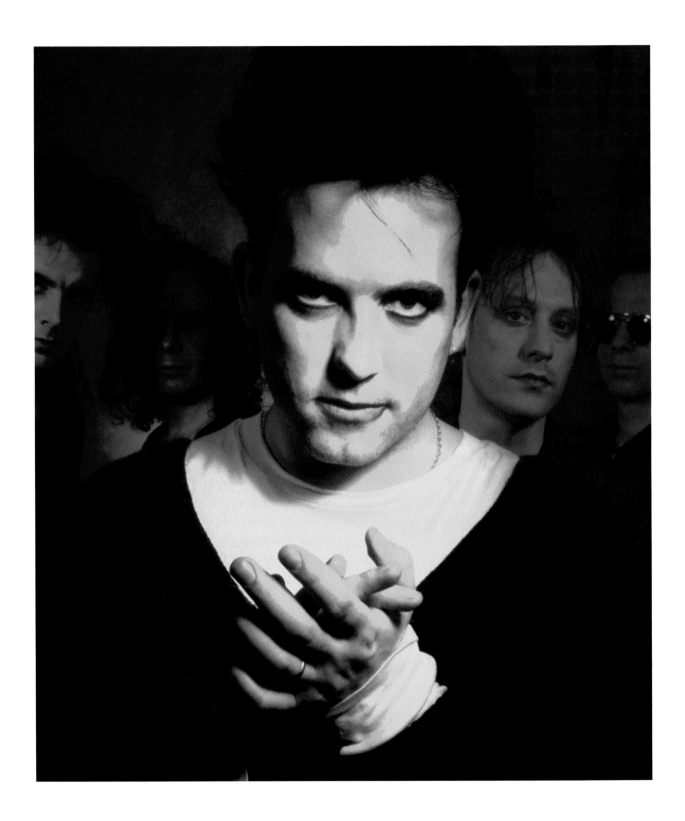

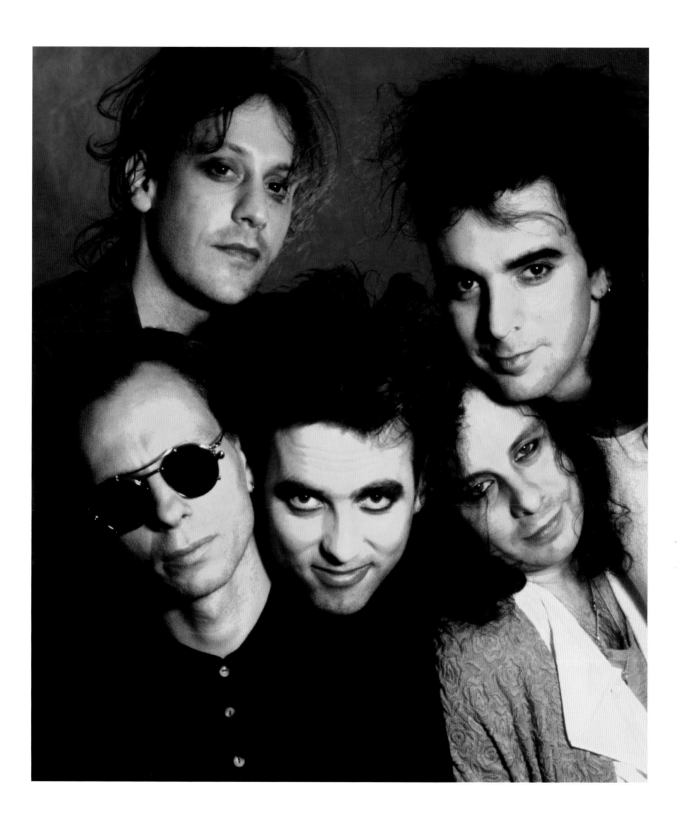

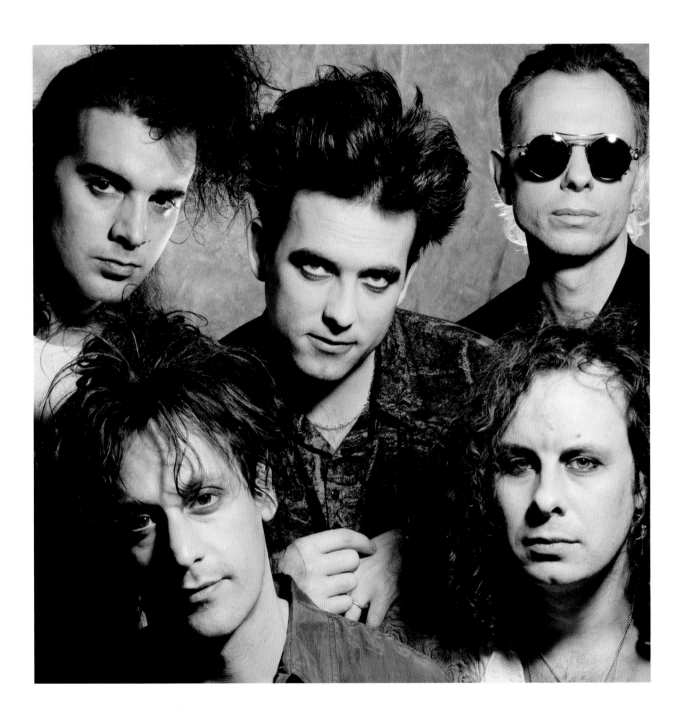

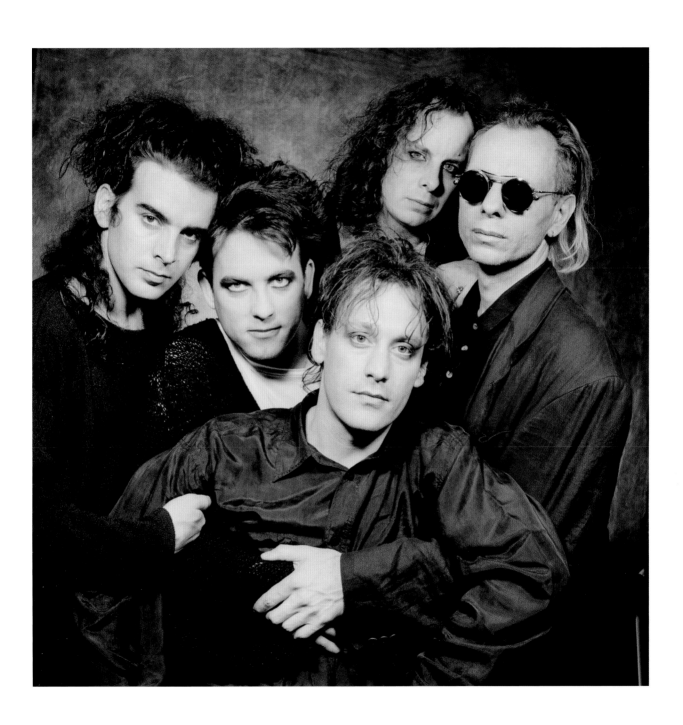

I spent some time with the band at
Haremere Hall in Sussex. It's a huge, grand
house where they'd set up a recording
studio in a big ballroom/dining room.

SUSSE

X 1994

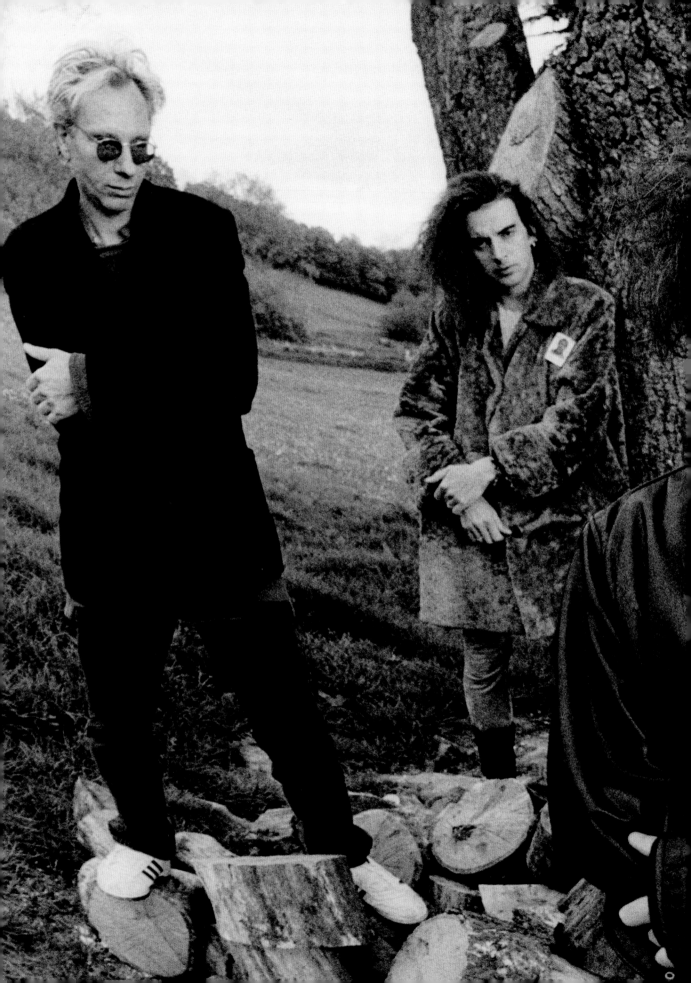

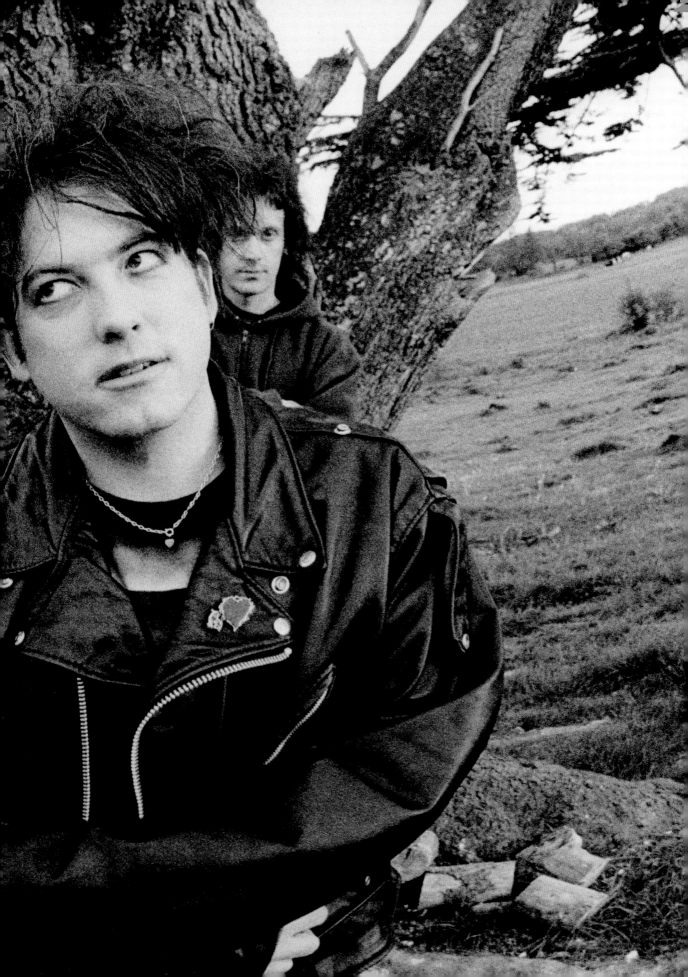

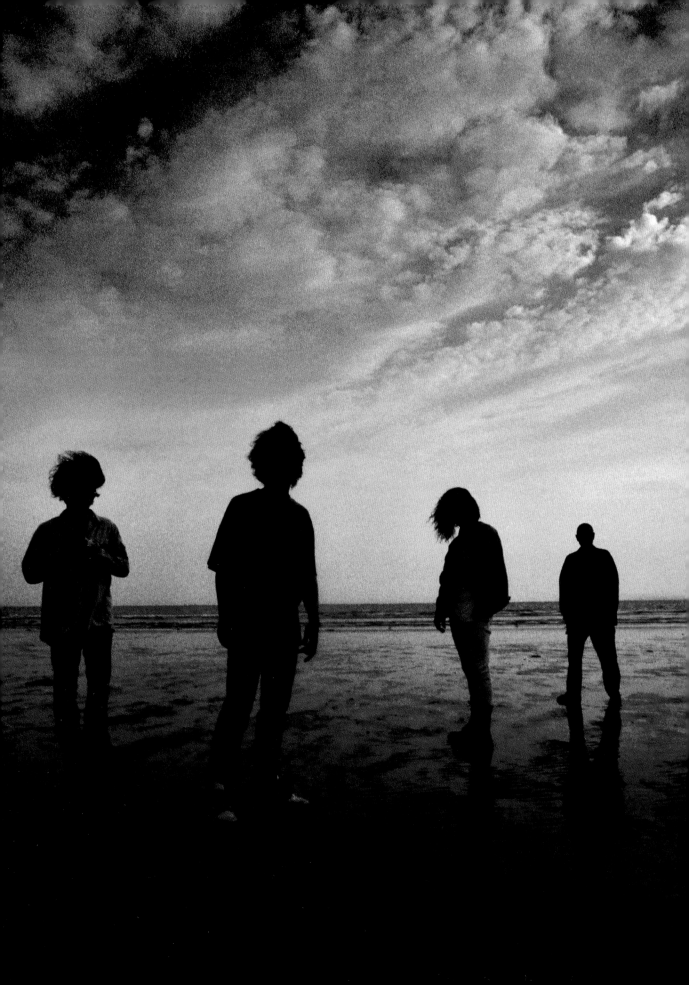

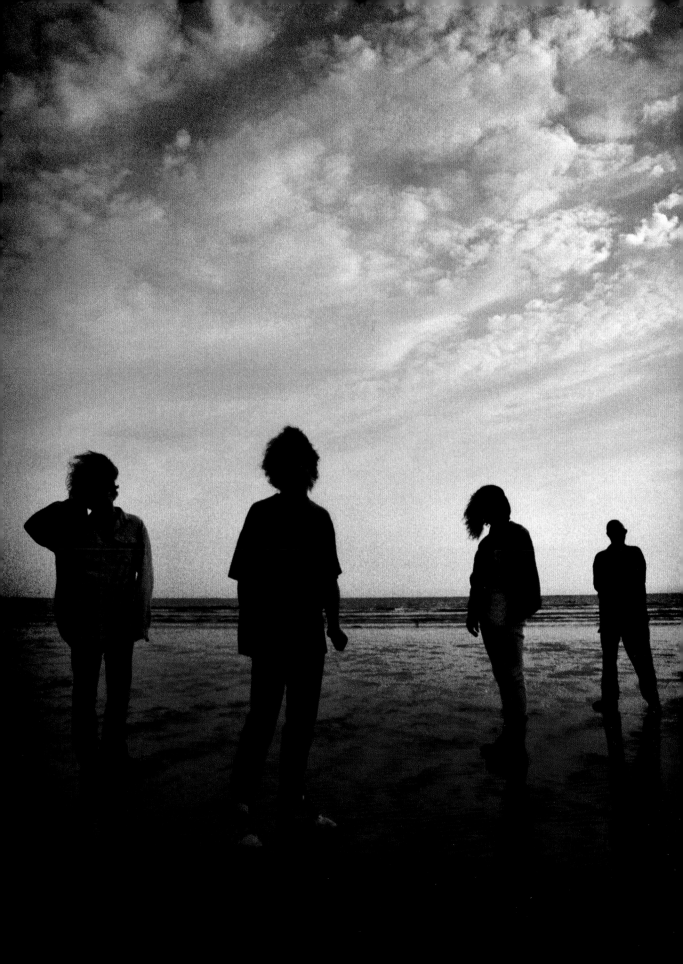

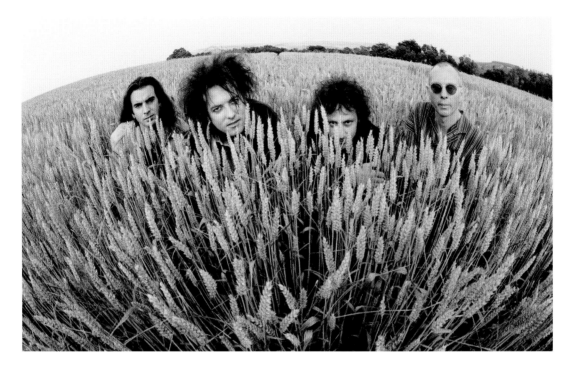

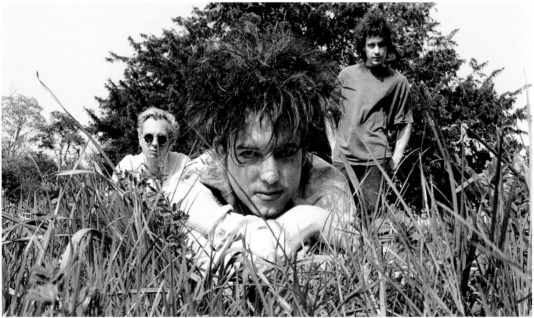

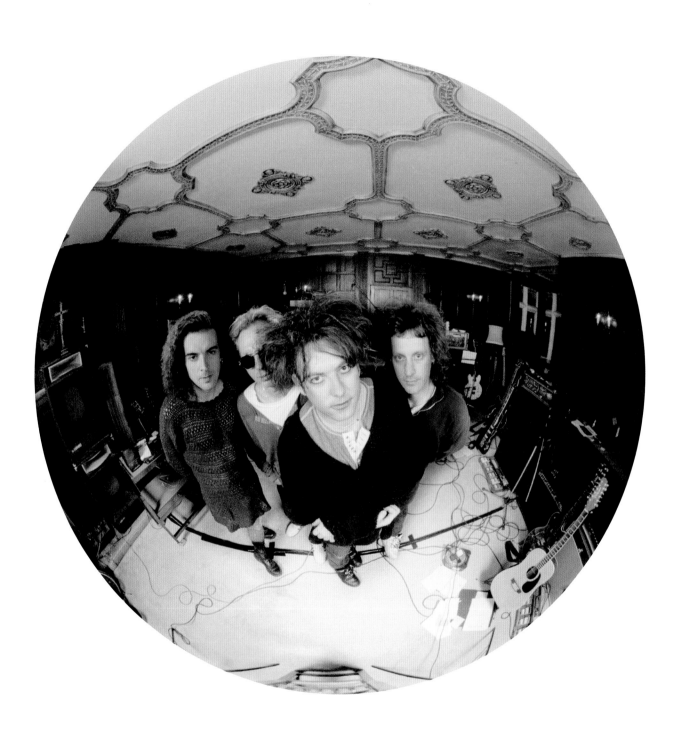

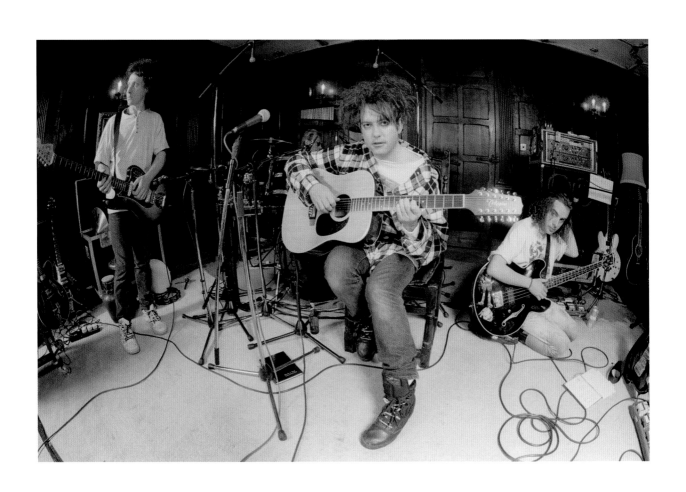

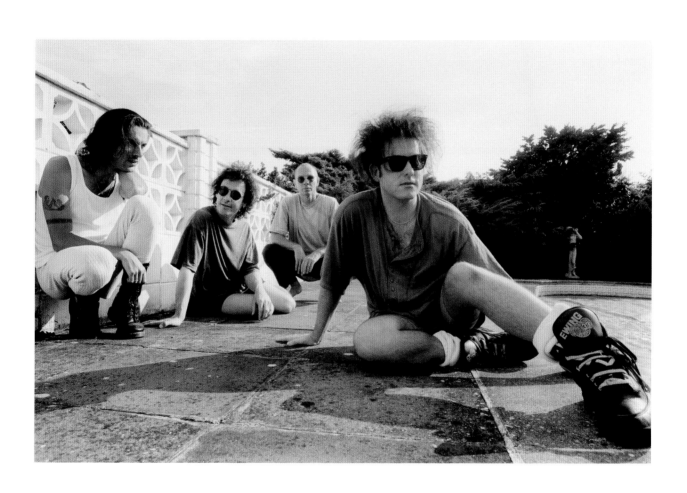

PICTURES OF US
(Forever: 1990–∞)

It is 4 a.m. Robert o'clock. It might be Europe, or Australia, or North or South America. The time zones can change but it will always be 4 a.m., Robert o'clock, and Robert will still be awake many hours after playing a set longer than most *Godfather* films to a crowd typically big enough to fill a flotilla of cruise liners, in some concert hall, stadium, castle, piazza, racecourse, park or vast acreage of dairy farm. If Mary isn't there with him he will phone her because she, too, operates on Robert o'clock, according to wherever in the world he is. The place doesn't matter. Nor does the year. It could be the Nineties, the Noughties, today or tomorrow… *Time passes. Listen. Time passes…* And that sound you can hear is a sound that will not die.

Because The Cure don't.

Unlike the *Challenger* space shuttle, The Smiths and the Berlin Wall, they manage to outlast the Eighties without cracking up. The Nineties aren't seven weeks old when Robert's band are seen in public again, on a stage, on television, receiving a 'Best Video' Brit Award from Bobby Brown – which must be twice as confusing for him as it is for them – for the *Disintegration* single 'Lullaby'. It's the first trophy they've ever won and, because the Fates haven't entirely lost their sense of humour, they receive it not for their sound but their imagery.

Robert's obstreperous vow never to tour again isn't broken, only bent like a spoon between Uri Geller's fingers with the announcement of a summer's worth of European festivals; a small miracle considering he 'fucking hates' such gatherings. Most encores end with the first new Cure song of the decade, its title all the explanation anyone needs for now as to why Robert isn't yet ready to disband them: 'Never Enough'. Baggy-edged and wah-wah-flared, it swaggers into a Top 20 puffing on its whistle to Deee-Lite, the KLF, Adamski and The Charlatans. Pap's accompanying end-of-pier freak-show video is shown on *Top Of The Pops*, now presented by Anthea Turner. The Nineties become the Nineties at terrifying speed.

It's followed by the whiplash-inducing oxymoron of a Cure 'dance remix' album and for a nervous split second it appears Robert might be entering some sort of disco codger midlife crisis, aged 31, jumping someone else's groovy train. But whatever it takes to survive the brutal cull of pop's ancient woodland by technotronic chainsaws. Personalities vanish behind hits programmed by faceless DJs dispatching human puppets to mime in their place. Melodies become less important than repetitive beats. Moshpits and Stratocasters are out, raves and Roland 303s are in. The communally individual becomes individually communal. Leather jackets are swapped for fluorescent cagoules and in the twitchy UK music press the zenith of 'cool' is defined by rackets for sweating goons gurning to death in the middle of a field near Rochdale in the wee small hours of Sunday morning. Which leaves Robert where, exactly?

'In a pop group – and I still want to be.'

Their first Brit has barely had two rubs of Mr Sheen when the following year Roger Daltrey hands them another. In Maggie-free 1991 The Cure are 'Best British Group' and Madchester splutters in disbelief. 'When I was asked to present this award, I had visions I'd be presenting it to a sampler and a drum machine,' guffaws Daltrey. Scratching his scalp at the podium, Robert gushingly thanks 'everyone through the years who's been to the concerts and bought the records. And if you've had half as much fun as we have, then we'll all die happy… well, nearly, anyway.'

And so The Cure brace the Nineties by reminding the world, and themselves, that they are now too gnarly a bunch of sticks buried in too deep a mud to be anything other than what they've always been. Something like a post-punk Bagpuss: an old, soggy cloth cat, a bit loose at the seams, but everyone loves them. At least enough people to send their ninth album, *Wish*, to number 1. Its easy passage is greased by the Top 10 singles 'High' and 'Friday I'm In Love', which in 1992 make the once joyous act of switching on the wireless marginally less painful than

Ugly Kid Joe would have us believe. Yet the assassins of style are unforgiving. A new Nineties music magazine giddy with delusions of hipness, all the stranger considering they've just whacked Bono on the cover, accuse Robert of being 'trapped' by his fat, furry, saggy old Image.

'The thing is, I don't feel that that image is me. I've shaved my head three times and I didn't feel any different inside. It's just something on the outside of me. It's odd that people think that image is me.'

Robert may not *be* the Image but the Image will always be his. When another Tim with a movie camera, not Pap but Burton, makes a Hollywood fantasy about a humanoid with scissors for hands, child's scribble hair, pale skin and prominent lips, everyone under the age of 40 points at the screen and sighs, 'Ah! Robert Smith!' The much-too-visible fame he still detests, unable to navigate the streets of Paris and certain parts of South America without serious consequences for the cardigan on his back. But every agonising yin having its soothing yang, as he begins his second decade as a recording star, the fiscal achievements of Robert Smith earn him an entry in the latest high-society volume of *Debrett's People of Today*. Which means he is already a millionaire.

As Robert, person of today, contemplates the sea view from his new beachside home and his likely fate as 'one of the local nutters in the pub', the Nineties drool on with end-of-millennium fever. Flags flap and isms jingo. A good five years after the *NME* referred to Robert back in 1989 as being among a 'Brit pop elite' the phrase is abducted by a new wave of yammering cartoons. Their hypnotic impact drives powdery note-rolling Noahs of taste-making to construct a fresh Ark for those sacred acts of yesteryear considered worth saving from the flood of cultural obsolescence. First dibs to moptops and anyone who ever wore a parka. Through sheer vice of knitwear, The Cure must join the now leprously archaic not piped aboard. What ought to be their celebratory tenth album, marking 20 years since Robert

formed the band is imperfectly aimed to land in May 1996, the very week tickets go on sale for Oasis at Knebworth. Hindsight will listen more kindly to *Wild Mood Swings*, but in the be-here-now of way-back-then it is the wrong record by the wrong band at the wrong time in history. The fresh page of the 21st century can't be turned quick enough.

The year 2000 AD is nothing nearly as exciting as Robert's favourite sci-fi comic teased. As technology speeds, group productivity slows and the patient faithful learn never to expect a new Cure album any quicker than every four years. The Noughties witness such an evenly staggered trio, the first restoring the group to their original factory setting of toe-tapping gloom, with Robert proudly selecting it as 'one of three classic Cure albums' in the same breath as *Pornography* and *Disintegration*, records which shoved him to the razor's edge of absolute resignation. *Bloodflowers* doesn't quite, and since Britpop is now a dead flash in a broken pan the penitent press have enough loose compliments jingling in their pockets to spend a few on The Cure once more.

In the digital jihad of the online age it is the critics now staring in the face of unemployed antiquity. Twenty-three years after printing the advert that set Robert wrongfooted on the right path, *Melody Maker* chokes its last before the kettle drums boom for 2001. Like the best of its medalled old guard, Tom Sheehan jumps ship to one of the new 'rock heritage' monthlies, where his first portraits of post-millennial Robert gracefully fill the page. Nostalgia soars on the Dow Jones index and the future of music reverses gear to relive its past, a foreign country which anyone with an internet connection can visit without having to change currency, never mind spend it. Context is erased and the searcher seeks and finds only the non-surprises they're looking for. Any kids who seriously 'wanna be a recording star' are taught the only available route is trial by televised humiliation, followed by tabloid-assisted nervous breakdown. New groups are judged by who they sound like on the spectrum of already-been-done, and those rare originals that draw a complete blank

become ever sporadic amid the deafening echoes of diluted duplicates. The best-selling music magazines become time machines to the Sixties and Seventies, and what's left of music journalism – its power spayed and influence neutered – surrenders to its twilight status as yesterday's papers rewritten for today as something to stick a gummy CD to. The good old days – of running to the newsie every Thursday, getting coalman fingertips reading the latest smudgy episode in the saga of 'Mad Bob' – never felt older.

Without the media that supported it, tribalism ceases, even if the ancient tribes remain, trying to make sense of a scroll-and-swipe world where strangers no longer meet through the distress signals of back-page classifieds listing sex, age and three favourite bands. So, too, The Cure, almost always one of those three favourite bands, who carefully monitor the change in pressure with a twelfth album in 2004 bearing, by their standards, the altogether mysterious title *The Cure*. Like Robert o'clockwork, four years later follows another, the computer-metal shiver of *4:13 Dream*. 'Every album we make is the last album by The Cure,' says Robert, as he did last time, and the time before that, and the time before that. Though it probably won't be, until the next last album by The Cure, as it stands it still is. But if a band falls down in an empty forest, does it make a noise?

Those like The Cure who, once upon a time, made albums with the urgency of a cat burglar's pulse merely to prove they were still together no longer have to. Like billions of others, they stay suspended in the fibre-optic aspic of streaming infinity that is modern music, with all its quantum promises of universal immortality. Old record sleeves that were carefully conceived, designed and photographed to offer the buyer some graphic complement, or intellectual hint, or aesthetic wink, or outright red herring as to the sounds within are redundant. Albums like *Pornography* are now atom-smashed into a million plays of a song on a platform on an electronic device built specifically to play music to be heard and never seen. And so the Fates save their best joke till last: that it has taken the most fantastic microchip minds of the last

40 years to create a technology culture where, as far as their average listener is concerned, The Cure really may as well be an ensemble of amorphous ectoplasmic wraiths. Because when the means erase the image, all that's left is the music.

~~Hair. Make-up~~. The Cure.

It's the reason why tens of thousands of people whose first language isn't English still guarantee a sell-out every time they play a Madrid, Lyon, Zagreb, Oslo, Mexico City or Santiago. And while giant video screens offer enough of a glimpse of hair, lipstick and eyeliner to reassure the children of the night they're definitely stood in the right hippodrome, most are there not to gape at the murky silhouettes on stage but to listen. The band is the music. The music is the gig. The gig is the audience. The Cure are us and we are The Cure.

So, in the end, Robert was right. The Cure never were about *image*. But when he first fell through the revolving doors of a Kensington hotel into Tom Sheehan's viewfinder in November 1982, he couldn't have found a better foil to develop one. Because even if The Cure don't need it now, they needed it then, in the viscerally visual renaissance of late twentieth-century pop, a high-stakes vanity fair which Robert could only ever have survived with the right warpaint. His, the sword of Mary Quant Crimson Scorcher, and the shield of KMS hair gel. For his sake, he struck his pose. For our sake, he got his ass up. For music's sake, he took his chances.

The Fates can die happy… well, nearly, anyway.

Robert's a big lover of the countryside, so for
this shoot we piled into a van and went out for
a drive – just me, the band and Bruno, their
tour manager. Robert had an idea of where he
wanted to go, so we'd stop off at various sites
he liked and take a few shots, no lighting, no
assistant, nothing. It was a really good day out.

SOUTH W

EST 1995

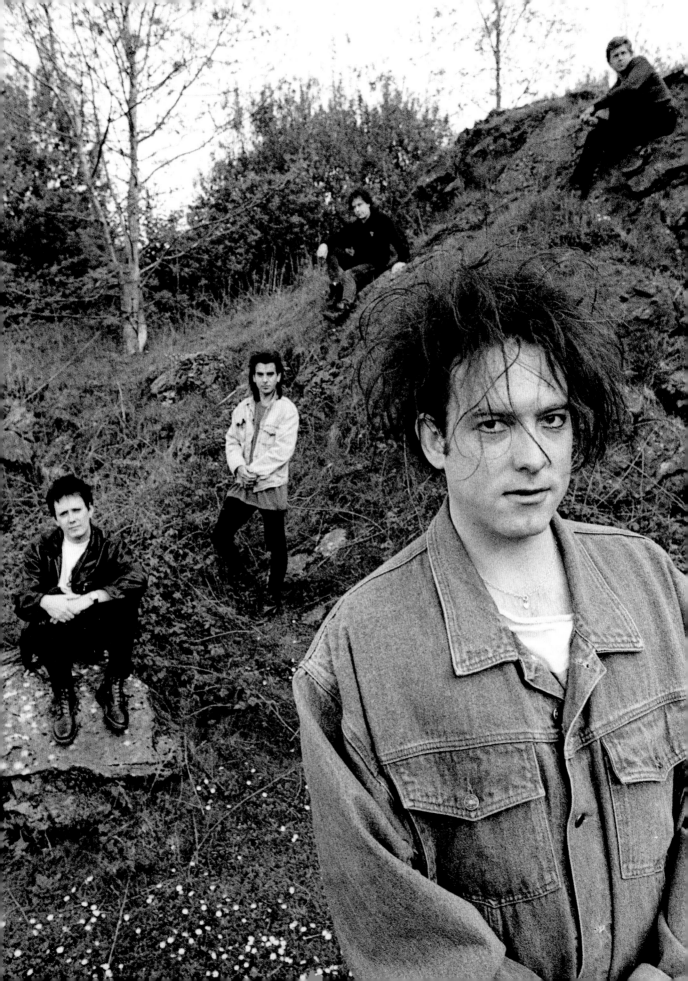

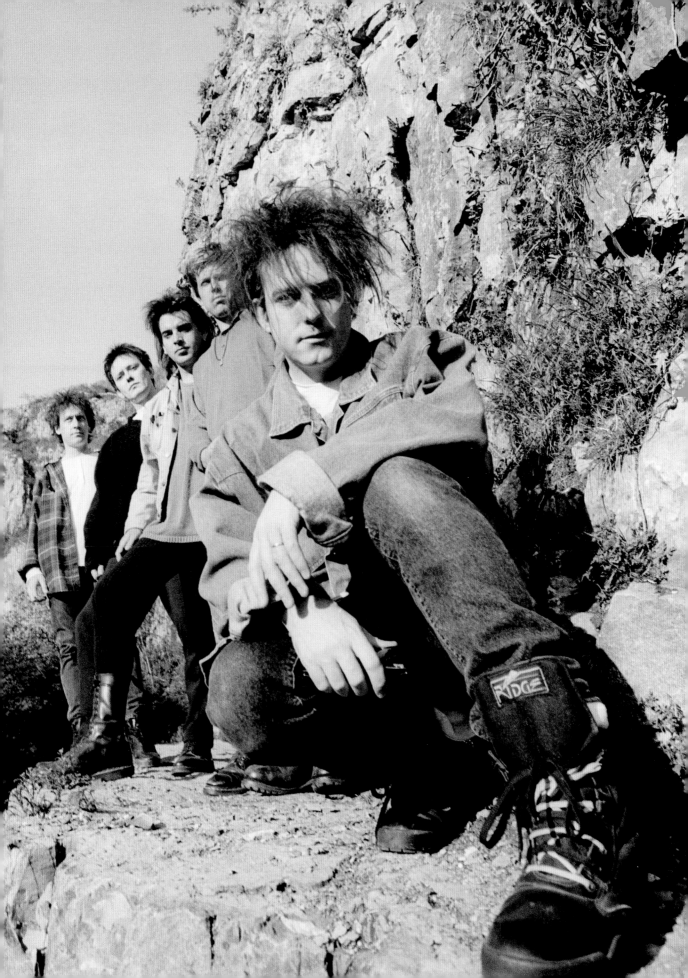

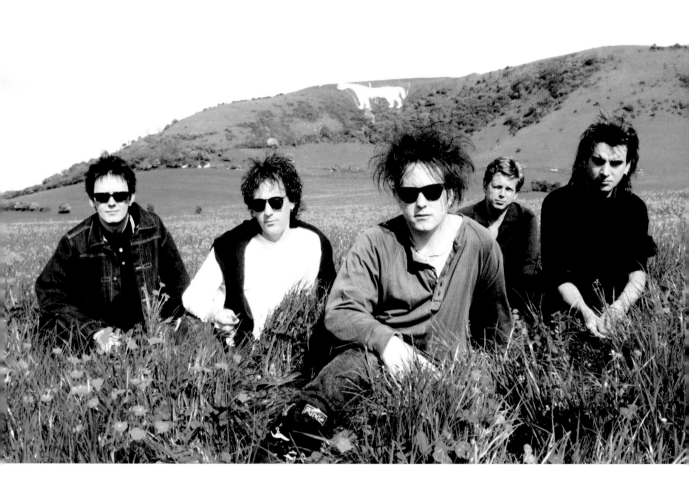

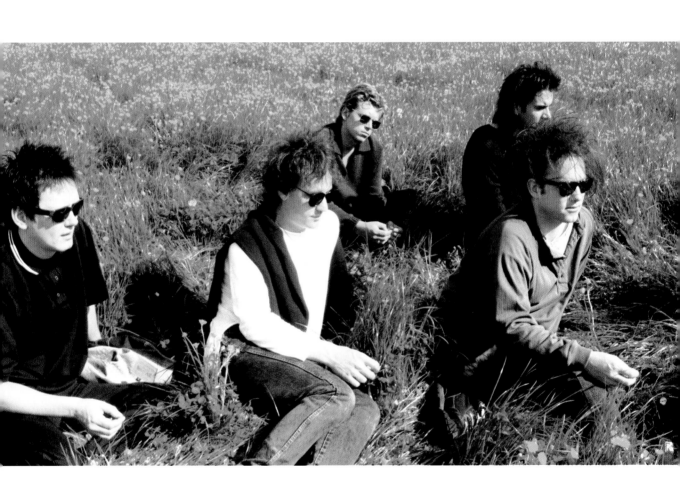

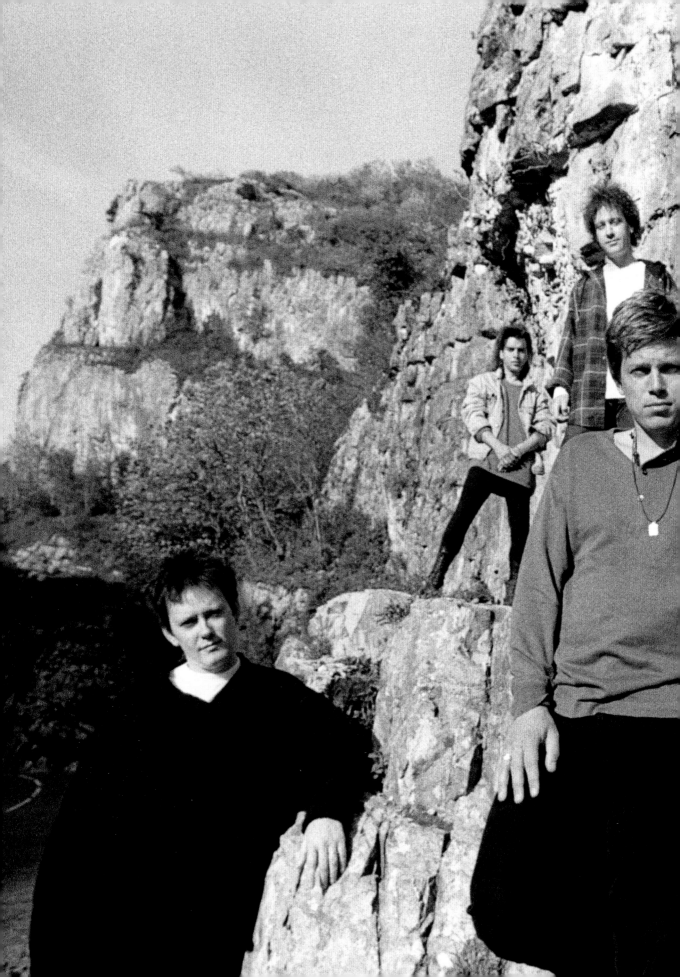

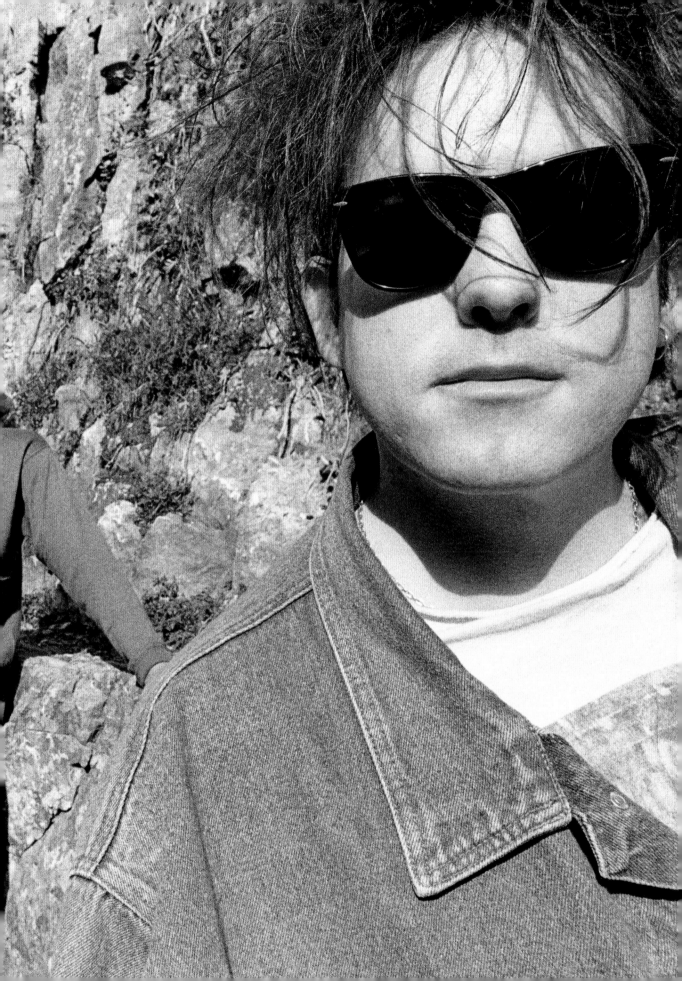

This was at the end of a day of press Robert had been doing in the Richmond Hill Hotel. I was the last person on the schedule that day, shooting for *Uncut* magazine, and when I arrived, Robert said he'd taken the liberty of ordering us a bite to eat and a beer or two. Work comes first, of course, so we went into the corridor and wandered around looking for a few shots, finding some interesting details here and there that worked well.

RICHMO

ND 1999

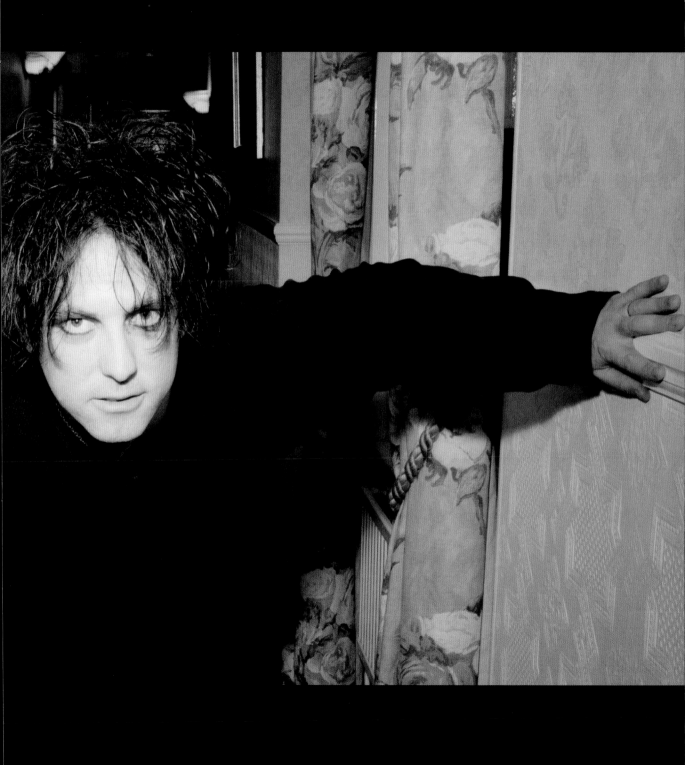

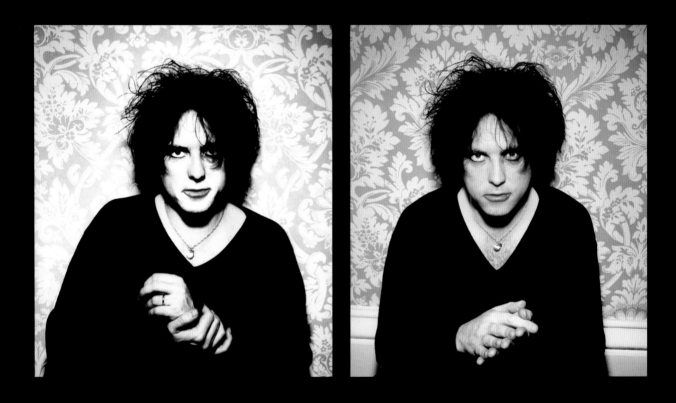

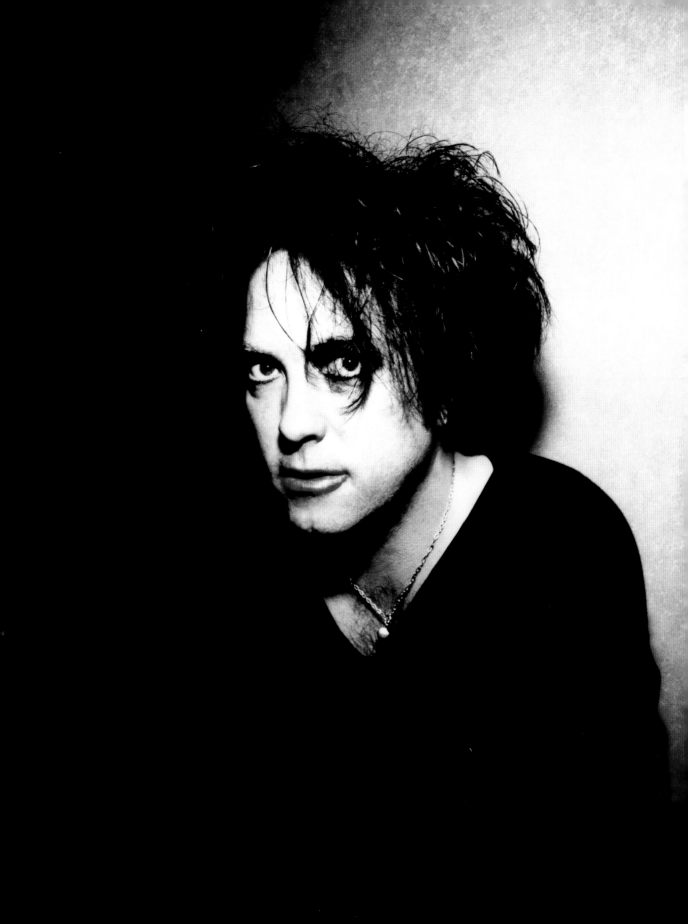

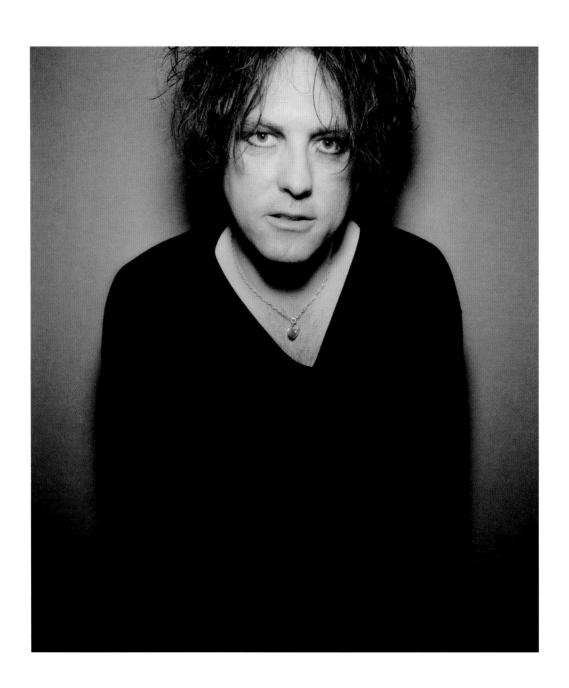

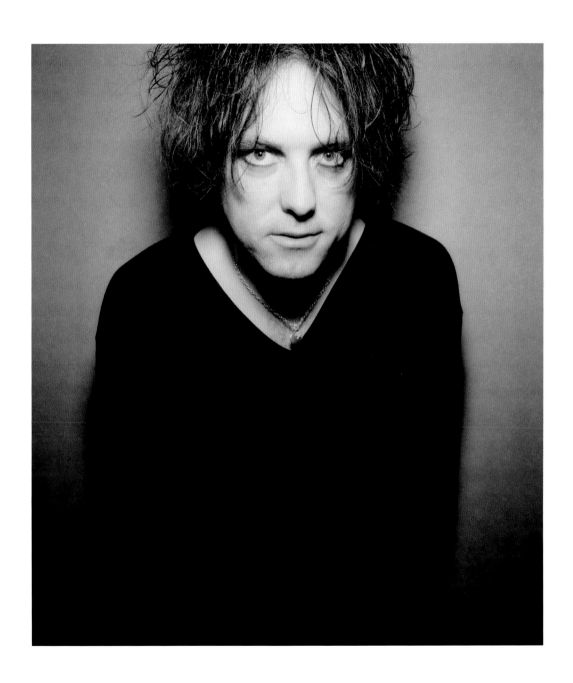

The band were rehearsing in a huge practice space used by loads of big bands – Oasis, Blur, all sorts. I wanted a few group shots, so I turned up with a couple of rolls of paper to use as makeshift backdrops, waited for them to finish up their rehearsals and rattled off a few frames.

BERMOND

SEY 2003

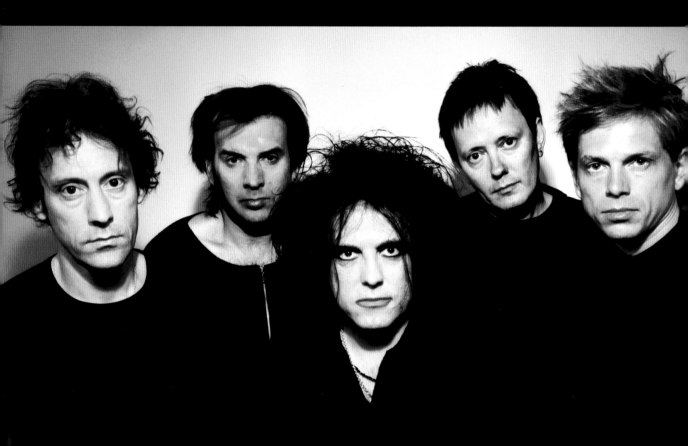

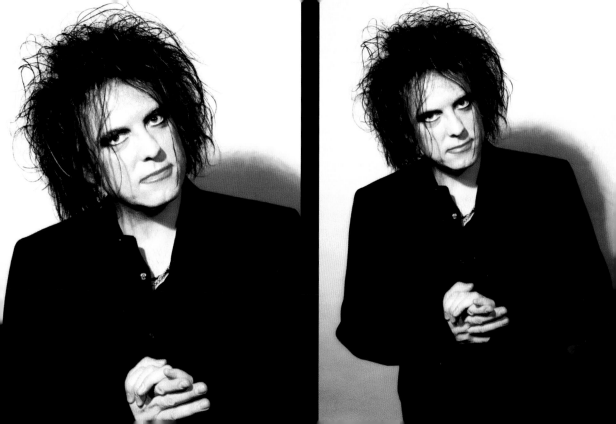

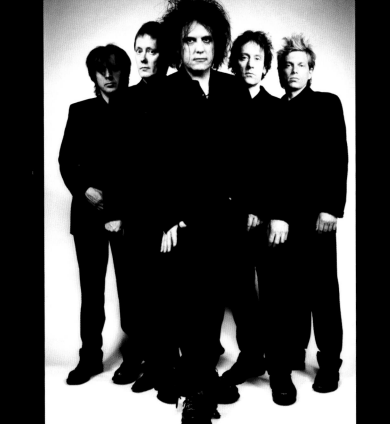

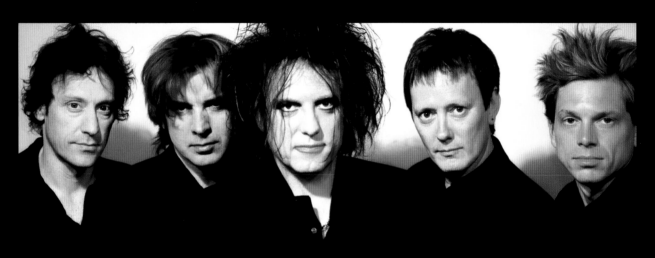

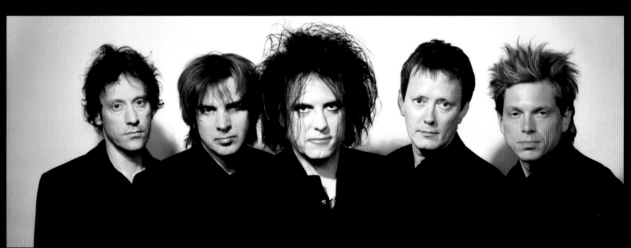

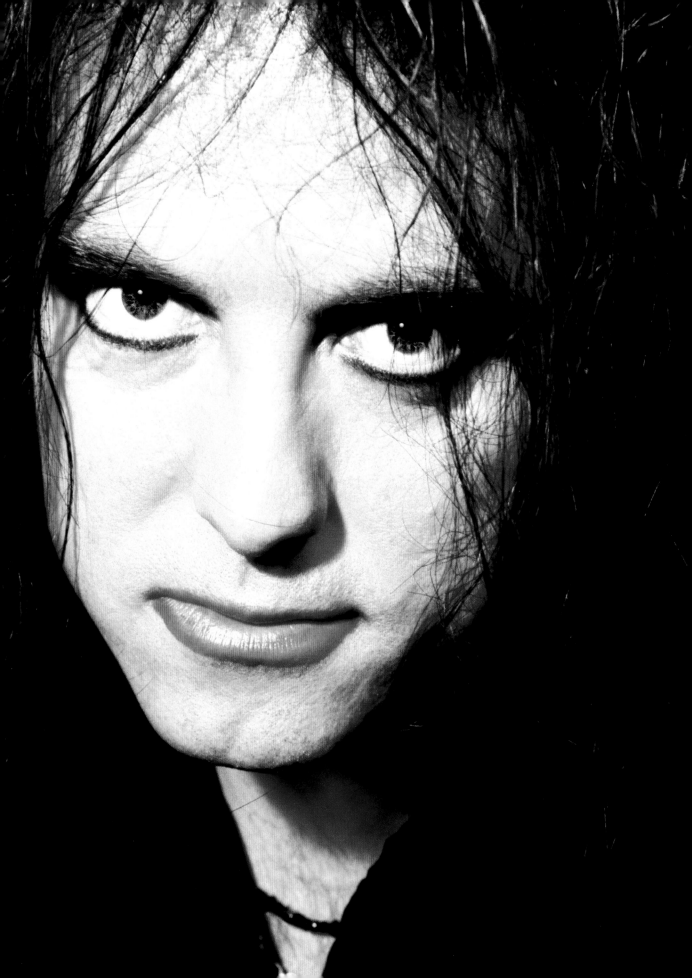

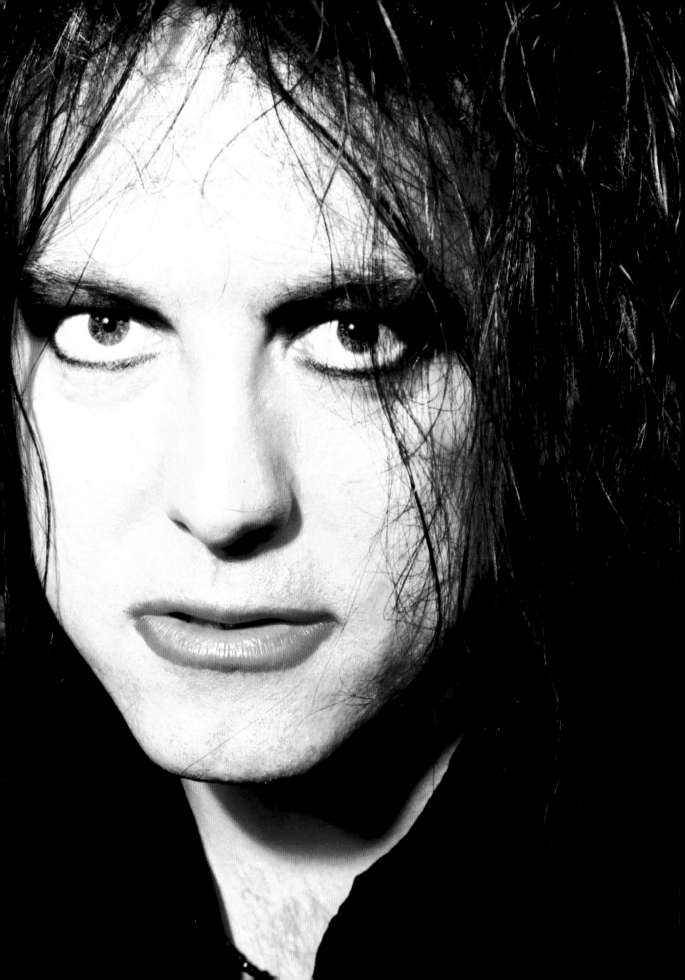

Robert's no stranger to Gatwick Airport, growing up just down the road in Crawley, but this time he was in a hotel for a day of press. I was taking his portrait for *Uncut*, but the hotel room he was based in was an appalling backdrop, nothing at all for us to work with. So I took him out on to the fire escape, where we could play with some interesting lines and textures.

GATWIC

K 2004

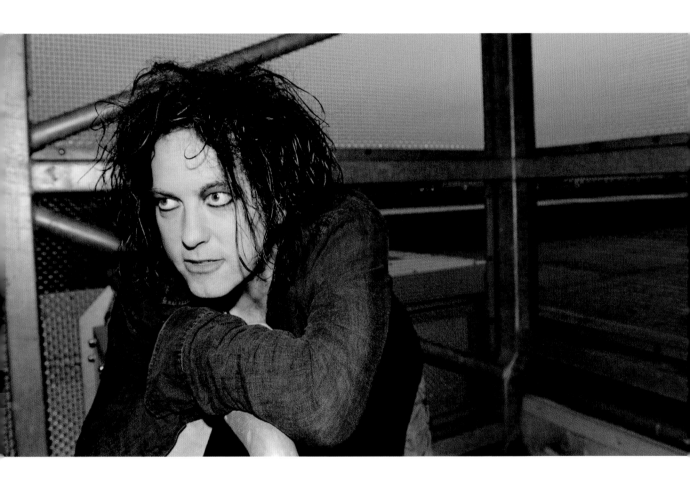

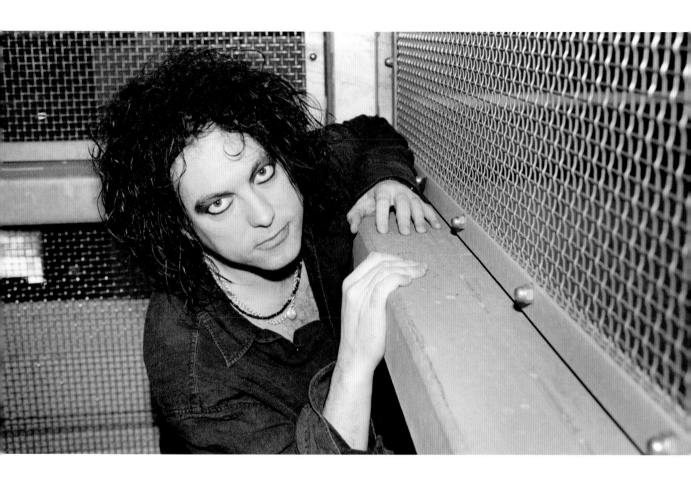

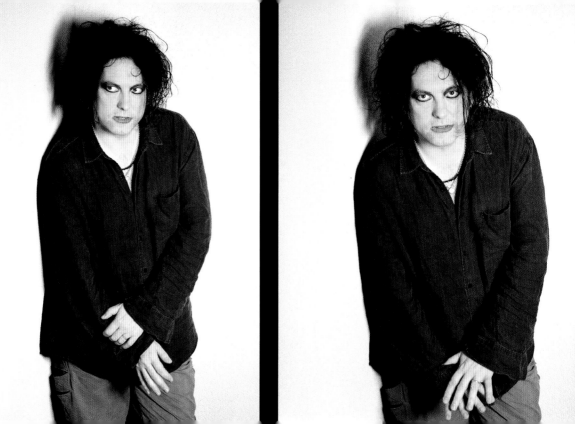

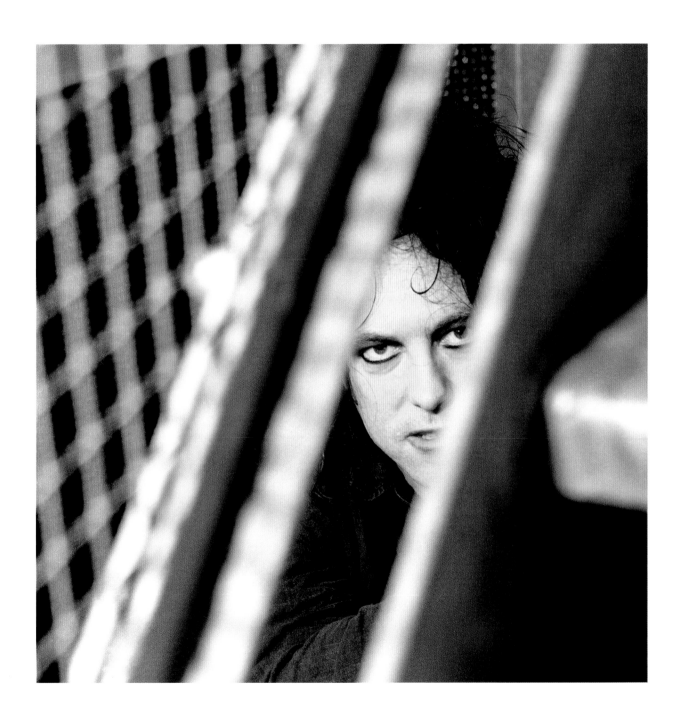

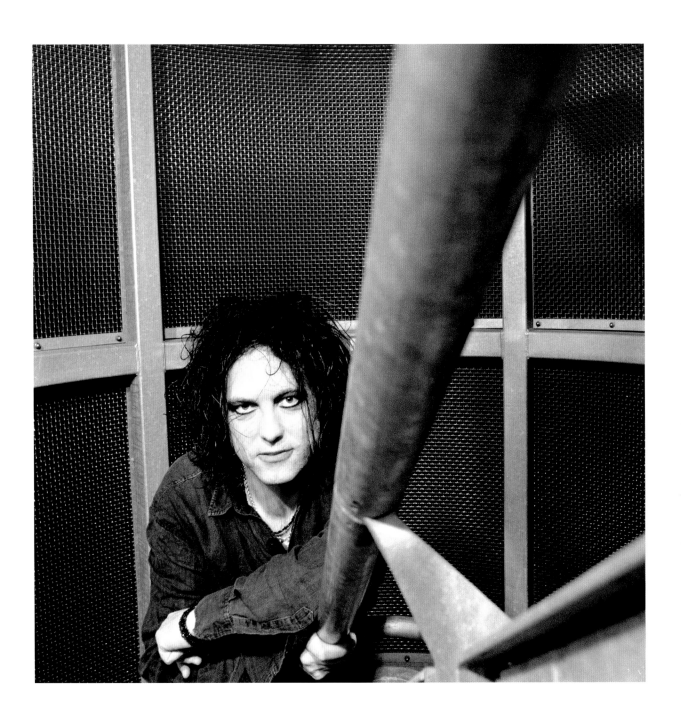

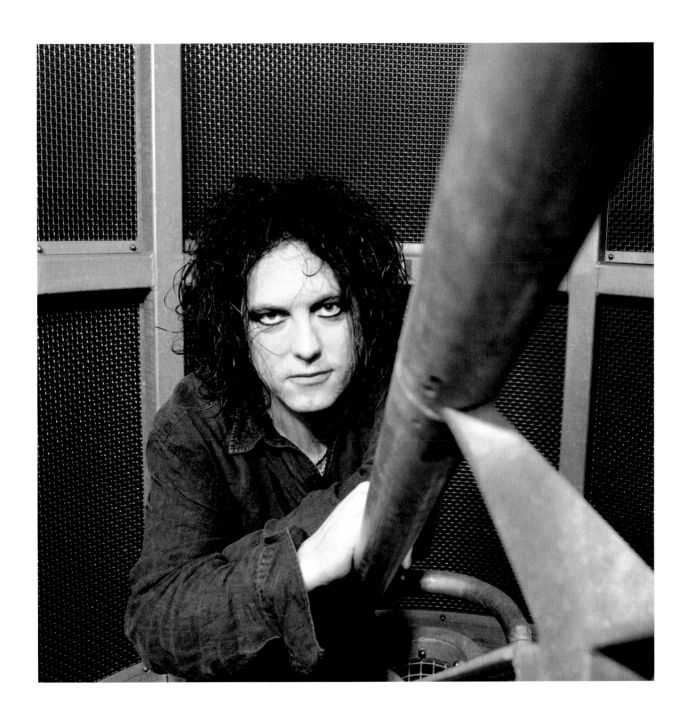

I was working on a series of portraits on music icons and the records that inspired them. I'd already shot a few artists, Paul Weller and the like, and Robert agreed to pose holding a copy of Bowie's *The Rise And Fall Of Ziggy Stardust And The Spiders From Mars*. We met at a studio Robert was working in, hence the leads and wires in the background. And we snapped a few frames on the spiral staircase that had nothing to do with the record – some nice portrait shots that look great.

WESTSIDE S

TUDIOS 2005

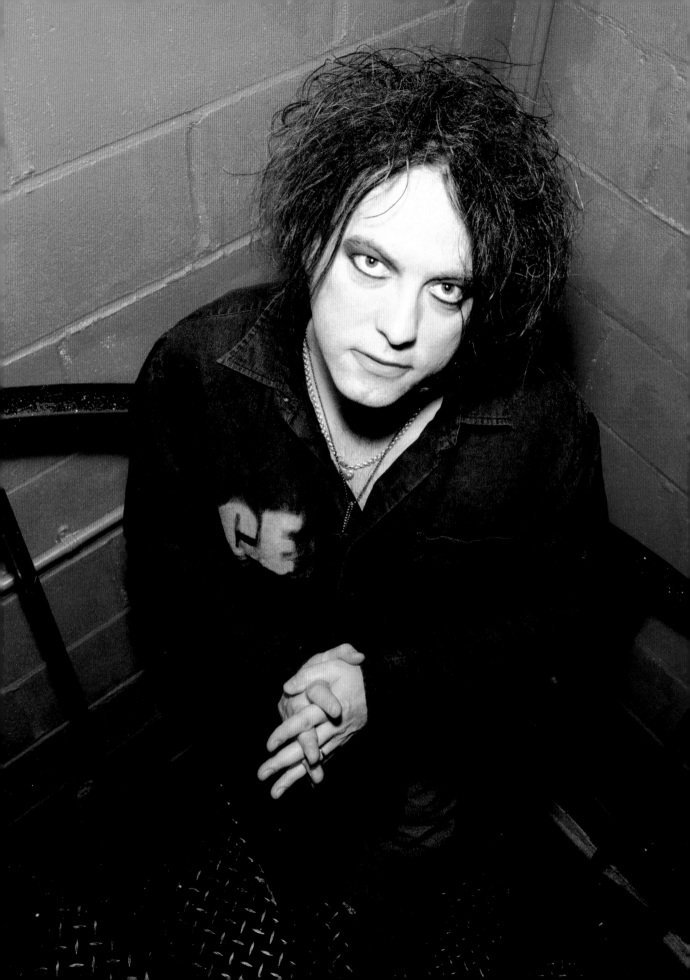

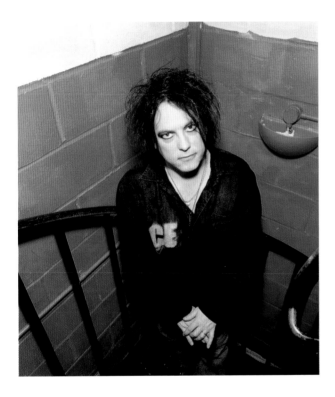
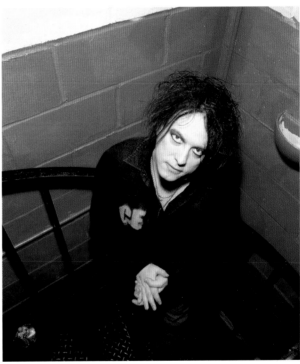

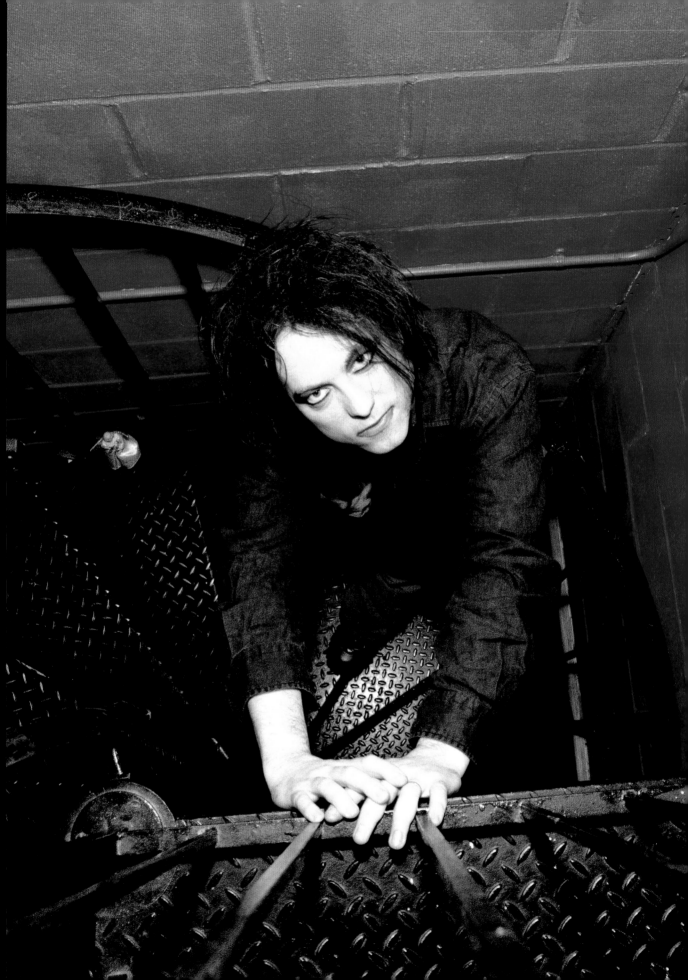

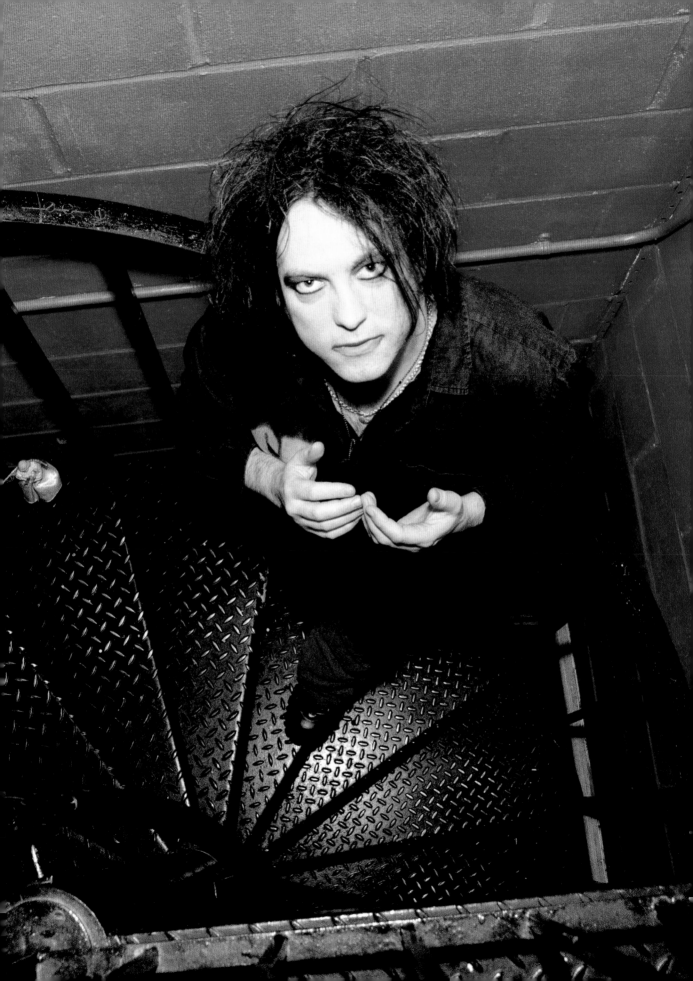

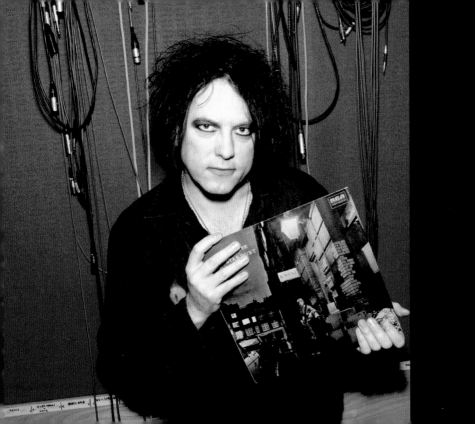

For Jamie, Alex and Florrie

Thanks to Robert Smith and The Cure, Carl Glover,
Simon Goddard and Joe Cottington.

TS 2022

Published in 2022 by Welbeck
An Imprint of Welbeck Non-Fiction Limited,
part of Welbeck Publishing Group.
Based in London and Sydney.
www.welbeckpublishing.com

Design by Carl Glover at Aleph Studio

A CIP catalogue record for this book is
available from the British Library.

ISBN 978 1 80279 396 3

Printed in China

10 9 8 7 6 5 4 3 2 1

the cure
pictures of you

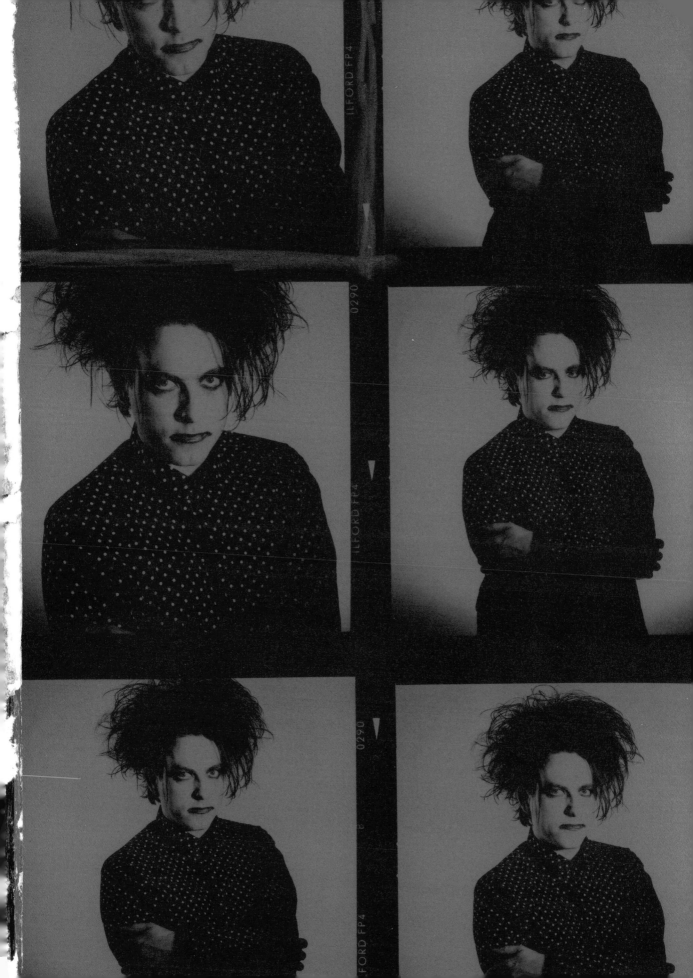

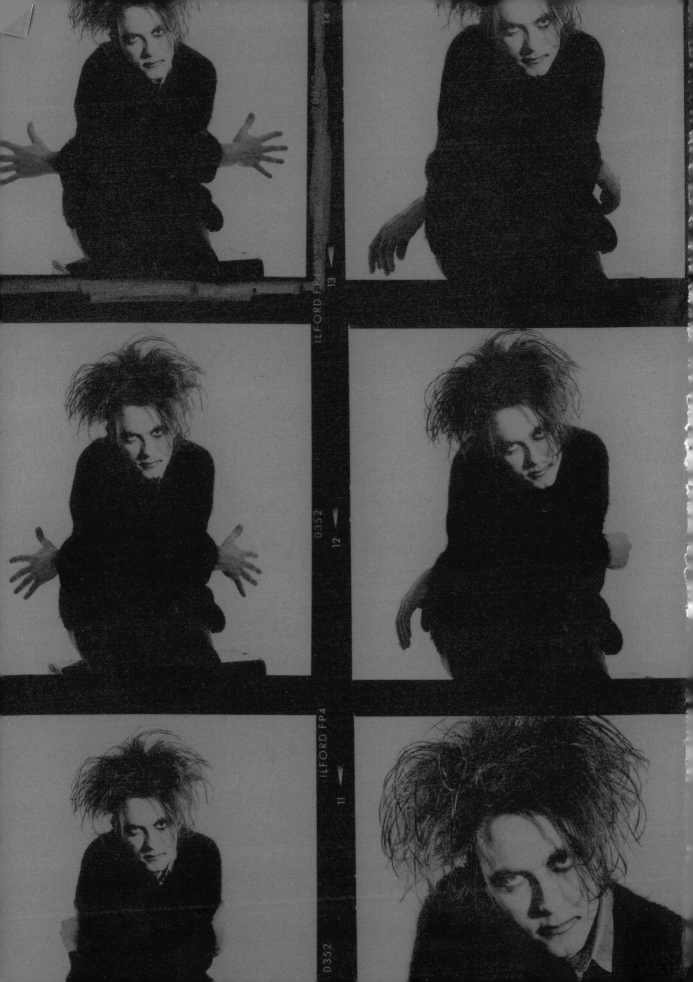